America's Art

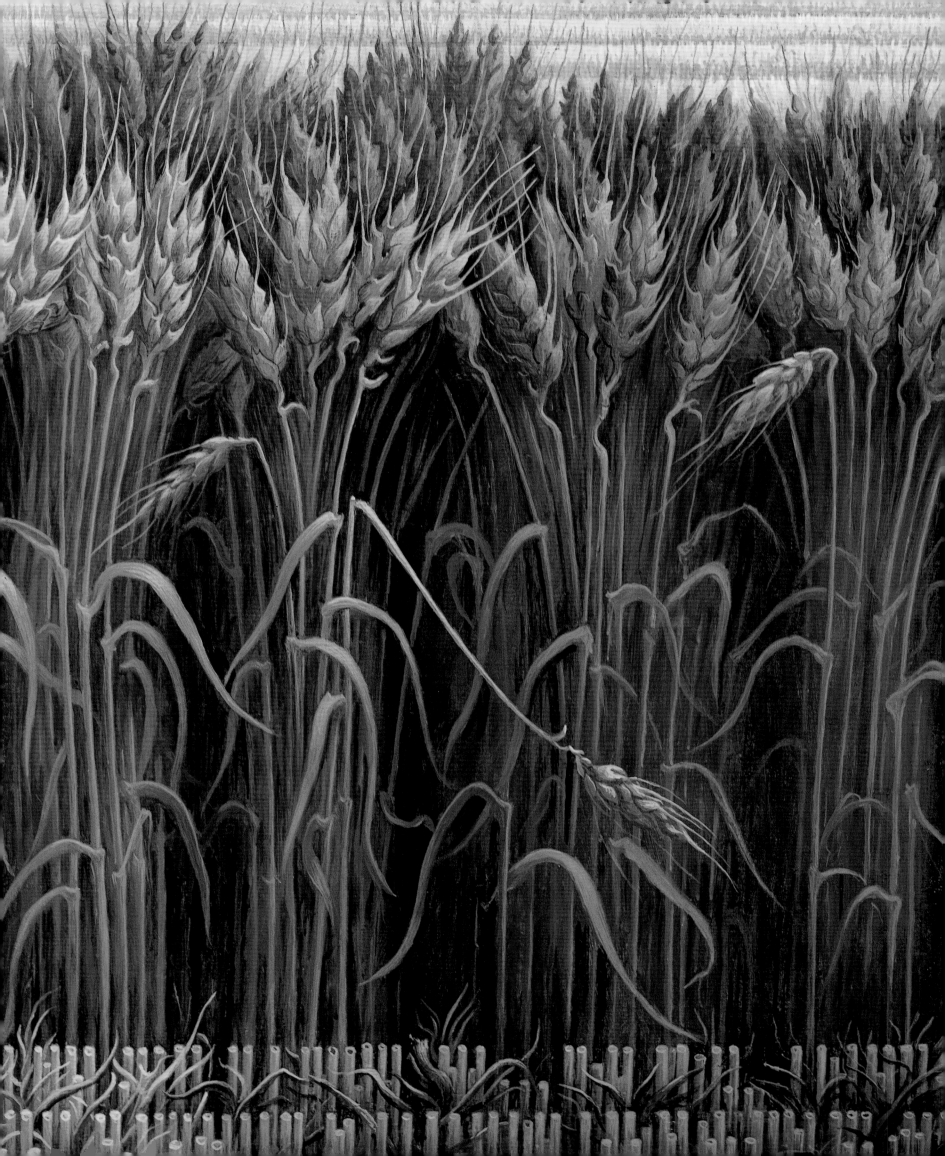

America's Art

SMITHSONIAN AMERICAN ART MUSEUM

Theresa J. Slowik

Foreword by Eleanor Harvey
Introduction by Elizabeth Broun

Abrams, New York, in association with the Smithsonian American Art Museum

America's Art, Smithsonian American Art Museum
By Theresa J. Slowik

Published on the occasion of the reopening of
the Smithsonian American Art Museum's historic
Patent Office Building, July 2006.

Project Manager: Theresa J. Slowik
Designer: Karen Siatras
Editors: Sara E. Beyer, Mary J. Cleary, Tiffany Farrell
Production Assistants: Valerie O. Kritter, Jessica Hawkins
Researcher: Aimee Soubier

*The Museum gratefully acknowledges the generous support
of Ruth S. and A. William Holmberg for this publication.*

The Smithsonian American Art Museum is home to one of the largest collections
of American art in the world. Its holdings—more than 41,000 works—tell the story
of America through the visual arts and represent the most inclusive collection of
American art of any museum today. It is the nation's first federal art collection,
predating the 1846 founding of the Smithsonian Institution. The Museum celebrates
the exceptional creativity of the nation's artists whose insights into history, society,
and the individual reveal the essence of the American experience.

The Smithsonian began an extensive renovation of the Museum's historic
building in 2001. The renovation will provide additional gallery space for collections
and improved visitor amenities, such as a café and museum store, as well as new
educational facilities. Additional enhancements include the Robert and Arlene
Kogod Courtyard, the Nan Tucker McEvoy Auditorium, the Lunder Conservation
Center, and the Luce Foundation Center for American Art, which will display 3,500
artworks from the Smithsonian American Art Museum's permanent collection in
densely installed secure glass cases.

The Renwick Gallery, SAAM's satellite museum, collects and displays
American crafts and decorative arts from the nineteenth to twenty-first centuries,
and is located on Pennsylvania Avenue at 17th Street NW.

For more information or a catalogue of publications, write: Office of
Publications, Smithsonian American Art Museum, MRC 970, PO Box 37012,
Washington, D.C. 20013-7012.

Visit the Museum's Web site at AmericanArt.si.edu

Library of Congress Cataloging-in-Publication Data
Smithsonian American Art Museum.
America's art, Smithsonian American Art Museum.
 p. cm.
Includes bibliographical references and index.

ISBN 0–8109–5532–6 (trade hardcover : alk. paper)
ISBN 0–8109–9192–6 (museum paperback : alk. paper)
ISBN 0–8109–9092–X (Smithsonian gift edition : alk. paper)

1. Art, American—Catalogs. 2. Art—Washington (D.C.)—Catalogs.
3. Smithsonian American Art Museum—Catalogs. I. Title.

N6505.S55 2005
709'.73'074753—dc22

2005017164

Cover: Eastman Johnson, *The Girl I Left Behind Me* (detail), 1870–75, oil on canvas,
42 × 34 ⅞ in. Smithsonian American Art Museum, Museum purchase made
possible in part by Mrs. Alexander Hamilton Rice in memory of her husband and
by Ralph Cross Johnson, 1986.79

Title page: Thomas Hart Benton, *Wheat* (detail), 1967, oil on wood, 20 × 21 in.
Smithsonian American Art Museum, Gift of Mr. and Mrs. James A. Mitchell and
museum purchase, 1991.55

page 6: Charles Burchfield, *Orion in December* (detail), 1959, watercolor and pencil on
paper, 39 ⅞ × 32 ⅞ in. Smithsonian American Art Museum, Gift of S. C. Johnson
& Son, Inc., 1969.47.53

page 10: Albert Pinkham Ryder, *With Sloping Mast and Dipping Prow* (detail), about
1880–85, oil on canvas mounted on fiberboard, 12 × 12 in. Smithsonian American
Art Museum, Gift of John Gellatly, 1929.6.102

Back cover: Winslow Homer, *Boys in a Dory*, 1880, watercolor and graphite on
paper, 10 × 14 in. Smithsonian American Art Museum, Partial and promised gift
of Sam Rose and Julie Walters, 2004.30.2

Printed and bound in China.
10 9 8 7 6 5 4 3 2 1

HNA
harry n. abrams, inc.
a subsidiary of La Martinière Groupe

115 West 18th Street
New York, NY 10011
www.hnabooks.com

CONTENTS

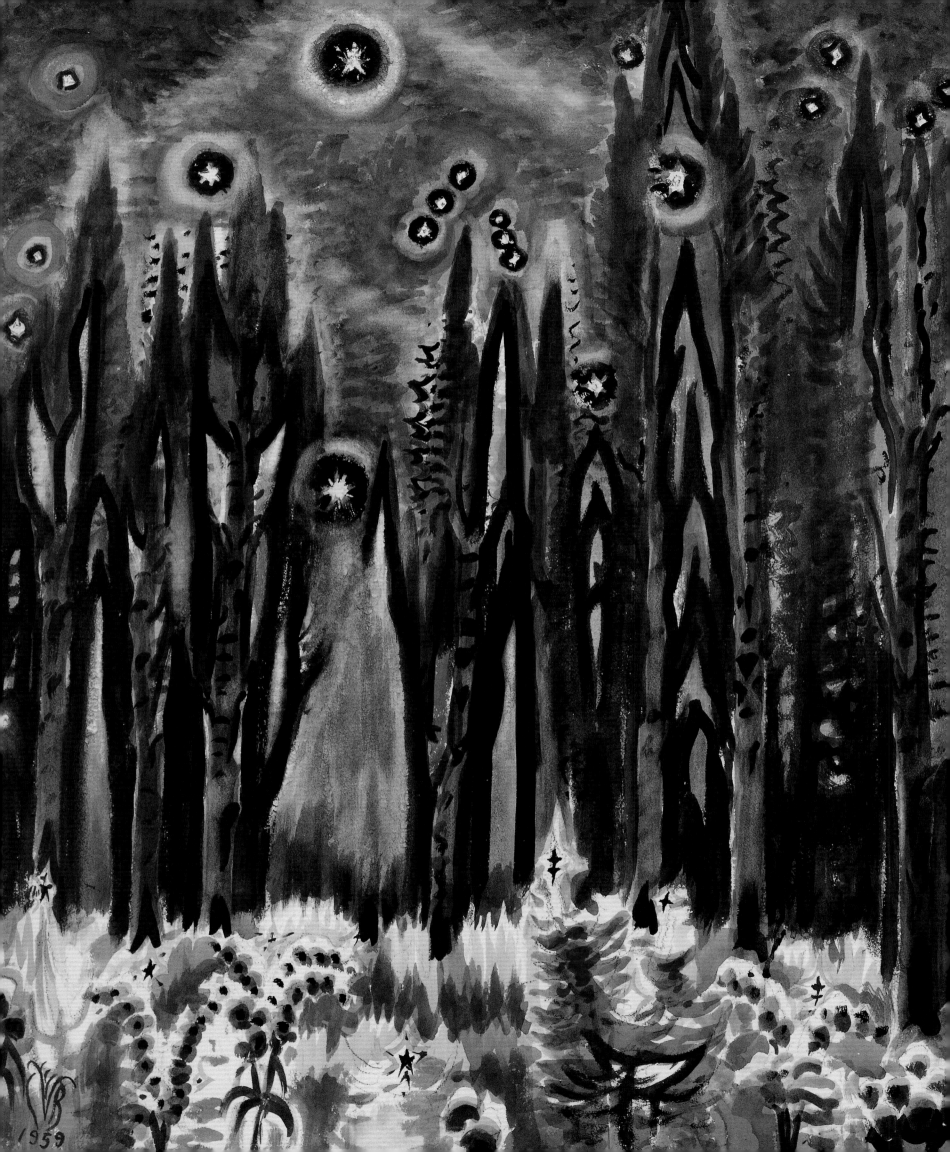

The Smithsonian American Art Museum is an American treasure. Its home is found in the heart of the nation's capital, in the historic Old Patent Office, the third major federal building to be built in Washington. The nearly simultaneous construction of the Patent Office Building, the Treasury, and the Post Office was concrete evidence that the glory of Pierre L'Enfant's civic plan might be realized. Begun in 1836 and completed just after the close of the Civil War, this neoclassical temple, built of native marble, granite, and sandstone, is a beautiful setting for the nation's collection of American art. Intended as a declaration of America's ingenuity and entrepreneurial spirit, the building and its history are interwoven with the aspirations and dreams of the nation.

The Museum's collection began to take shape shortly before the building began to rise out of the city's mud. In 1829 a civic-minded and prosperous man named John Varden decided to enrich the cultural life of this raw locality; he declared that the nation's capital needed a museum. He began with his own collection of mostly European art, to which he added a group of historical and natural curiosities. By 1836 he had installed this mélange in a room he added on to his home and had thrown open the doors of the "Washington Museum" to an eager public. By 1841, Varden's collection was exhibited on the top floor of the newly constructed Patent Office Building.

To celebrate the move into grander and official quarters, Varden adopted the title of curator for himself and bestowed a new name—the "National Institute"—on the collection. The first inkling of the collection's national destiny was a minor clause in the institute's charter, which specified that when the charter expired, the collection would become federal property.

James Smithson's bequest to the young nation to establish a national institution "for the increase and diffusion of knowledge" resonated with American ambitions, and Congress passed legislation establishing the Smithsonian in 1846. By 1855 the Smithsonian "Castle" was complete; two of its galleries were devoted to art exhibitions. The collection was transferred to the Smithsonian building in 1858, and the National Institute was dissolved in 1862. Early efforts to expand the hodgepodge of European "old master" paintings, portraits, and sculpture into a national collection worthy of the name were ill-fated. In a profound statement about the nature of the country and the character of its exploration and settlement, the Smithsonian acquired more than three hundred works by John Mix Stanley and Charles Bird King, depicting Native Americans and western scenes. Tragically, these collections were destroyed in a fire that gutted the second floor of the Castle in January 1865. Over the next fifteen years, the Smithsonian regents dispersed the surviving

collection through loans to William Wilson Corcoran's museum, the Library of Congress, and other institutions. But the conviction that Washington needed an official art museum was not dead—merely dormant. It took another bequest, this time from Harriet Lane Johnston, who served as White House hostess to her uncle James Buchanan during his presidency, to breathe new life into the idea. On her death in 1903, Mrs. Johnston left her collection of paintings to the nation for a "national gallery of art."

This gift, while not large, was enough to remind the Smithsonian that it had an interest in the subject, and in 1906 a federal court ruled that the 1846 legislation that had founded the Smithsonian had also established under the same authority a National Gallery of Art. Once reassembled, the collection attracted new patrons, including Ralph Cross Johnson and his daughter Mabel Johnson Langhorne, while gifts from William T. Evans collected and preserved for the nation an incredible body of late nineteenth- and early twentieth-century painting, including masterpieces by Winslow Homer, Childe Hassam, William Merritt Chase, John La Farge, and one piece by Albert Pinkham Ryder. John Gellatly, another early patron, was a powerful advocate for the excellence and even superiority of American painting and sculpture. While he collected European as well as American works, it was with the avowed

purpose of asking viewers to draw a comparison favorable to American artists when contrasted with established European traditions. Gellatly also believed his role as a collector was to support living artists; his advocacy for such American icons as John Twachtman, Abbott Thayer, Thomas Wilmer Dewing, and Childe Hassam can still be seen in the galleries of the Museum, while the seventeen paintings he gave by Albert Pinkham Ryder are among the Museum's greatest treasures.

Through a succession of similar bequests, the collection expanded far beyond the capacity of the Castle to contain it, and in 1906 it was moved to the second Smithsonian building to be built, the 1881 Arts and Industries Building. By 1910 the collection moved across the Mall to a hall in the newly completed Natural History Building. Though cramped almost from the beginning, the collection remained there for fifty-eight years.

By 1957, as Washington embarked on a frenzy of urban renewal, a bill was introduced in Congress to demolish the Old Patent Office Building and replace it with a parking garage. But historic preservationists had their say, and in 1958 the building was turned over to the Smithsonian to become the permanent home for the Smithsonian American Art Museum and the newly created National Portrait Gallery. During the ten years it took to vacate and renovate the building, the museum staff undertook vital conservation work, catalogued

the collection, and—with the possibility of a real home at last—established an active acquisitions program. The collection and its supporting research resources expanded rapidly, with works by Hiram Powers, paintings and decorative arts from the Alice Pike Barney Collection, hundreds of works by William H. Johnson that came through the Harmon Foundation, the contents of Joseph Cornell's home on Utopia Parkway, a stunning folk art collection, the core of which was assembled by Herbert Hemphill Jr., the Sara Roby Foundation Collection, the Patricia and Phillip Frost Collection of early abstract American art, the Arthur J. and Edith Levin Collection, the Charles Isaacs Collection of early American photography, and others.

By the end of the twentieth century, the Museum's historic building needed attention. On January 1, 2000, the Smithsonian American Art Museum and the National Portrait Gallery closed their doors and moved their collections out of the building to allow renovations to begin. In July 2006—a fit time to celebrate this collection and its connection to the American people—those doors open again to admit visitors eager to see favorite works in a fresh installation, and to enjoy newly acquired works by Nam June Paik, David Hockney, H. C. Westermann, Deborah Butterfield, Martin Puryear, and Liz Larner. We hope you visit often, and come to love these works and this building as much as we do.

Eleanor Harvey
Chief Curator

INTRODUCTION

When I take visitors through the Smithsonian American Art Museum, I begin by saying we have a wonderful collection that tells the story of the country and its people. We look at John Singleton Copley's portrait of *Mrs. George Watson* (1765), where the red satin gown and blue-and-white vase allude to Mr. Watson's import business in colonial Boston. Next we stop near *Daniel La Motte*, Thomas Sully's aristocrat seated before his Maryland estate (1812–13), and I mention Jefferson's idea that America should have a representative democracy, managed by wise landowners on behalf of the broader population. Soon Frank Mayer's *Independence* (1858) comes into view—a self-made man lounging on his rough-hewn porch—inspiring words about Andrew Jackson's Era of the Common Man, which ushered in a more direct democracy. For some visitors, it comes as a revelation that artists express deep structures of society in seemingly incidental portraits and landscapes.

Once it's pointed out, people see how paintings from the 1850s about the gold rush highlight physical changes in the California landscape, while, paradoxically, later western vistas by Albert Bierstadt and Thomas Moran seem "untouched by man," despite increasing numbers of miners and settlers flooding into the West. This makes the useful point that artists sometimes paint a subject the way people wish it were, glossing over harsh realities. We understand that the artworks present subtle but powerful evidence about larger issues. They are emissaries from their age, and we can see how ideas work in them.

A museum devoted to a nation's art provides a unique perspective on the issues and people of that country. As Robert Hughes has written, "Americans like any other people inscribe their histories, beliefs, attitudes, desires and dreams in the images they make." The story I tell is personal to me as much as it is a record of the country. Each of my museum colleagues would construct a valid and completely different thread through the same collection, and visitors too bring their own experiences to these artworks that create a framework for understanding. The narratives shift with individuals and the times, but the objects continue to prompt new interpretations and insights.

We're apt to agree with Charles Burchfield's idea that "an artist, to gain a world audience, must belong to his own peculiar time and place." Personal selfhood; family relationships; ancestry and heritage; township or city; section and region; nation—these identities are like widening circles in water, defined at the center, blurring at a distance. In America, national identity is the sum of innumerable other identities. Each individual or cultural group has an "origin myth" about coming to the United States and becoming a participant in this many-cultures society.

There are many democracies in the world, but ours is distinguished from those more homogeneous societies by its

history. The United States was founded as a place where immigrants would enjoy equal rights under the law. British, Scotch-Irish and Irish, Africans, Scandinavians, Chinese, Jews, Germans, Italians, Poles—many such groups left a distinctive stamp on our culture following a large migration of their people. Today we struggle, in our neighborhoods and as a nation, with the differences that arise. How can we forge an America that embraces such variety as Cuban Americans and Mexican Americans, first- and third-generation Chinese Americans, East and West Coasters, and rural Southerners and urban Northerners?

Some now argue that a strong national identity is problematic in today's globalized world. Telecommunications beam across borders to help topple nationalistic ideologies. Global economics and multinational corporations are displacing protectionist philosophies. The mass culture promoted by media conglomerates is losing ground to the "many to many" model of Internet users. Everywhere the way seems paved for a new era based on "acting locally, thinking globally."

What then is the appropriate and meaningful role for a museum dedicated to a nation's art, when we are poised at the beginning of this brave new world? One answer is to go back to the beginning and retell the American story from the start. This time, let's put the missing chapters back into the narrative, the ones that flesh out the heartwarming and heartbreaking story of

this country. My museum tour should include the Hispanic colonial art of the Southwest and the Caribbean, along with the British colonies on the Atlantic coast. And let's acknowledge that African Americans made art long before Emancipation.

There are so many untold chapters, so many artists left out—not because the work is poor but because we have streamlined the story. As a native midwesterner, I know there are many wonderful artists who drop between the cracks when shows are organized, because they're not immediately before us in the trade. Half-German, I'm also aware that wide dispersal of Germans and two world wars have discouraged a German-American identity in this country, obscuring their crucial contribution, their dedication to fine workmanship, whether construed as a well-made picture or a piano in the parlor. Self-taught artists abound in every part of America, expressing their highly individualized visions outside of any academic tradition or approved convention. This country has always been too vast in geography, too fluid in social structure, and too anarchic in politics to achieve a centralized culture.

There is so much more to know about who we are as a people, about our tumultuous and inspiring history, and our contentious but exciting present. Because art is a special record of experience, offering new insights and raising new questions, American art museums have a rare opportunity.

The tour of our galleries is most fun in the great vaulted Lincoln Gallery, where you can imagine the excitement of Abraham Lincoln's second inaugural party, held here in 1865. This huge space is where we display art of the past half-century, roughly "our own time." Today's art is in part a celebration, but it's also a field of struggle for identity and acceptance. In another peak immigration period, we can't deny that some of the most beautiful and urgent art today responds to the sense of possibilities and openness that has always attracted artists here. Masami Teraoka's *Oiran and Mirror* (1988) is a haunting meditation on AIDS. Carlos Alfonzo's *Where Tears Can't Stop* (1986) expresses painful memories of his escape from Cuba's Mariel Harbor.

I don't mean to suggest that contemporary reality and issues are only available to ethnic and immigrant artists. Eric Fischl and Jennifer Bartlett both portray studio interiors as sacred space, now disturbed or violated by the world beyond. As always, much art continues to be preoccupied with formal aspects of seeing, even seemingly neutral artworks have a basis in experience that yields valuable insights.

One museum member wrote, "What is notable to me is not the birthplace of artists, but their subscription to the American idea. We are wrestling with a value-set that has fostered—uniquely—immense talent now for centuries." The more I work with American art, the more I admire this unique value-set that comprises the "American democratic experiment." Our national ideal—creating a fair and equal society—is a case study for the larger world. The ideas of Ralph Waldo Emerson, Henry David Thoreau, Walt Whitman, and Martin Luther King, which all began as specific to a region, cause, or people, now have universal meaning for people searching for freedom everywhere. I'm inspired that this country from the beginning was meant to be home to people, including artists, who were not reconciled to life in their native land. It's interesting that among the grievances against King George III cited in the Declaration of Independence are "obstructing the laws for Naturalization of Foreigners; refusing to pass others to encourage their Migrations hither." I like knowing that the Constitution provides that someone may serve in the Congress who is "seven years a citizen"—an open door for immigrants to help shape society.

Artists shape this society through their work rather than by passing legislation. They preserve and challenge traditions that enliven the mix in this country, and they create our cultural memory. Today's art, no less than the historical works, are containers for rich experience, waiting to be unpacked, each holding ideas that can be traced through experience and history.

Elizabeth Broun
The Margaret and Terry Stent Director

13

From Distant Shores

Historians have told us many stories about the European discovery of America. Who left the first footprints here? Was it the Vikings who pulled their longboats onto the shores of Vinland? Did French and Irish fishermen make landfall on this side of the Grand Banks but keep their knowledge a trade secret? Or did North Africans sail their reed *kaday* through the Caribbean to influence Mesoamerican cultures? Knowledge of lands to the east of Europe, gained in part through the Crusades, whetted the European appetite for travel and trade. With his mind on the riches of the East, Columbus sailed westward under the banner of Isabella and Ferdinand.

Whoever had come before 1492, Christopher Columbus's voyage changed both worlds—the old and the new—forever. The news he took back to Portugal and Spain, though based on false assumptions, fueled a race to claim land and bring wealth from the New World to finance the growth of empires. He was quickly followed by Amerigo Vespucci, the Florentine navigator who gave his name to two continents; Ferdinand Magellan; Vasco da Gama; and Ponce de Leon; as well as French, English, and Dutch explorers. Mariners and monarchs soon understood that the islands of the Caribbean were not the East Indies and that Central and South America were not China or India. The size of two oceans and two new continents separating Europe and Asia, though stunning news, was quickly absorbed.

Spanish conquistadors, French trappers, and English cavaliers and Puritans all came with the idea of impressing their identity and notions of civilization on the New World. Driven by the restlessness of the age of discovery, they saw themselves and the Americas in terms of classical ideals that harked back to the Renaissance. New Spain and New France were funded by their respective kings and driven in part

by a missionary zeal to bring new souls into the Catholic fold. The English colonies, though also founded on religious ideals, were diverse enough to make religious toleration an advantage. Those classical ideals are still visually explicit in the work of Benjamin West. A Pennsylvania native, West emigrated to England in 1763, where he was inspired by classical themes, as in *Helen Brought to Paris*.

The Spanish and the Portuguese were the first to claim islands, then the continents. During the sixteenth century, only Iberians were able to establish more than a temporary foothold. By 1540, Mexico City was a powerful colonial metropolis. Cortés had ordered a Christian church erected on the ruins of the Aztec Templo Mayor; in 1573 the church was demolished and work began on a larger and grander cathedral. Other nations were founding colonies by the seventeenth century. By 1607 the English had settled the James River; in 1608 the French founded Quebec; and in 1614 the Dutch built Fort Nassau on the Hudson River, while by 1609 the Spanish had pushed as far as Santa Fe on the Rio Grande.

In contrast to the grandeur and wealth of Mexico City, Jamestown, Plymouth, and the early English colonies were tiny settlements of fifty to 150 souls who lived in wooden thatched houses and could not hope to produce the flood of wealth for their empire that Spain enjoyed. At one point the colonists at Jamestown refused to work and went off into the woods to search for gold. Finding none, they returned to the hard labor of clearing and planting. By 1614, John Rolfe, famous for his marriage to Pocahontas, shipped tobacco to London. Exporting such products as timber, hides, salt fish, and food crops, colonists in Virginia and New England gained first a living for themselves and eventually, profits to share with their English backers.

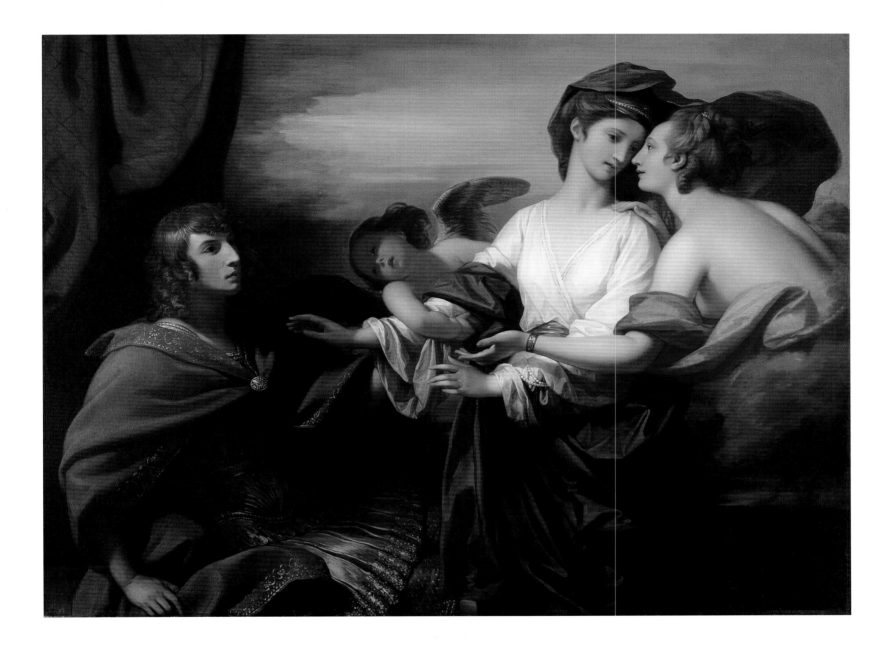

BENJAMIN WEST

Helen Brought to Paris
1776

Early colonists came to the New World expecting to gain wealth through some combination of luck and hard work and return to their home cities or towns to enjoy their prosperity. The names of the places they settled—New Spain, New England, New Amsterdam, New York, Nova Scotia—and the nature of the portraits they commissioned tell us that they did not think of themselves as Americans, but as transplants. Whether they wear ethnic dress, military uniforms, or court costumes— whether they carry a sword or hold a delft vase with a Dutch tulip—they identify themselves as Europeans. When the landscape is glimpsed through an open window, it is not an American landscape, but a generic one—tamed and cultivated, as civilized as the people in the portraits.

The Catholic Spanish colonists produced a wide variety of religious painting and sculpture. *Los Reyes Magos* resonates beautifully with Spanish sensibilities. The kings carry the promise of Christian salvation, perhaps for the natives who were catechized by Jesuit missionaries in the New World, and a casket of gold, which in this case could symbolize wealth traveling from the New World back to the empire of Spain as easily as a gift for the Christ child. Using carved and painted saints, missionaries hoped to convey the glory of God to a world of new converts. And portraits, sometimes painted for European eyes, showed how cultured and refined these transplanted Europeans remained.

◄

UNIDENTIFIED ARTIST

> *Nuestra Señora de los Dolores*
> (Our Lady of Sorrows)
> about 1675–1725

▶

CABAN GROUP

> *Los Reyes Magos* (The Three Magi)
> about 1875–1900

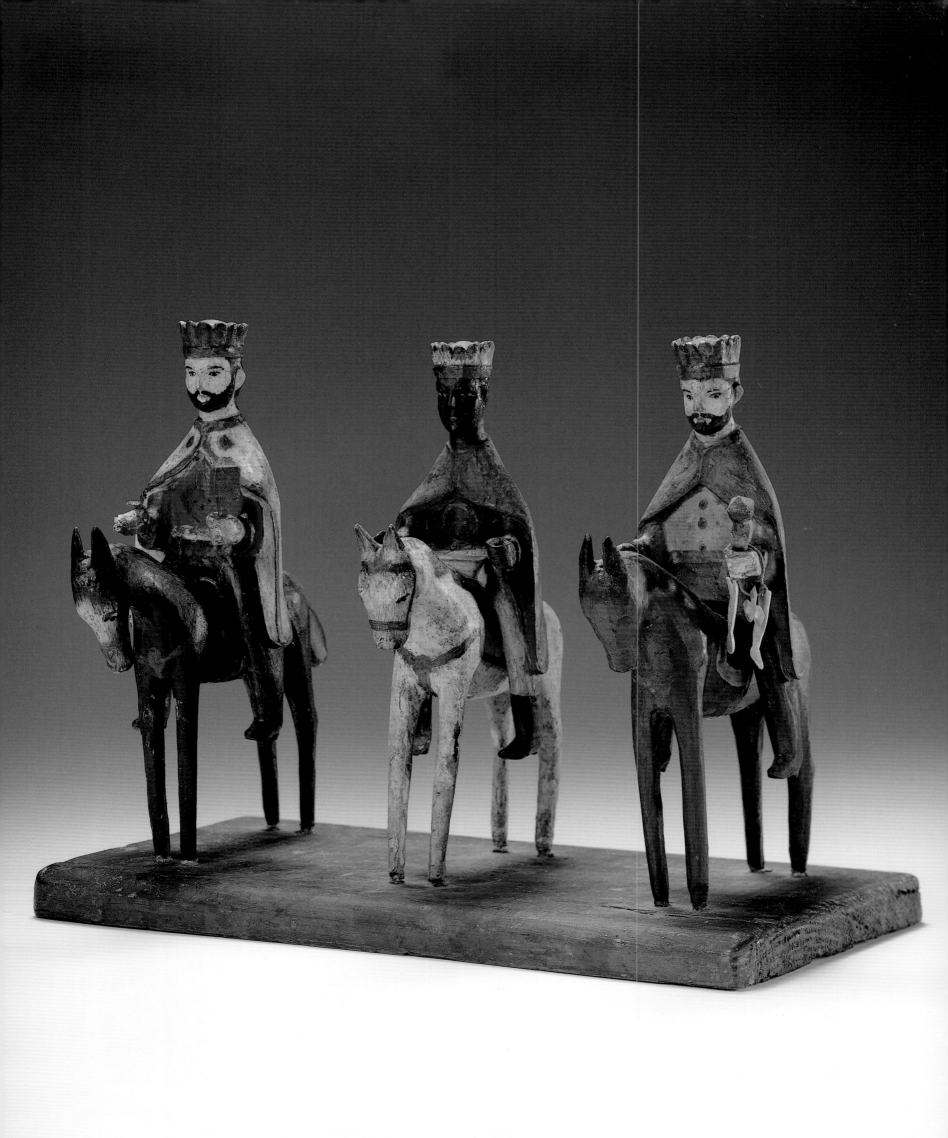

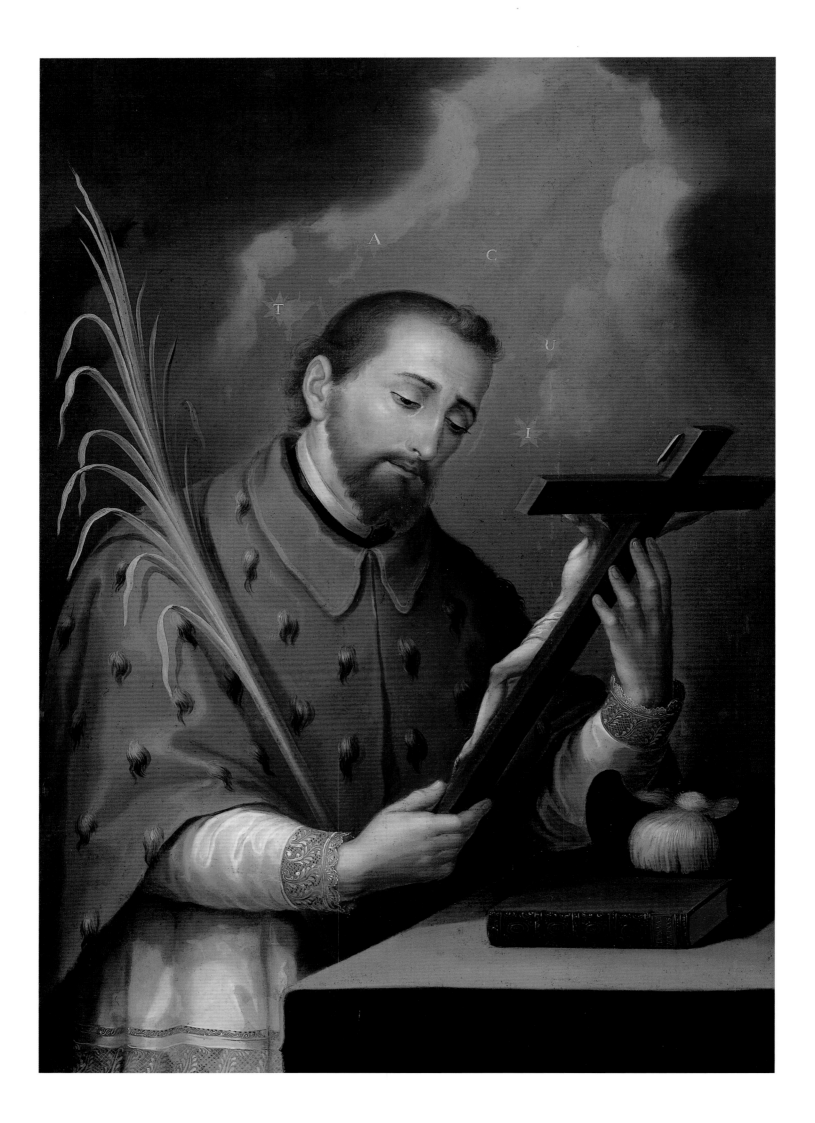

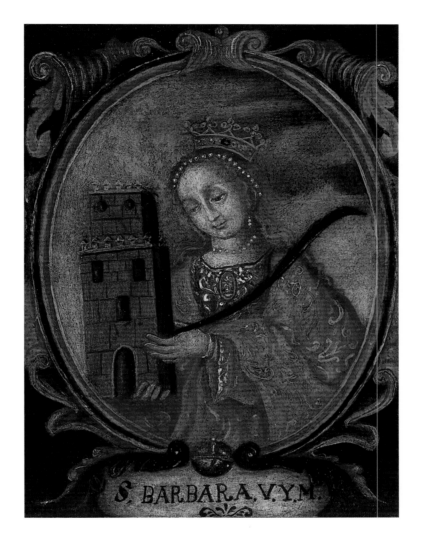

▶

UNIDENTIFIED ARTIST
Santa Barbara
about 1680–90

◀

JOSÉ CAMPECHE Y JORDAN
San Juan Nepomuceno
about 1798

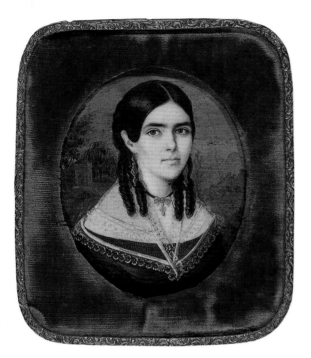

*And although we had gone to their shores solely to seek the
precious pearls of their souls ... they thought we came like
others who at other times, sometimes not without injury to
their people, had landed on their shores in search of the
many and rich pearls.*

FATHER PICOLO
1702

▲

UNIDENTIFIED ARTIST

Joven Criolla (Young Creole Girl)
about 1835–50

▶

JOSÉ CAMPECHE Y JORDAN

Don José Mas Ferrer
about 1795

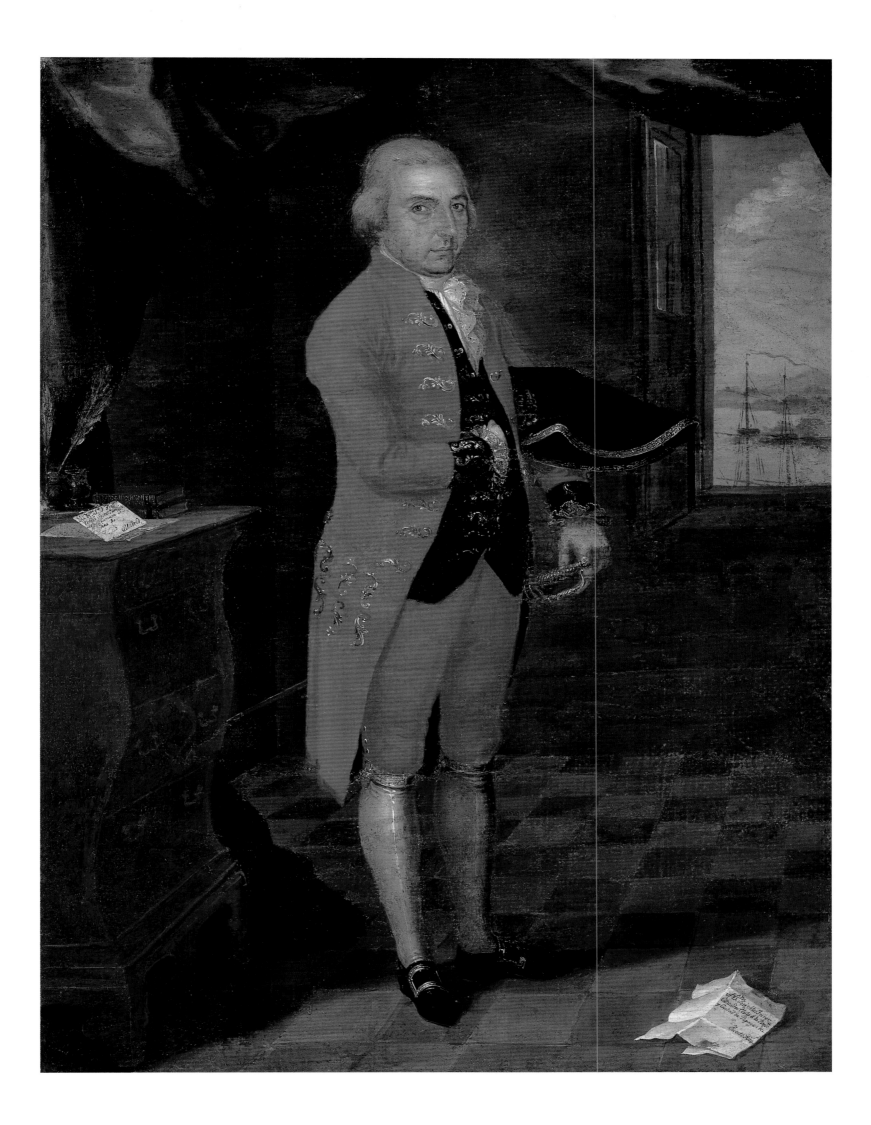

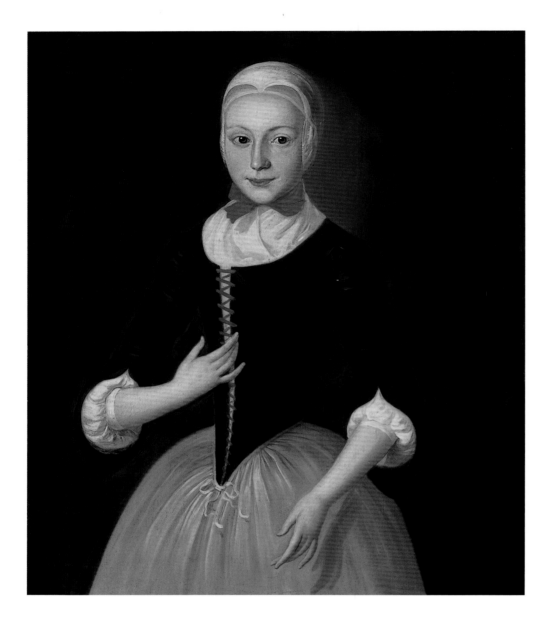

▲

JOHN VALENTINE HAIDT
Young Moravian Girl
about 1755–60

▶

JOHN SINGLETON COPLEY
Mrs. George Watson
1765

NEW ENGLAND

Artists found a way to earn a living in the New World by the mid-seventeenth century. An unknown limner was painting shop and tavern signs and applying crests and decorative panels to coaches by 1674. In 1738, Benjamin West and John Singleton Copley were born in Pennsylvania and Boston; both were prodigies who produced acceptable portraits by age fifteen. One cultural difference between the English and Spanish is apparent in this collection of images. Steeped in the restraint of the English Reformation, Puritans and Quakers were horrified by saints' pictures or rich religious objects. The variety of religious persuasions crowded into the English colonies created conflict but also an understanding that tolerance—at least of Protestant brethren—could make coexistence easier.

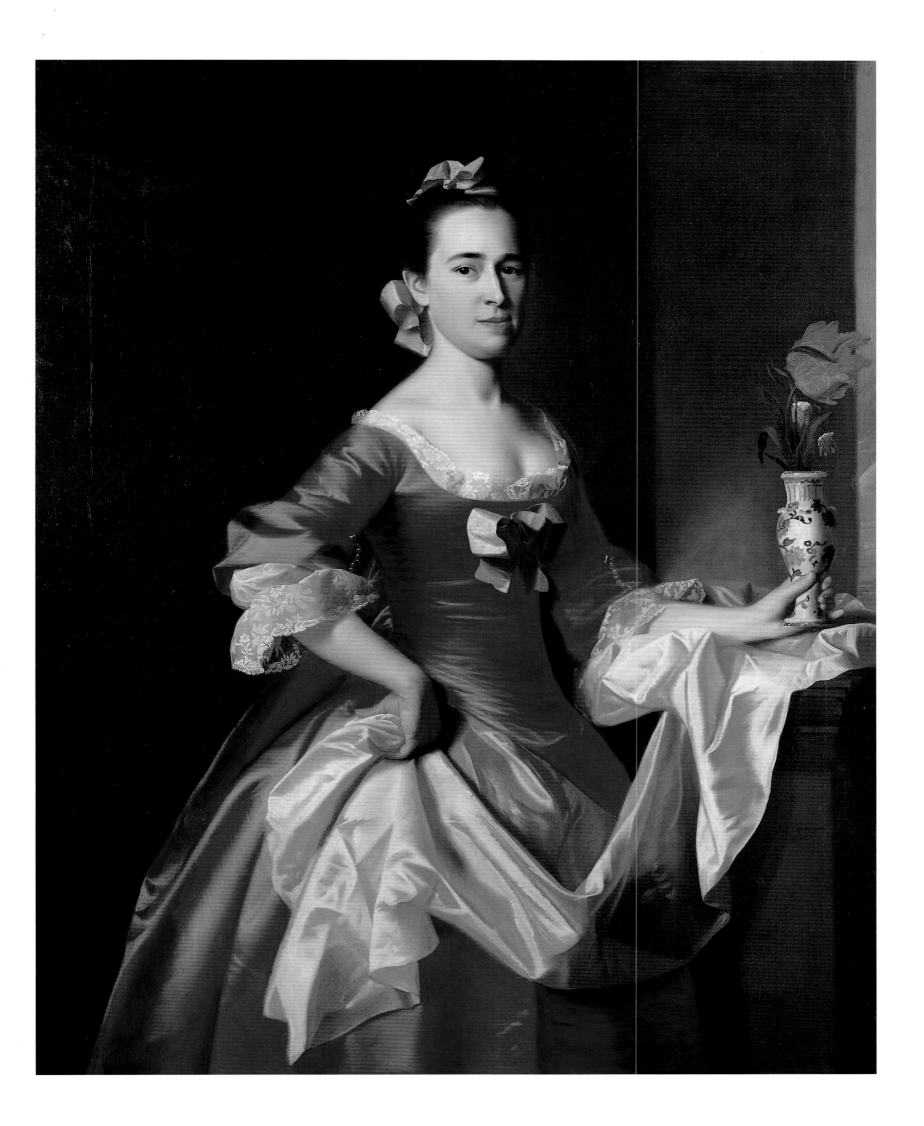

JOSHUA JOHNSON

Portrait of Sea Captain John Murphy
about 1810

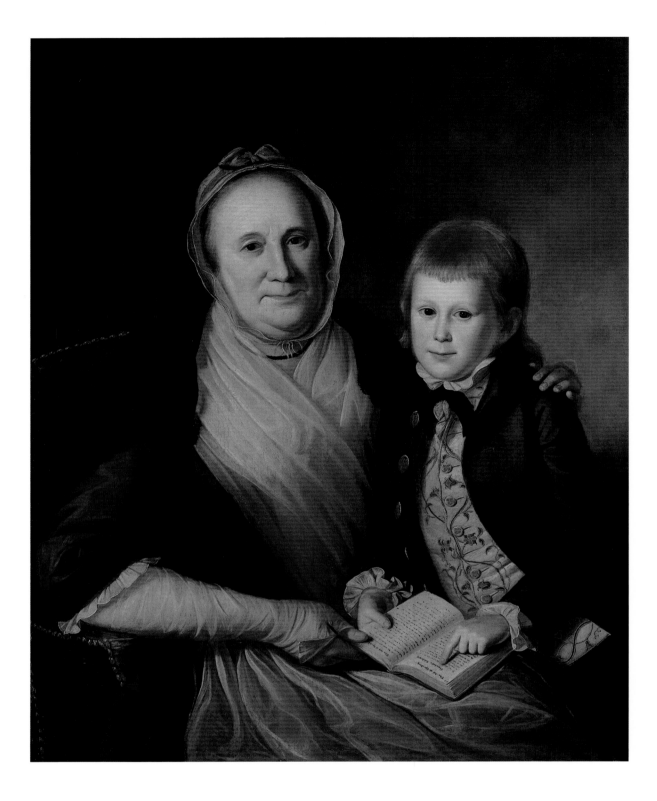

CHARLES WILLSON PEALE

Mrs. James Smith and Grandson

1776

RALPH EARL

Mrs. Richard Alsop

1792

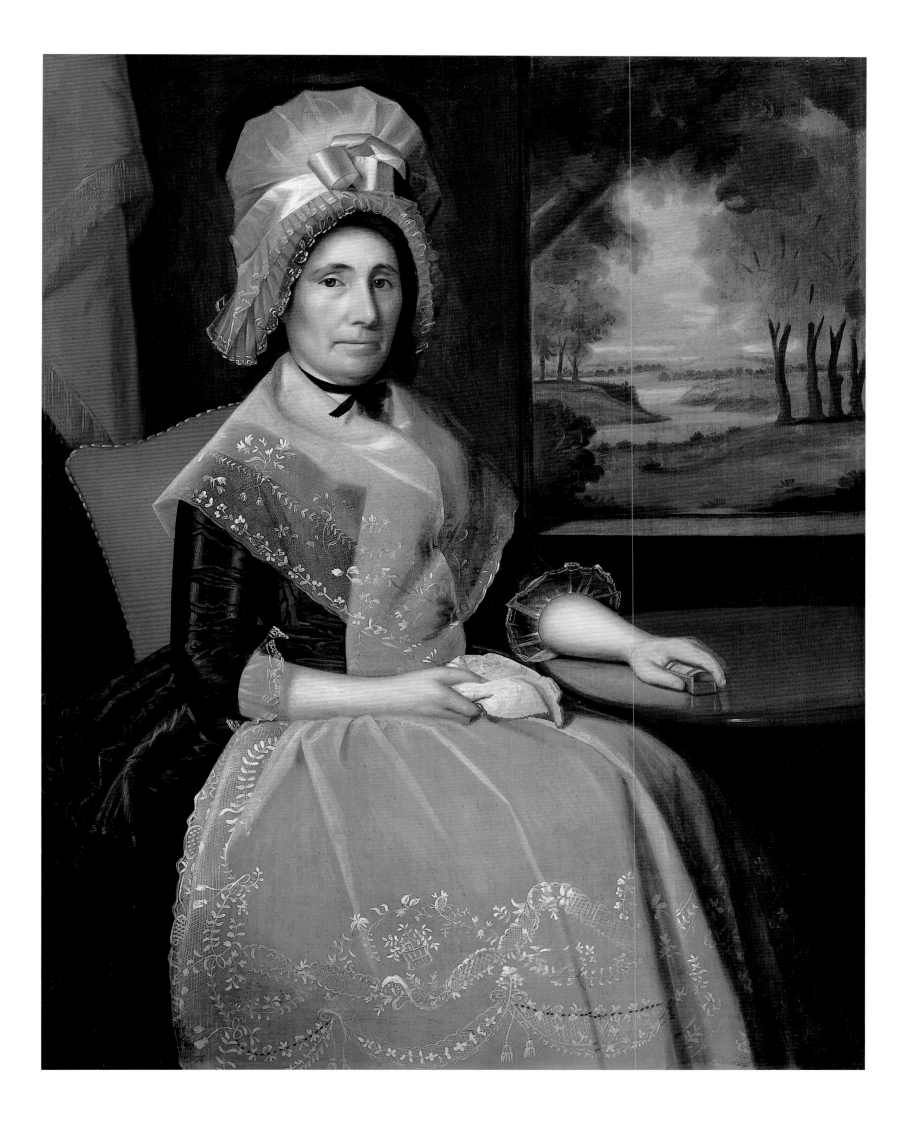

...he shall make us a praise and glory,
that men shall say of succeeding plantations,
"The Lord make it like that of New England."

JOHN WINTHROP
"A Modell of Christian Charity"
1630

▶

ROBERT FEKE

Thomas Hopkinson
1746

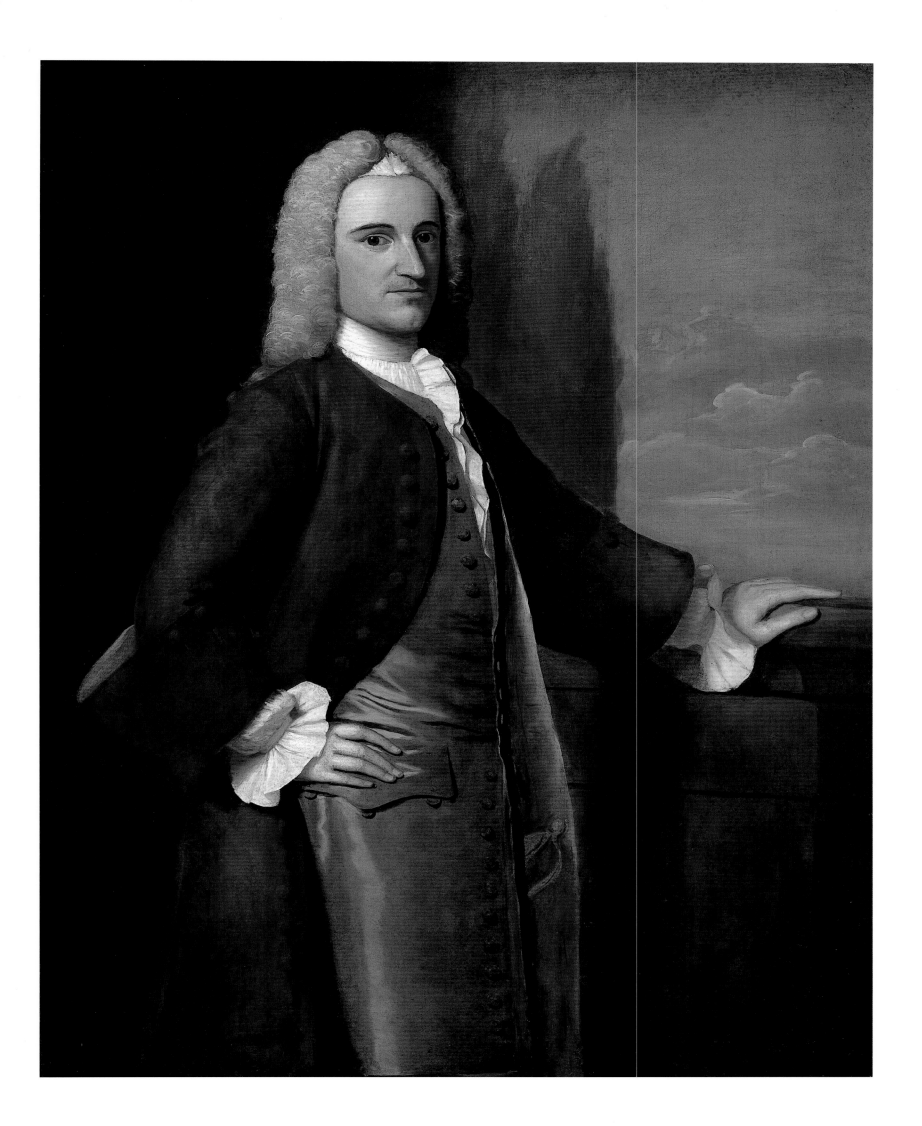

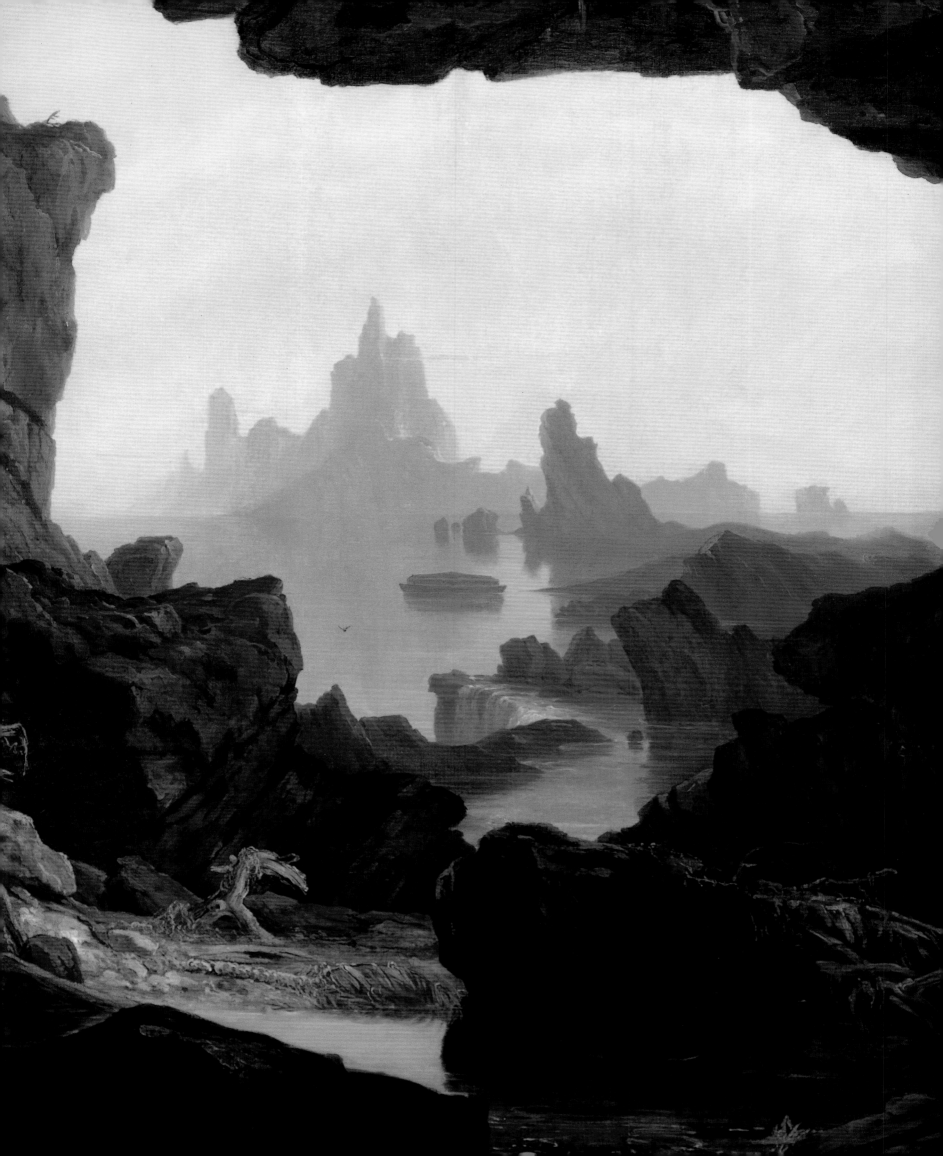

This Other Eden

The glimpse of a safe, bounded garden through an open window was inadequate to convey the realities of the American landscape. It was impossible to live in this land without being transformed by its scale and richness, its harshness and grandeur, and its beauty.

European sailors told of being able to smell the pine forests of North America before they were within sight of land. Early explorers sometimes described possible settlements along the coast in tempting terms. Captain John Smith of Virginia made a whaling expedition to New England in 1614; he subsequently published a book describing the region's genial climate, fair coasts, and natural harbors. He noted that forests of pine and fir could fit entire navies with great masts. For immigrants to New England, used to an English countryside of soft hills farmed for centuries, the sheer scale and wildness of this American landscape inspired awe.

Immigrants endured hardships on their journeys and in their first years in America. Some portion of each new settlement perished from hunger, exposure, disease, or conflict, yet the stream of new settlers kept coming. They crossed the Atlantic for many reasons: some for wealth, some to escape political or religious institutions they saw as oppressive or corrupt. America was a magnet drawing them westward, its pull strong enough to overcome the distances and dangers.

Artists painted an America completely unlike a comfortable and domesticated Europe, and certainly a far cry from the harsh realities of the early settlements. Thomas Cole made images of rocky crags washed clean by floods, the land emerging from the water as if itself reborn. Natural wonders like Niagara were both impediments to further exploration and challenges that begged to be overcome. Distant peaks seem to invite the bold explorer to climb them. In paintings by Asher Durand

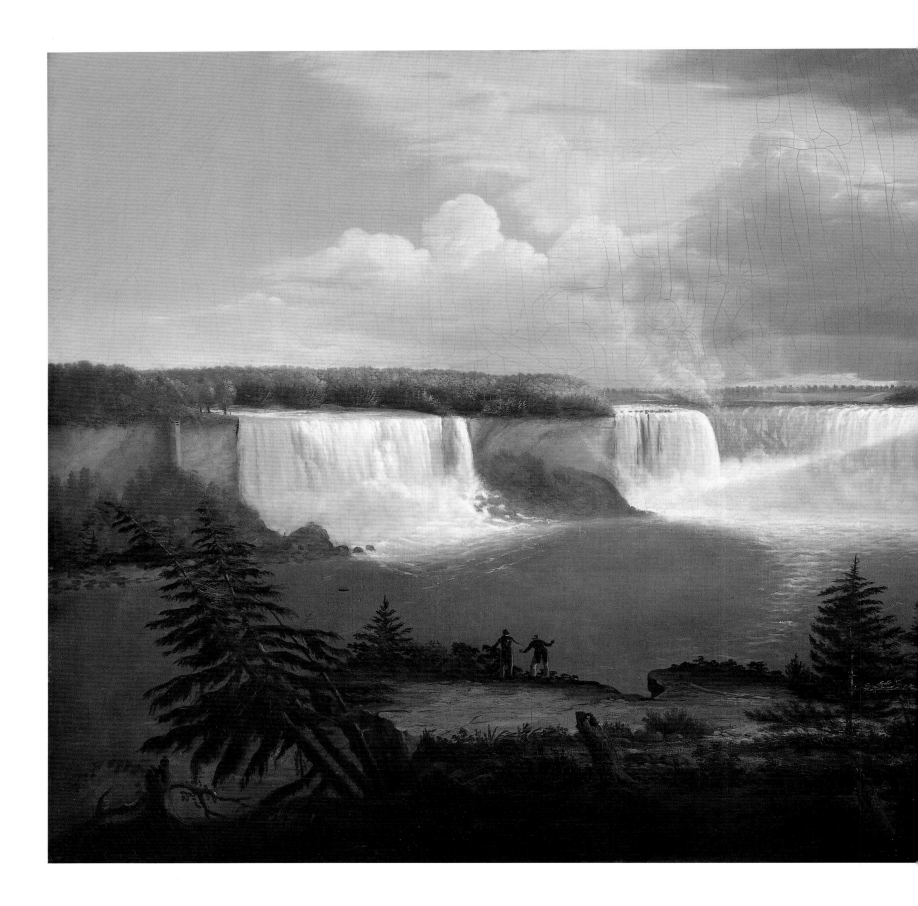

*... we stood a while like men ravished
at the beautie and delicacie of this sweete soile.*

JOHN BRERETON

Discoverie of the North Part of Virginia

1602

and Alvan Fisher, people and animals are tiny figures in verdant pastures, dwarfed by the broad expanses of mountains and sky. Beneath the promise of a rainbow, these figures look toward a gap in the hills, imagining what lies over the horizon.

Three hundred thousand square miles of forested land between the Mississippi and the Great Lakes, originally called the Ohio country, promised more riches than all the gold of New Spain. It would need to be explored, surveyed, settled, and fenced. At the age of seventeen George Washington, whose older brother Lawrence was an early investor in the Ohio Company, took up his surveyor's chain, level, compass, and angle to help prepare the way for future settlers. From each new promontory he plotted future farms, towns, and roads even as he learned patience and precision and honed his ability to observe. Biographer Thomas A. Lewis remarked, "For the rest of his life he would regard land as a jeweler inspects a gemstone, with minute attention to its flaws, facets, and values."

Landscape painters revealed that ours was not a garden of human design but a new Eden. Here European transplants, weary of wars, politics, plagues, and corruption, could create new selves and a new society. The innocence man lost in the first Eden could be reclaimed in this new one. Fallen man learned he must toil for his bread, but the New World offered rivers full of fish and fertile valleys full of game. These signs of God's favor meant that here man would live free from want. Unknown plants, animals, and birds invited naturalists to complete Adam's delightful task of naming and classifying the natural world. The land itself would transform the immigrants, waking them from the sometimes harsh realities of their former lives to an American dream.

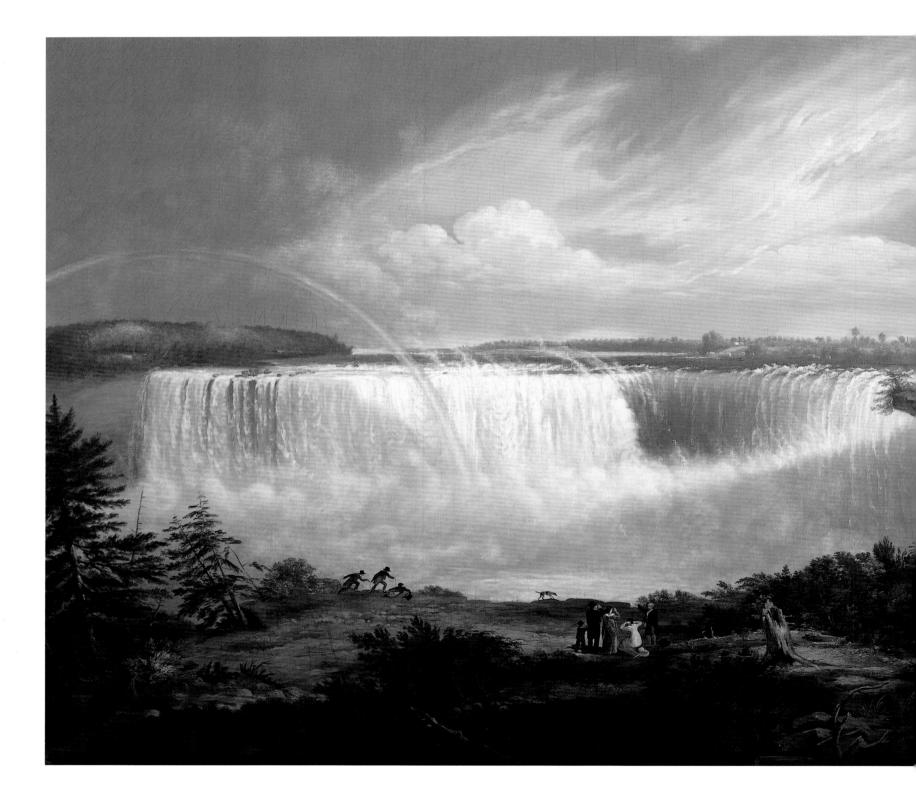

▲

THOMAS COLE

The Subsiding of the Waters
of the Deluge
1829

◄

ALVAN FISHER

The Great Horseshoe Fall,
Niagara
1820

▲

ROBERT S. DUNCANSON

Landscape with Rainbow

1859

▶

UNIDENTIFIED ARTIST

On the Ohio River

about 1840

My footstool earth, my canopy the skies.

ALEXANDER POPE

Essay on Man

1733–34

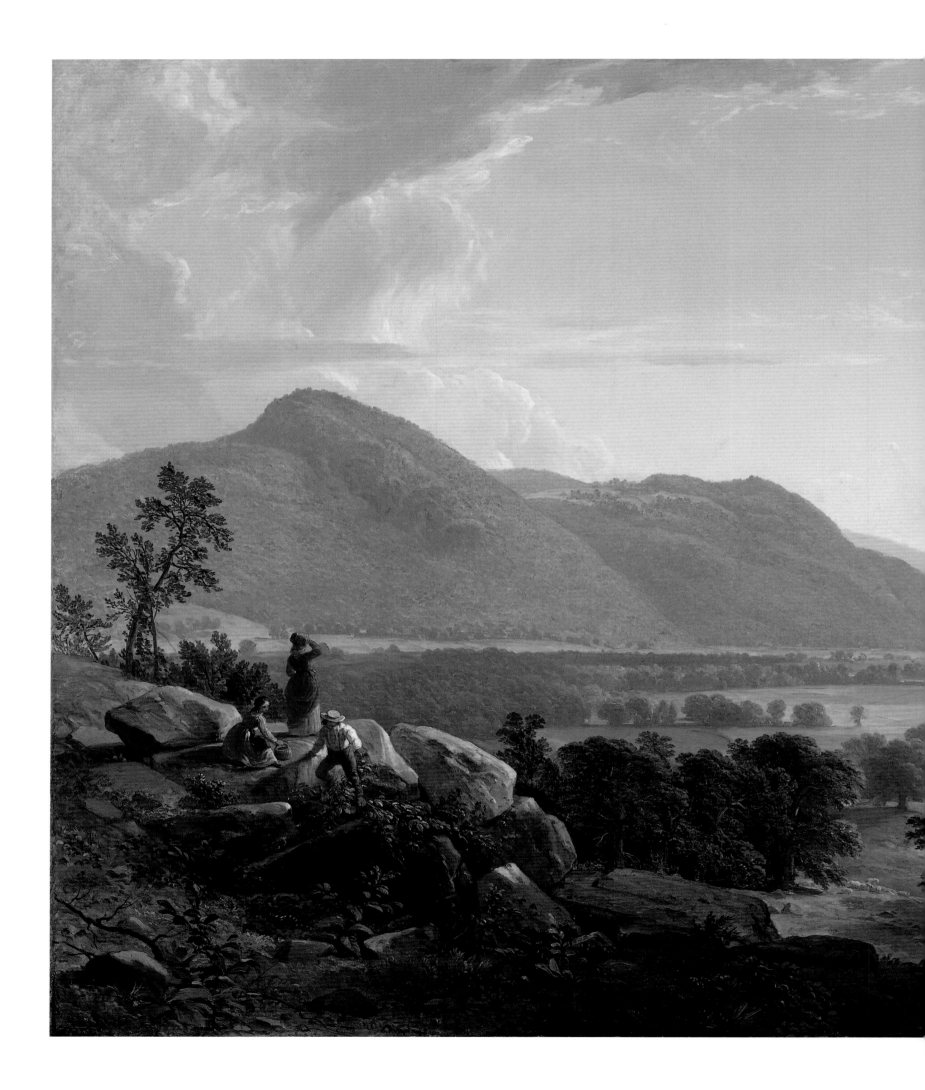

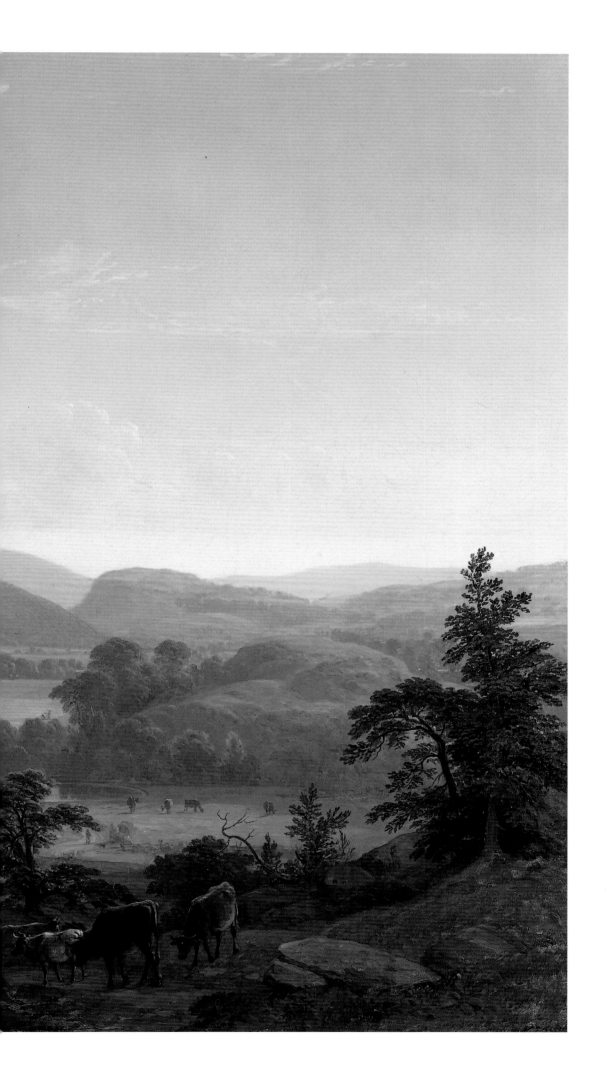

◄

ASHER B. DURAND

Dover Plain, Dutchess County,
New York
1848

▶▶

ALBERT BIERSTADT

Among the Sierra Nevada,
California
1868

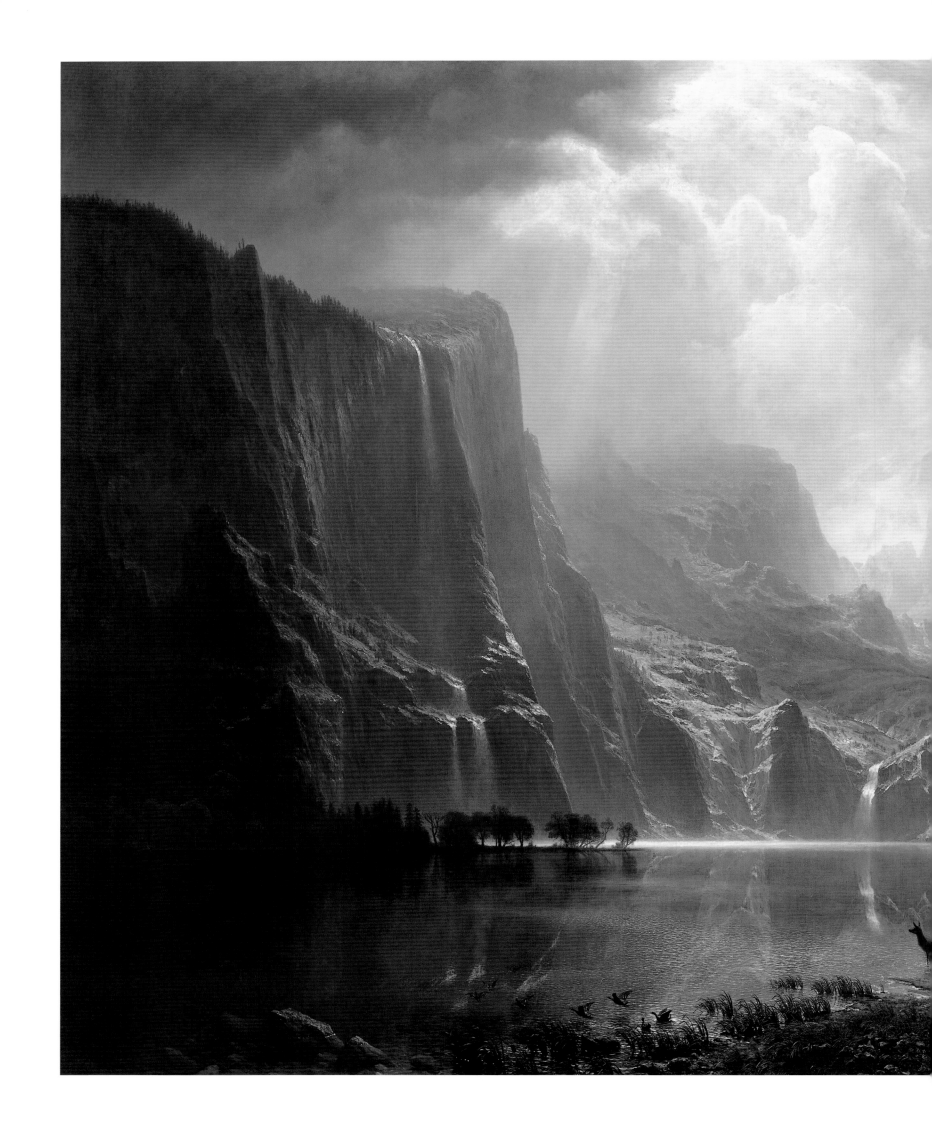

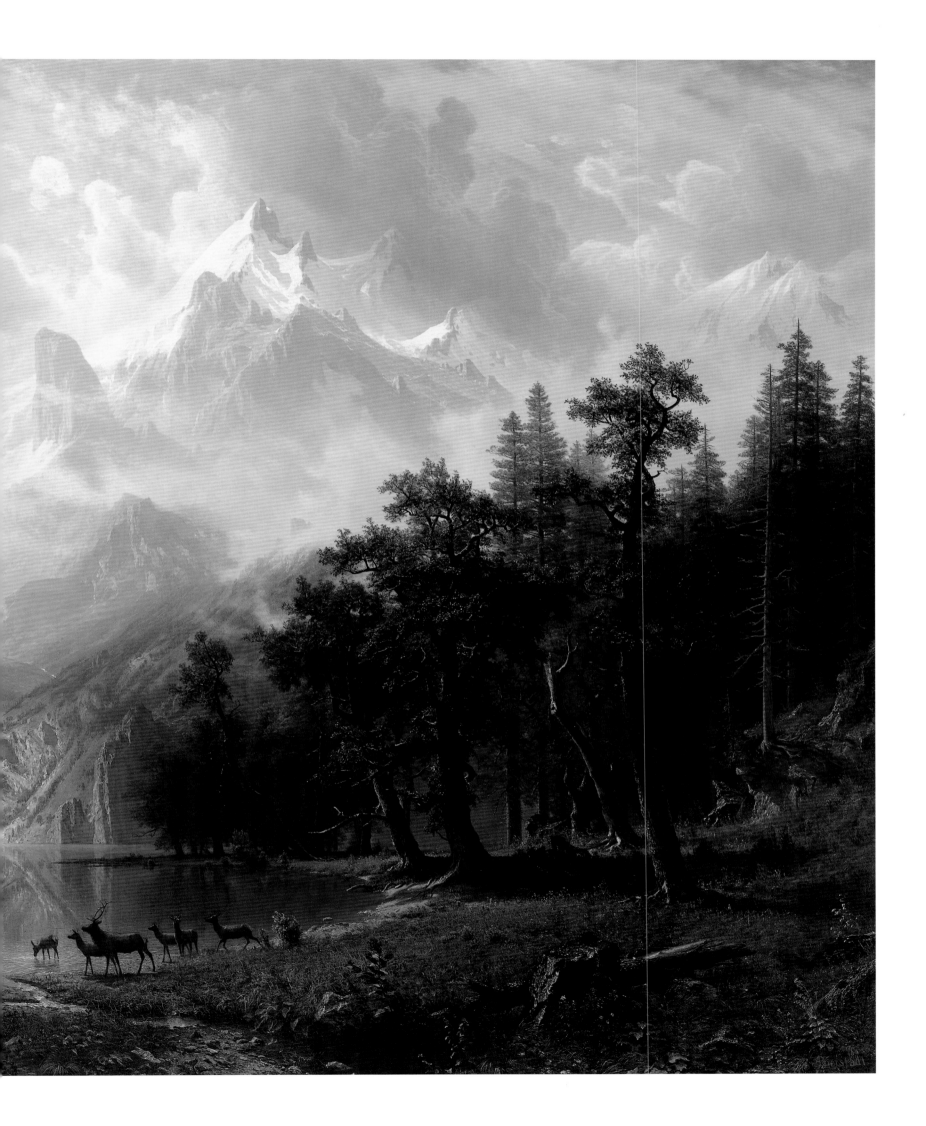

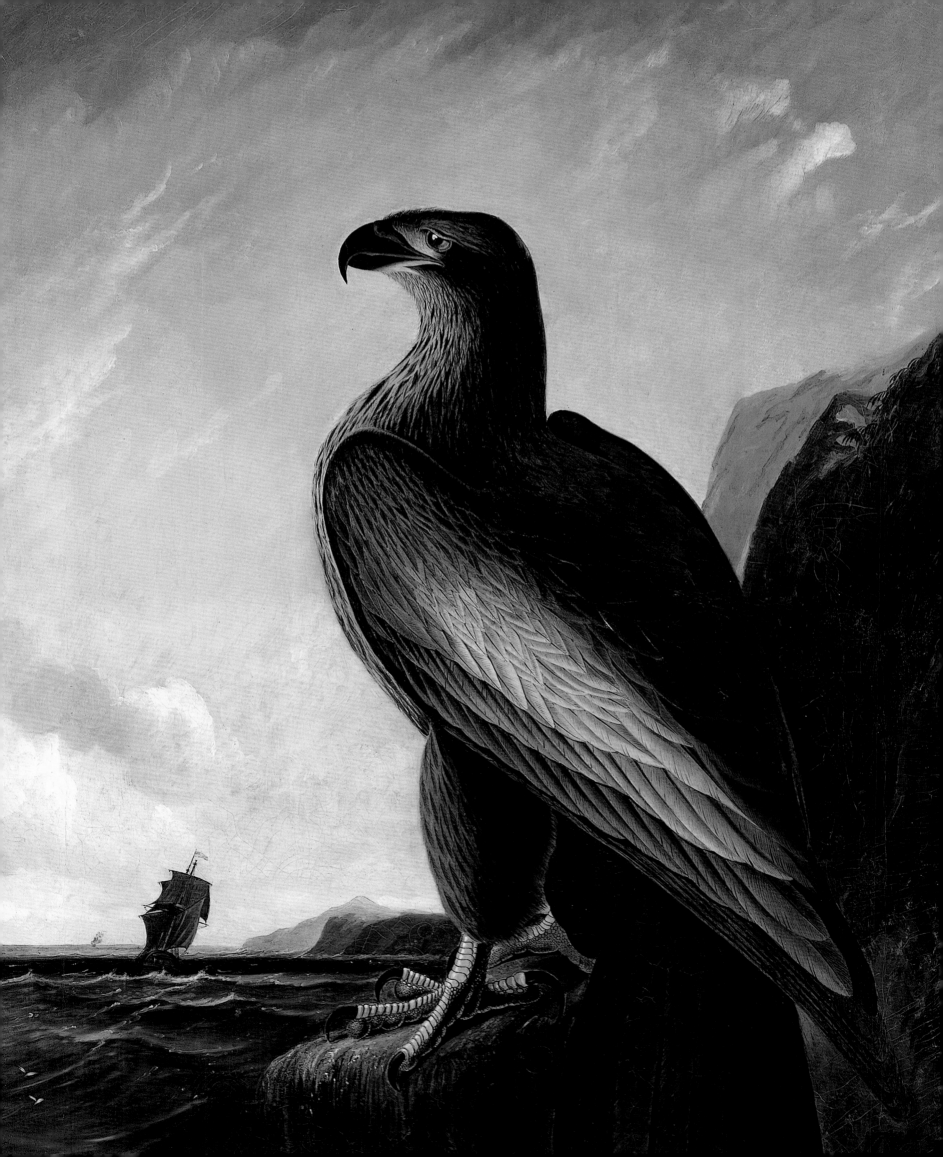

Liberty More than Life

Loyal Englishmen—who happened to live in America—came to revolution against their king and country driven by military, political, and economic events; by radical impulse; and in the end, by careful reasoning. A series of small military conflicts began in 1739; the War of Jenkins's Ear and King George's War led to the French and Indian War and the Seven Years' War, which involved a confusing complex of combatants. British and American Whigs had grandiose visions of controlling the Great Lakes, the St. Lawrence basin, and the Ohio and Mississippi valleys. Allies through these wars, by 1748 the English and Americans were better acquainted with each other. The English emerged from these conflicts convinced that it was time to turn a more attentive eye to colonial matters, while the colonists were eager for British troops to leave their soil and hoped official busybodies would let them pursue business in peace. With the defeat of the French-Catholic threat north of the St. Lawrence River, the colonists were less dependent on the English for protection. George III hoped to buy some peace when he created the Proclamation Line in 1763, declaring that settlers must have royal permission to move beyond the Alleghenies. To enforce a law that Americans had no intention of heeding, the crown installed British soldiers in frontier forts and charged them with protecting the Indians. This action placed Americans with designs on western land in conflict with their former allies.

The colonists, accustomed to having their rights as Englishmen protected under common law, instead saw them eroded. In 1768 the British parliament, where the colonies had no representation, began to make laws for the empire as a whole. They felt they were under attack from every quarter: commerce was stifled by the Currency Acts, bans on manufacturing, and limits on trade; expansion was choked by

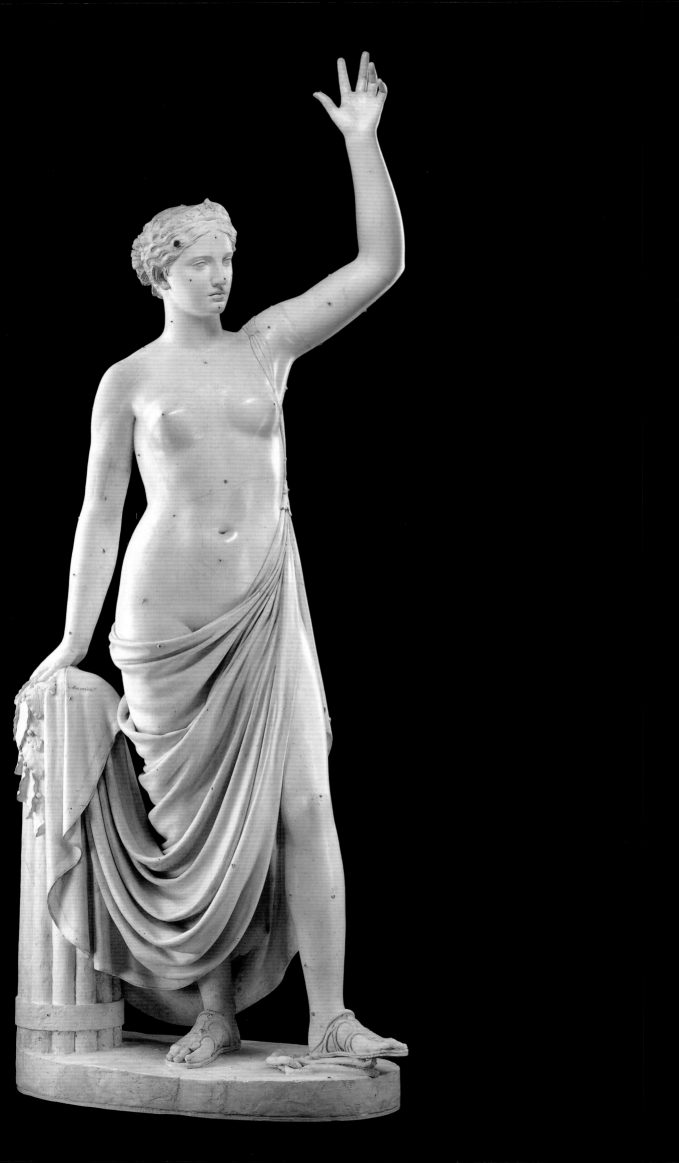

…freedom of thought and the right of private judgment,

in matters of conscience, driven from every other corner of the earth,

direct their course to this happy country

as their last asylum.

SAMUEL ADAMS

1776

HIRAM POWERS

America

1848–50

JOHN JAMES AUDUBON

Washington Sea Eagle (detail)

about 1836–39

the Proclamation Line; and freedom of conscience was threatened by the imposition of a tax to support Anglican bishops.

Patrick Henry and Samuel Adams passionately denounced English actions, while Benjamin Franklin, James Madison, Thomas Jefferson, George Washington, and John Adams logically deliberated their way to oppose the Crown and Parliament. These men were farmers, scientists, inventors, businessmen, and merchants. They were southern aristocrats, Yankee upstarts, soldiers, tradesmen, and shipping magnates. To a man they would have described themselves as loyal Englishmen. Why did they describe their state as slavery and determine that war with England was preferable to continued coexistence? What was this liberty they demanded?

The colonists' grievances accumulated during and after the French and Indian War, including the Currency Acts, the Stamp Act, the Proclamation Line of 1763, and the tax on tea. On November 30, 1773, Bostonians dressed as Mohawks dumped 340 chests of tea into Boston Harbor. Determined to teach the rebellious colonists a lesson, Parliament passed a series of bills that closed the port of Boston, disbanded Massachusetts's assembly, and gave the new military governor the right to appoint all officials. Support for the beleaguered Bostonians came from as far south as Virginia, where George Washington wrote: "Boston's cause now is and ever will be considered as the cause of America (not that we approve their conduct in destory'g the Tea)."

Why did colonists—including the well educated and wealthy—risk their lives, their considerable fortunes, and sacred honor—over a minor tax? Americans were taxed far less than the English, and enjoyed the highest standard of living in the world. It was not only a matter of money. A common moral and spiritual thread

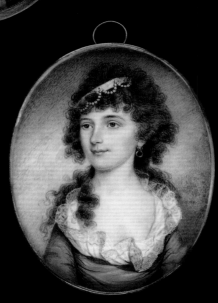

Any government is free to the people under it where the laws rule and the people are a party to the laws.

WILLIAM PENN
1682

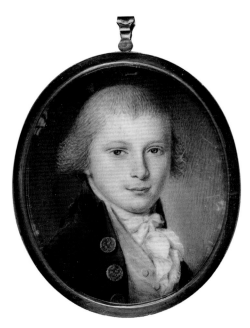

JAMES PEALE

Josiah Hewes Anthony

1790

EDWARD GREENE MALBONE

Mr. Lawrence of Boston

1803

EDWARD GREENE MALBONE

Henry B. Bounetheau's Aunt

about 1804

JAMES PEALE

Mrs. John McCluney

about 1795

linked New England Protestants to Pennsylvania Quakers to Maryland Catholics, and bonded Boston's urban merchants to Virginia's plantation cavaliers to the frontier woodsman. For all, self-government, religious freedom, economic opportunity, and territorial growth were becoming inseparable. They knew their history, read the classics, and developed their arguments about the rights of free Englishmen and against tyranny in lengthy correspondence with one another. Though their differences were many, they could agree at least that civil and religious liberty were inseparable; liberty was seated in virtue; and liberty would be choked if territorial and commercial expansion were constrained. The pen preceded the sword in this war, with every action justified in advance.

From the Declaration of Independence through Cornwallis's surrender at Yorktown in 1781, the political and military missions were inextricable—to make amateur soldiers competent to fight a highly professional British imperial army, to convince them that they were fighting for themselves, and to help them be good citizens of an idealistic republic. Tall, handsome, and an excellent horseman, Washington understood his symbolic value was nearly as important as his military successes. He exemplified the ideals of freedom and equality advanced in the Declaration, maintaining throughout the War of Independence that he and the army served at the pleasure of Congress, who had entrusted him and the army with "the maintenance and preservation of American liberties."

Once the fighting was over and the occupiers were ousted, the rebels faced the mammoth task of putting their ideals into practice and framing a new government. United by desires for expansion, the new nation was forced to deal with British forts and Indian uprisings to the west. Their independence of mind did not make

I agree with you that there is a natural aristocracy among men. The grounds of this are virtue and talents.

THOMAS JEFFERSON
Letter to John Adams
1813

it easy to compromise with each other, but a weak coalition of states with no army, no treasury, and no international standing could not carry them into the nineteenth century. So the loyal Englishmen-turned-rebels were transformed again into the wise founders, who debated and compromised their way to writing and ratifying a constitution. Even in retrospect, Washington and Jefferson were depicted as heroic, animated by the ideals for which they fought. Gilbert Stuart's portrait of John Adams shows an elder statesman, seasoned by political struggle.

The Federalists rose to meet challenges that included rivalries among the states, resistance from foreign powers and Indians to western expansion, commercial and monetary squabbles, and the lack of a national military. Washington, John Jay, and Alexander Hamilton all argued for a stronger central government. One of their most important converts was James Madison. His brilliant Federalist Papers, written with Hamilton and some assistance from John Jay, lay out the overlapping sovereignties of local, state, and federal governments; the checks and balances among executive, legislative, and judicial branches—at once guarding against the passions of the mob and the corruption of power. He envisioned a government like a clockwork universe, in which interests operated in balance, revolving around each other in a measured scheme that obeyed the laws of nature and proportion.

The Constitutional Convention began in May of 1787, and by September 17 it had produced a document that thirty-nine of the fifty-five delegates were ready to sign. It would be no easy task to get it ratified by the states; it finally passed in New York in July of the following year on condition that a Bill of Rights would be added to the document. In Philadelphia, where citizens turned out to cheer, Benjamin Rush wrote: "'Tis done. We have become a nation."

▶

THOMAS SULLY
Daniel La Motte
1812–13

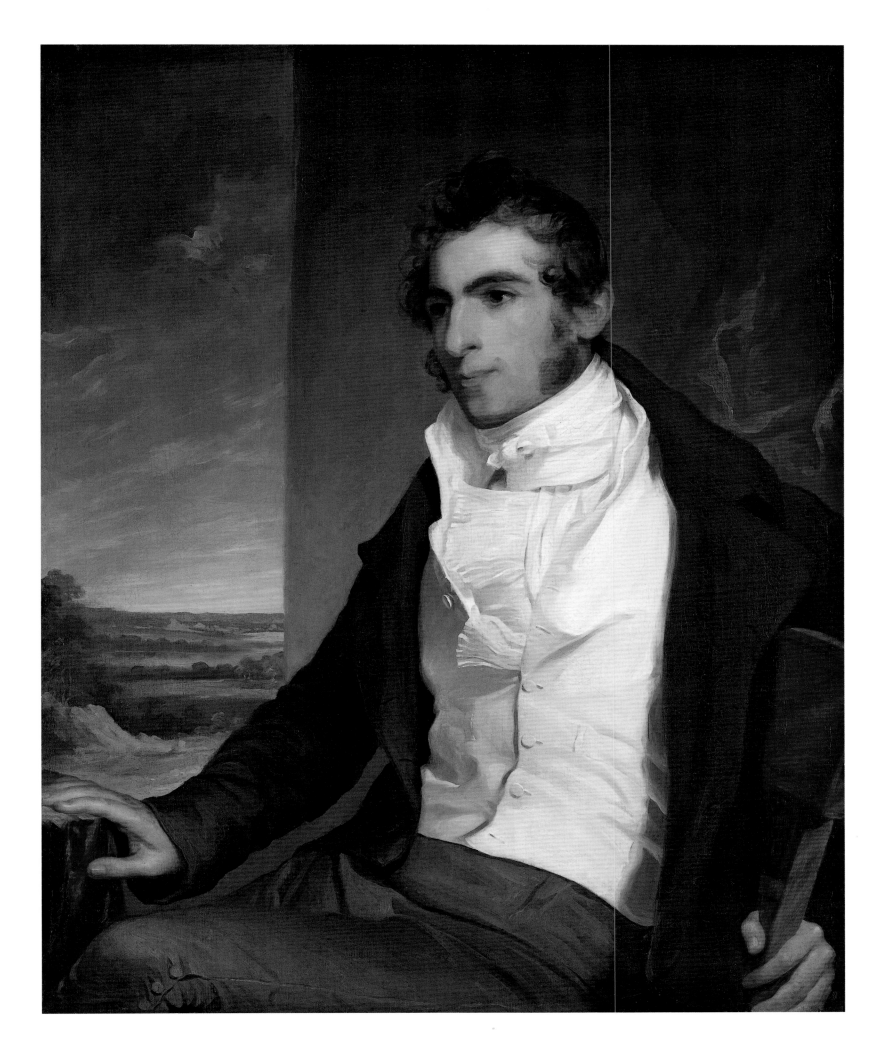

These are times in which a Genious would wish to live.

It is not in the still calm of life, or the repose of a pacific station

that great characters are formed....

Great necessities call out great virtues.

ABIGAIL ADAMS
Letter to John Adams
1780

▶

HENRY BRINTNELL BOUNETHEAU
General George Washington
about 1845

▶▶

THOMAS CHAMBERS
Capture of H.B.M. Frigate
Macedonian *by U.S. Frigate* United
States, *October 25, 1812*
1852

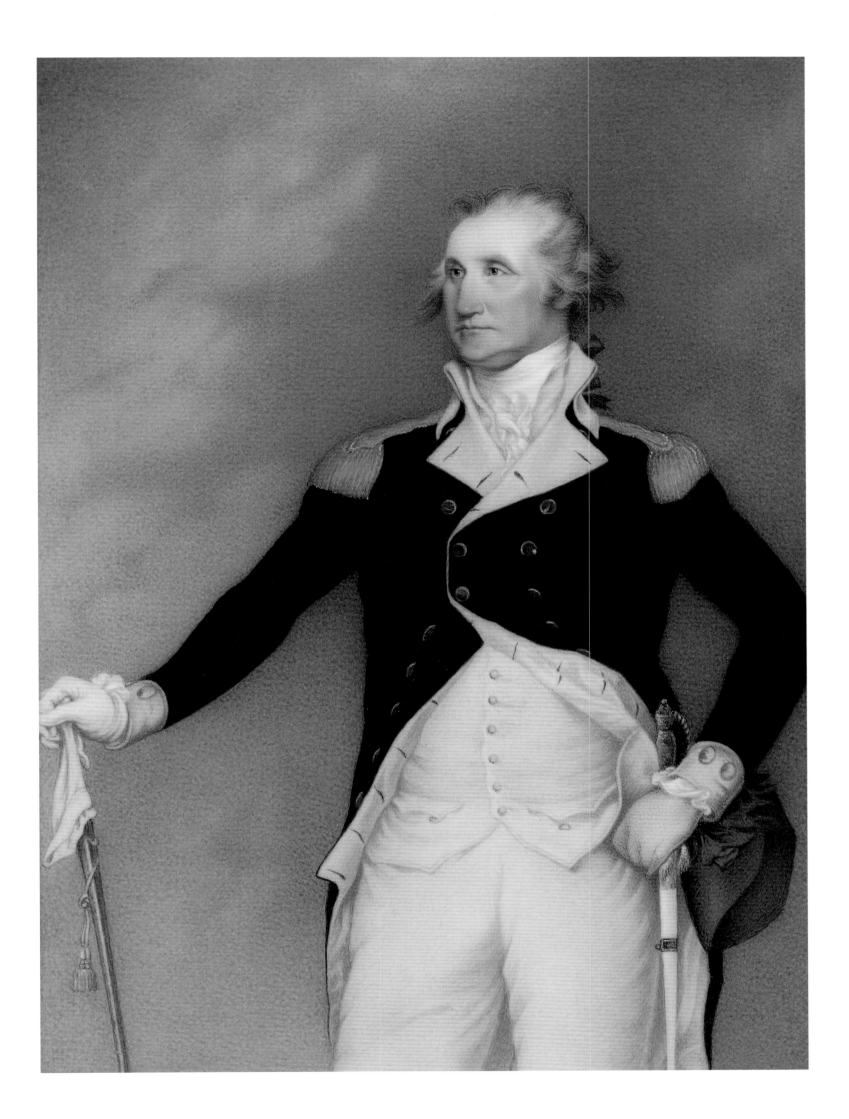

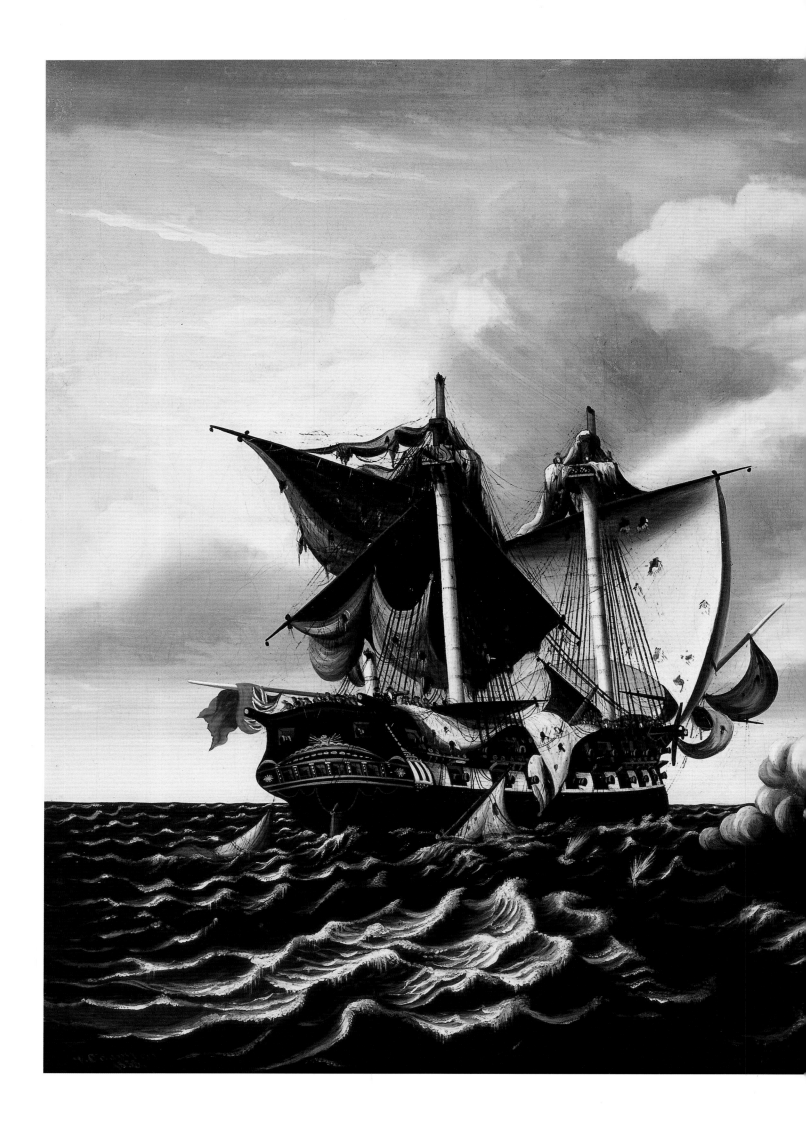

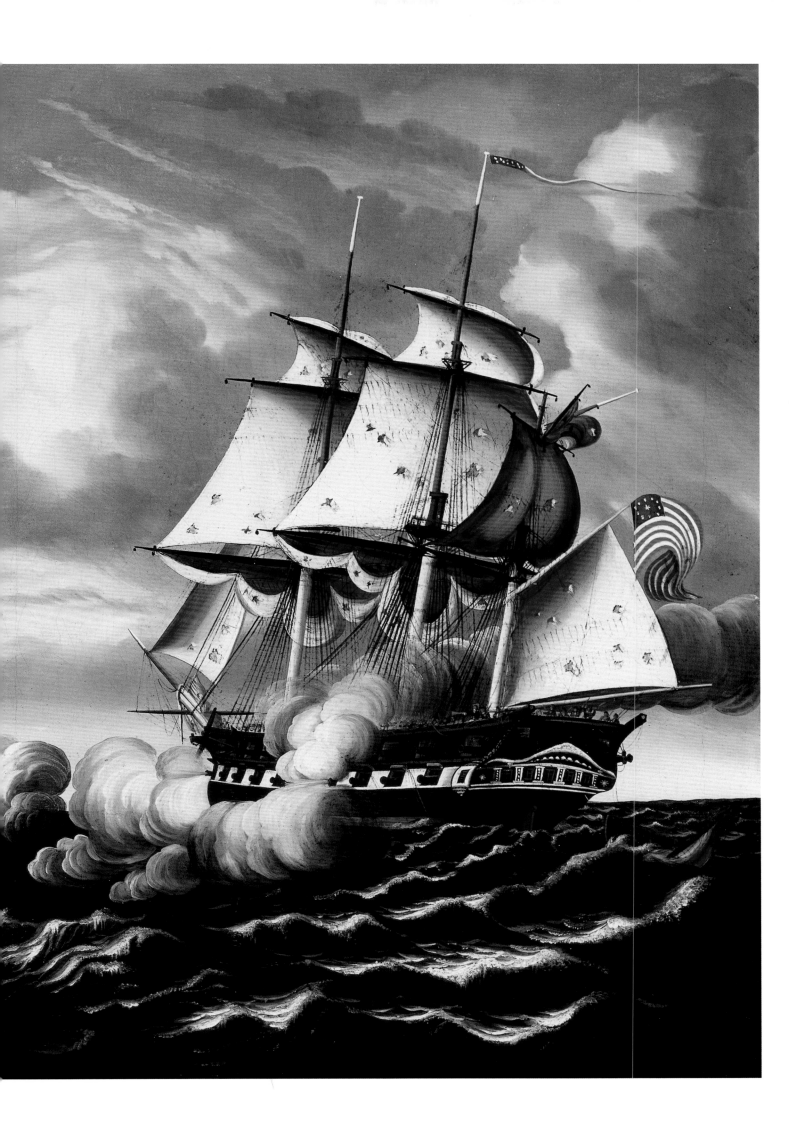

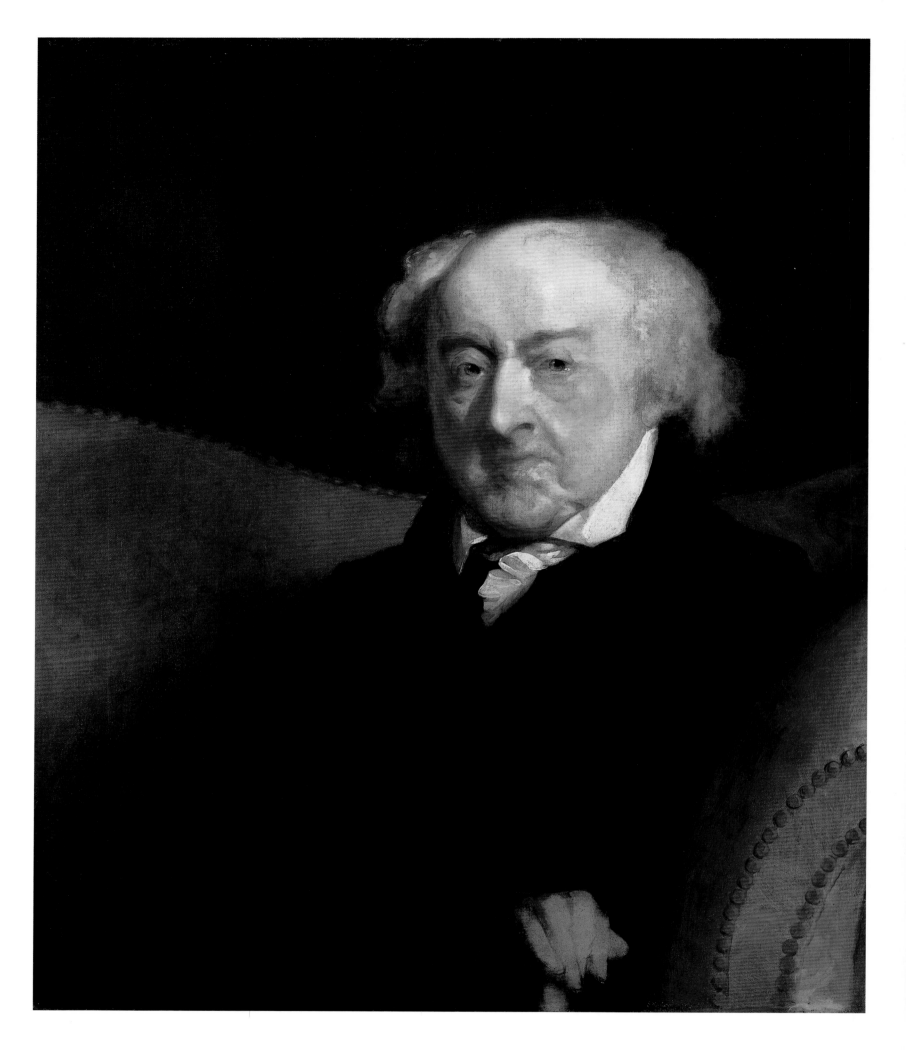

Enlighten the people generally, and tyranny and oppressions of body and mind will vanish like evil spirits at the dawn of day.

THOMAS JEFFERSON
Letter to P. S. du Pont de Nemours
1816

▸

HIRAM POWERS
Thomas Jefferson
modeled 1860–62

◂

GILBERT STUART
John Adams
1826

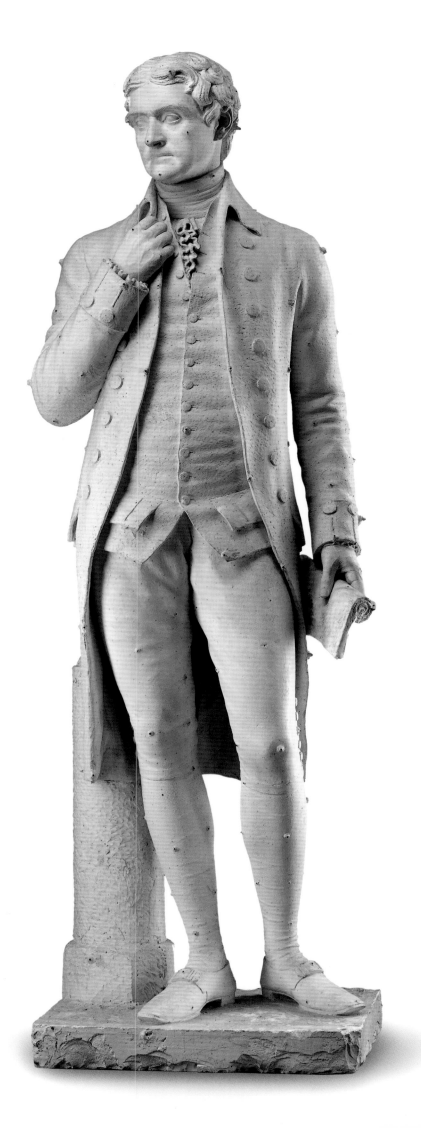

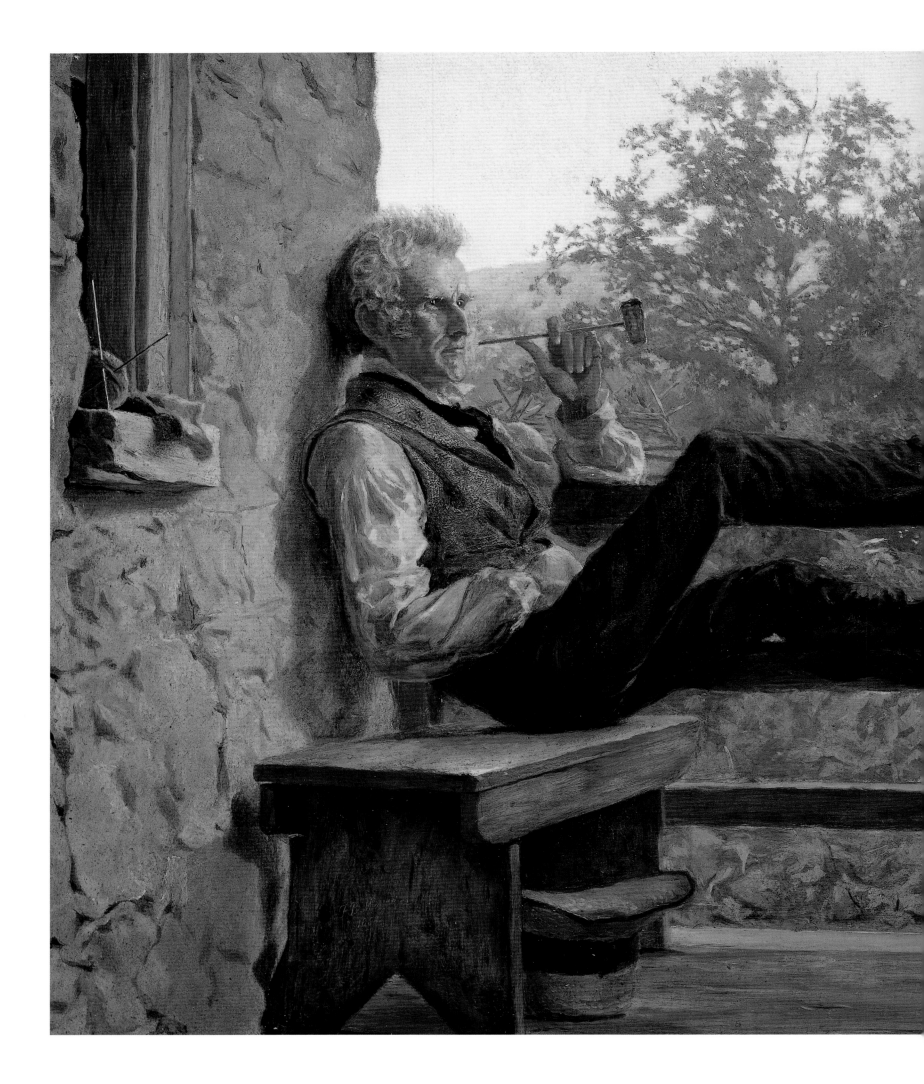

*Not a place on earth might be
so happy as America.*

THOMAS PAINE
The American Crisis
1776

◄

FRANK BLACKWELL MAYER
Independence (Squire Jack Porter)
1858

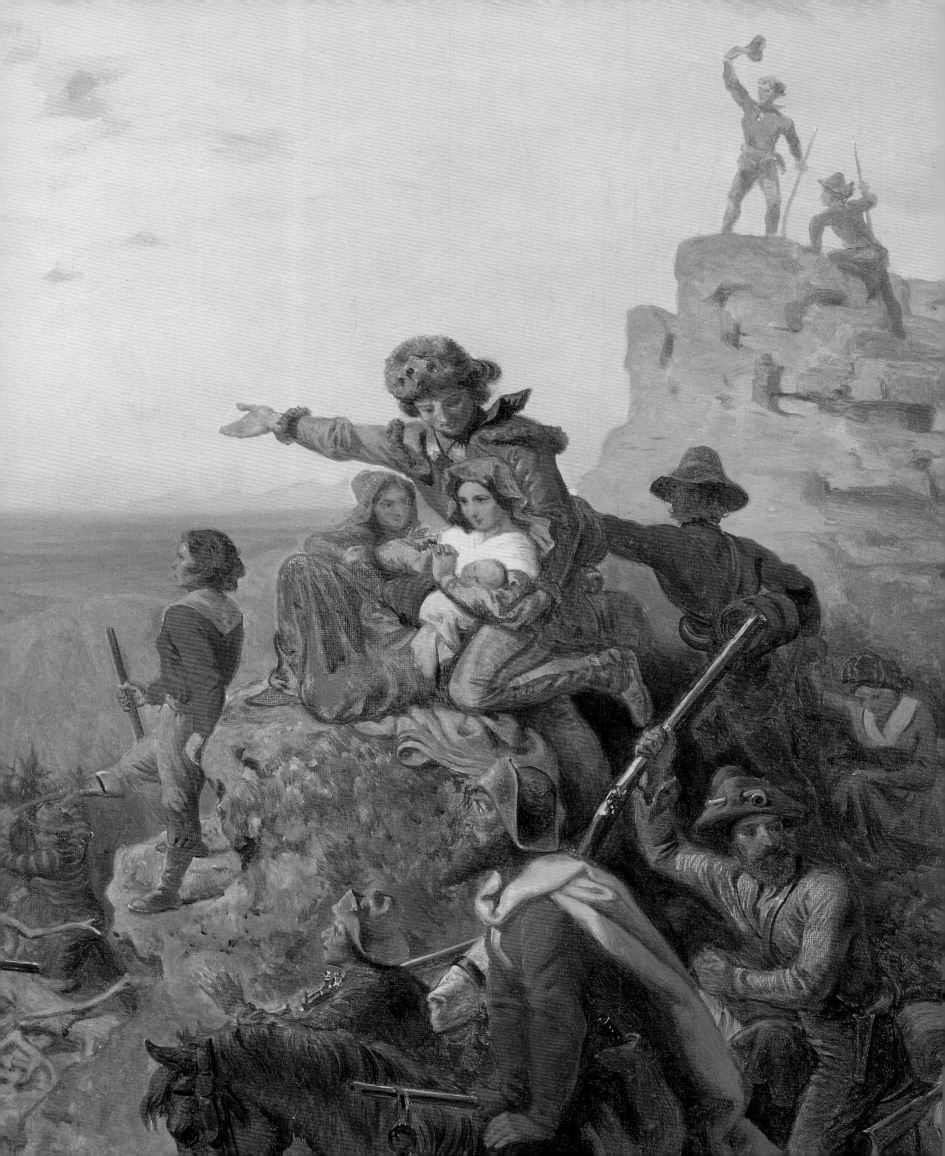

Ever Westward

The American continents had been peopled for 30,000 years before Europeans came. Their vision of a virgin wilderness was partly willful blindness but also the result of native populations diminished by measles, smallpox, influenza, and plague. The Pilgrims at Plymouth had settled near an Indian town that had been abandoned following an epidemic in 1617. Both the English and Dutch built on Indian sites, happy to make use of cleared fields and easy access to water. European maps showed Indian country as unoccupied wilderness—ready to be claimed and tamed. On the contrary, across the continent, nomadic hunting tribes and sedentary farming groups formed a complex network of trade relationships. Bison hunters on the Plains traded with groups of farmers in the valleys of the Missouri River and the Rio Grande. Seed corn, pottery, turquoise, metals, shells, and tobacco were traded across vast distances.

The French entered the New World through the St. Lawrence and the Great Lakes, where they discovered that the fur trade was far more profitable than farming on the rocky Laurentian shield. New France had immediate success because their coureurs de bois and voyageurs were merely new players in a thriving commercial system that spanned the continent. These newcomers hardly seemed like a threat, and besides they offered exotic goods that natives were anxious to own.

Along the eastern seaboard, settlers first clung to the coast, but soon they spread westward, forcing the Indians before them. In some cases entire tribes were wiped out; in others, groups were decimated by diseases imported from Europe and conflict with immigrants or, as they crowded into land already occupied, among tribes. American painters traveling along the Ohio and Monongahela, up the Mississippi and the Missouri rivers encountered Indian cultures and portrayed them according to the European ideals—men living in their natural state of nobility. George Catlin,

O brave new world,

That has such people in't!

Charles Bird King, and John Mix Stanley all determined to document native cultures before they were irrevocably changed or eliminated. Caught in their own sensibilities, they portrayed their subjects as heroic warriors, equal in nobility to their ancient Greek and Roman counterparts.

For American Indians, daily life hardly resembled the ideals projected in these elegant portraits. For each explorer who stood on a ridge or mountain peak, answering the call of a beckoning western horizon, another crowd of migrants came behind him. Generation after generation, settlers pursued a "fresh start" in the West, with little regard for its indigenous people.

Westward expansion began in earnest in 1803. Thomas Jefferson negotiated a treaty with France in which the United States paid France $15 million for the Louisiana Territory—828,000 square miles of land west of the Mississippi River—effectively doubling the size of the young nation. The lands acquired stretched from the Mississippi River to the Rocky Mountains and from the Gulf of Mexico to the Canadian border. Jefferson later owned that he had "stretched the Constitution until it cracked" to acquire Louisiana. As soon as the treaty was signed, he sent Meriwether Lewis and William Clark with their Corps of Discovery to find a route to the Pacific. They returned, with their mission completed, in 1806.

Intimidated neither by vast distance nor limited time, Jefferson launched a second group before his first team had returned. In 1805 he sent Zebulon Pike to discover the headwaters of the Mississippi and negotiate peace treaties with the Indians. Pike traveled as far as he could by boat, then continued on foot; he reached Leech Lake near the Canadian border, 2,000 miles from his starting point. In 1806, Pike led another expedition, this time covering the southwest quadrant of the Louisiana

GEORGE CATLIN

Stu-mick-o-súcks, Buffalo Bull's Back Fat, Head Chief, Blood Tribe

1832

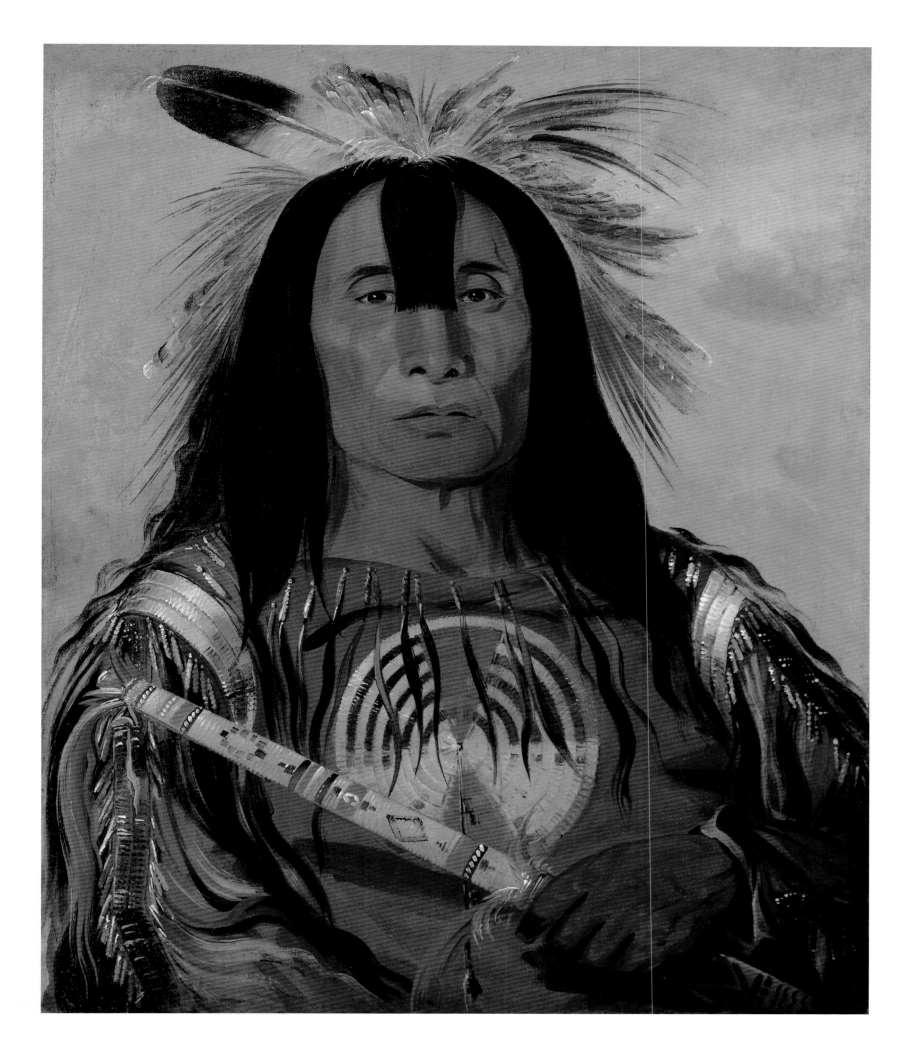

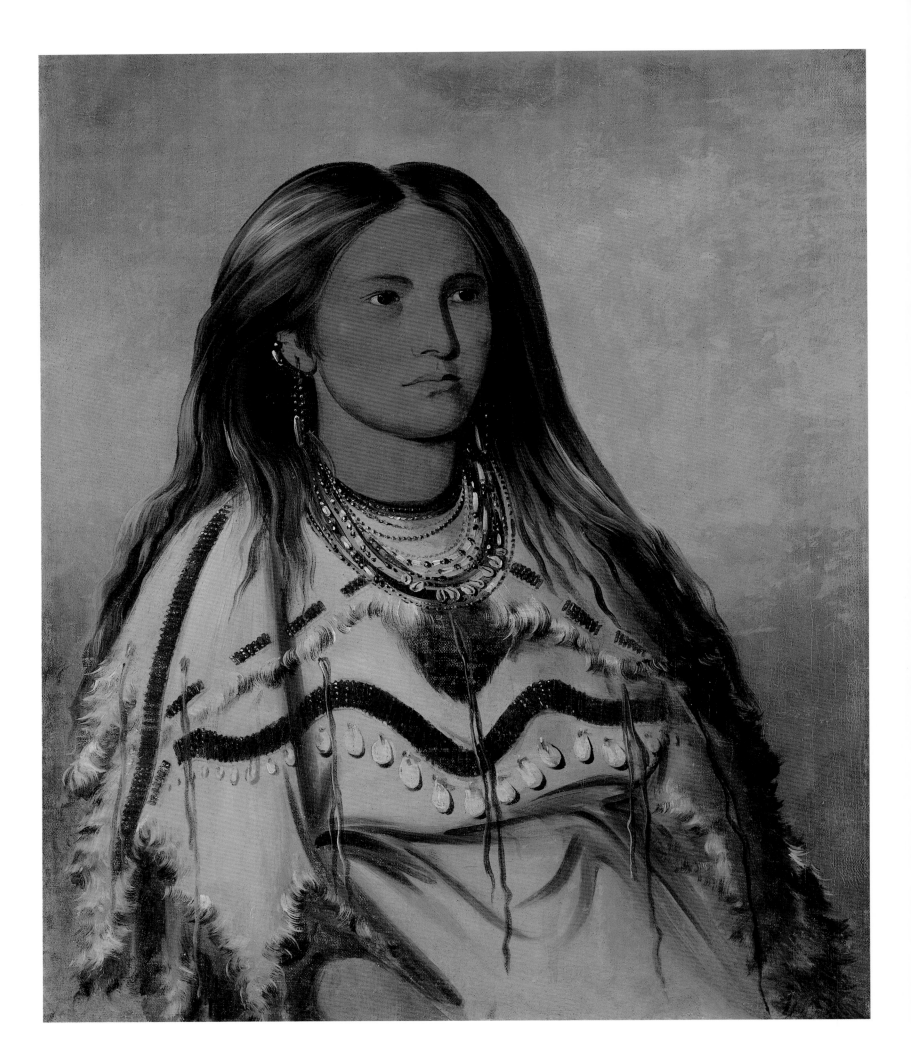

Territory. His party headed south from Colorado, ending up in what is now northern New Mexico, where he was arrested for entering Spanish lands illegally. Spanish officials confiscated all of Pike's maps and notes and they escorted the party across Texas and released them on the Spanish-American border in Louisiana in 1807. Pike's reports encouraged settlement in Texas and in what would become New Mexico.

Lewis, Clark, and Pike were followed by such memorable characters as John Charles Fremont, known as "the pathfinder," and eventually, John Wesley Powell. In 1841, Fremont headed his own expedition into the Iowa country to survey the Des Moines River for French scientist Joseph Nicollet; in that same year he secretly married Jessie Benton, the seventeen-year-old daughter of Senator Thomas Hart Benton of Missouri. Fremont made three major expeditions along the Oregon Trail and into the Sierra Nevada between 1842 and 1847, mapping routes that would be followed by migrants' wagon trains as well as railroad surveyors over the next decades. Fremont filed his first report to the Senate—actually written by his wife, Jessie—on March 2, 1843. It made a powerful impression on Congress and the American people, and fanned the flames of the Manifest Destiny movement.

The discovery of gold in California poured kerosene on the fire of westward expansion. Discussion of a transcontinental railroad had been in the air, but at mid-century the rhetoric gained new urgency. Between 1846 and 1849, significant additions of territory had reshaped the United States; it now truly stretched from sea to sea. Missouri's redoubtable senator, Thomas Hart Benton, intoned at length about a transcontinental road. He assumed it would be a simple matter to gain the consent of the Indians, do the mapping and engineering, and finance the entire project by the sale of public lands. He gave his vision the strength of historical imperative when

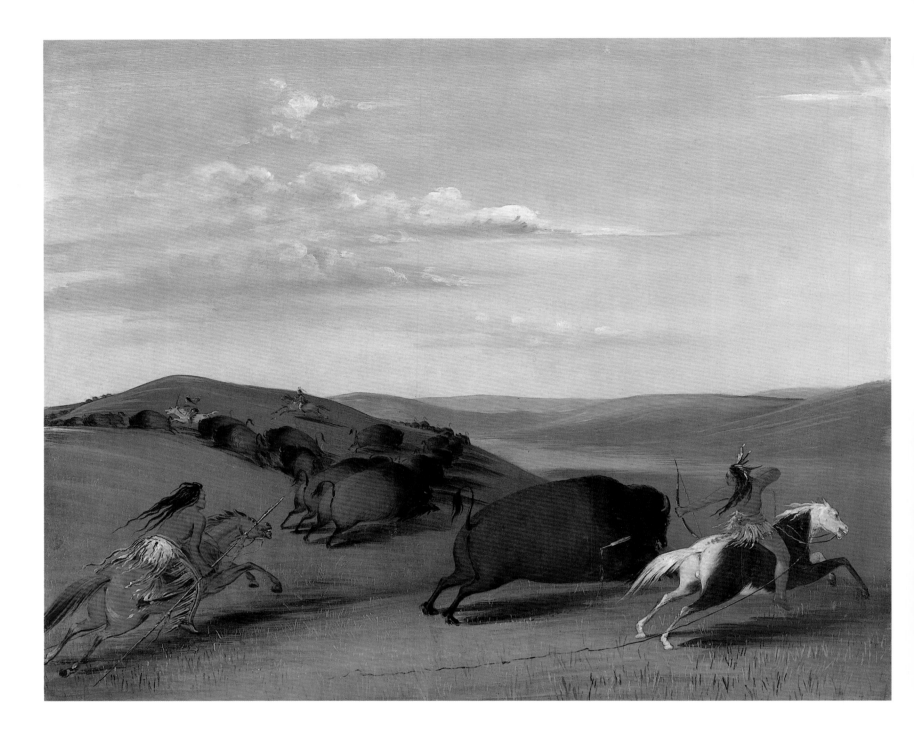

GEORGE CATLIN

Buffalo Chase with Bows and Lances
1832–33

he spoke of the realization of the great idea that filled the mind of Columbus, "the American road to India." In 1853, Congress authorized expeditions and surveys to "ascertain the most practicable and economical route...from the Mississippi River to the Pacific Ocean." Engineers and mapmakers spent years calculating distances and elevations, assessing the availability of water and timber, and observing the weather; and lawmakers and backers spent even more time arguing the costs and political merits of each possibility. Photographers accompanied many of these expeditions. Images from the cameras of Timothy O'Sullivan and William Bell were powerful propaganda for proponents of the railroads and westward migration.

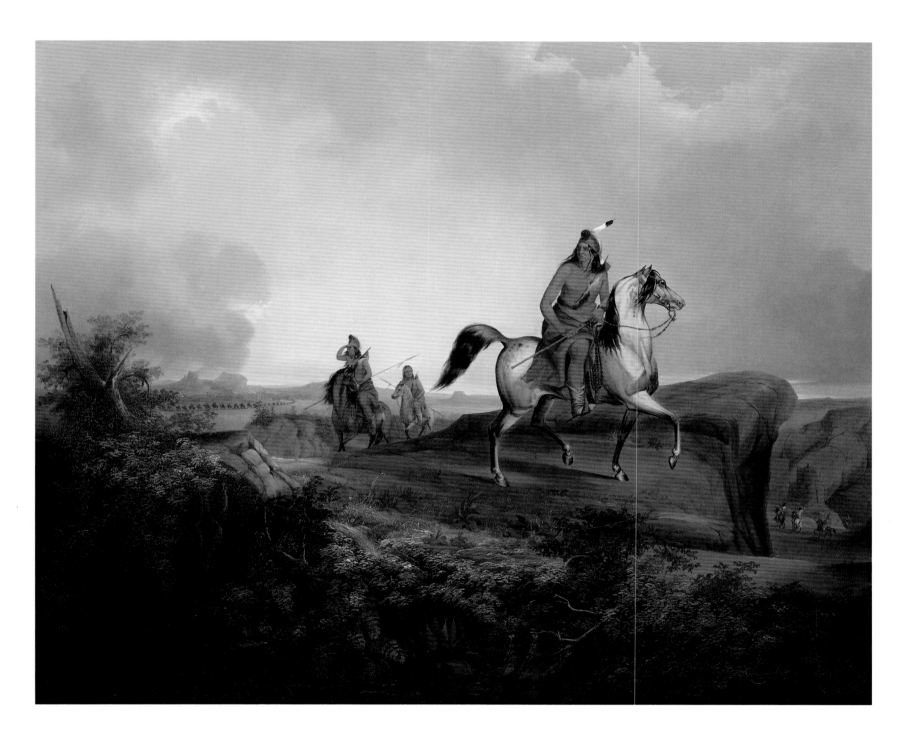

JOHN MIX STANLEY

Black Knife, an Apache Warrior
1846

My horse fights with me and fasts with me, because if he is to carry me in battle he must know my heart and I must know his or we shall never become brothers. I have been told that the white man, who is almost a god, and yet a great fool, does not believe that the horse has a spirit. This cannot be true. I have many times seen my horse's soul in his eyes.

PLENTY-COUPS
date unknown

Yes, more, more, more!…till our
national destiny is fulfilled and…
the whole boundless continent
is ours.

JOHN L. O'SULLIVAN

1845

◄

EMANUEL GOTTLIEB LEUTZE

*Westward the Course of Empire
Takes Its Way* (mural study,
U.S. Capitol)
1861

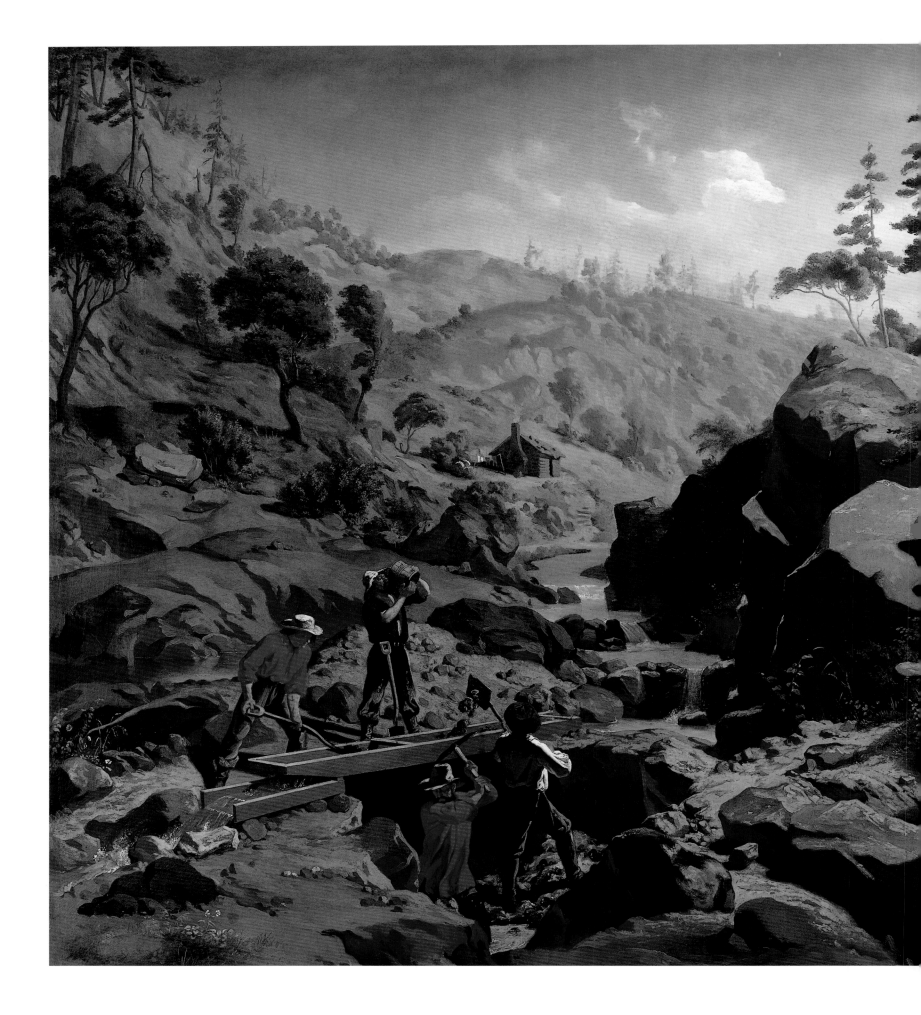

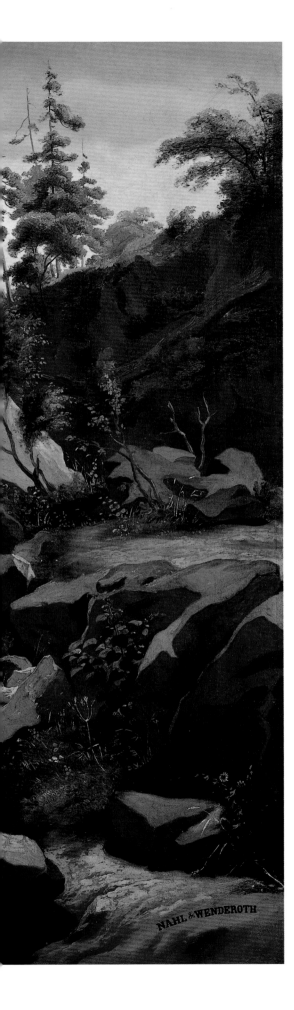

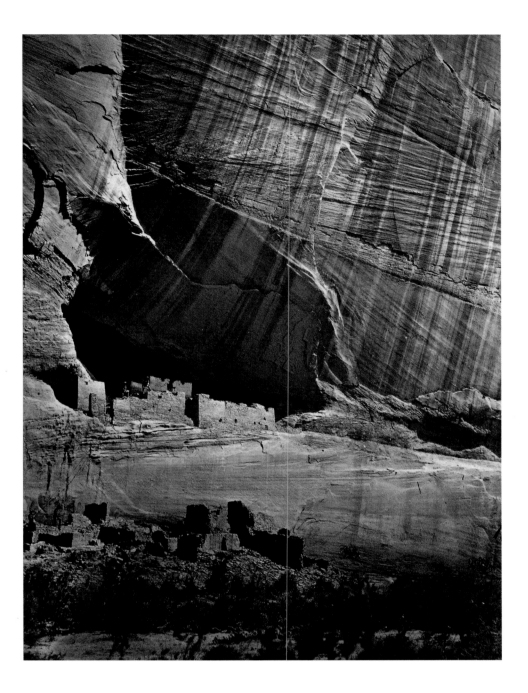

◄

CHARLES CHRISTIAN NAHL AND
AUGUST WENDEROTH

Miners in the Sierras
1851–52

▲

TIMOTHY H. O'SULLIVAN

*Ancient Ruins in the Cañon
de Chelle, N.M.*
1873

▶▶

THOMAS MORAN

*Cliffs of the Upper Colorado River,
Wyoming Territory*
1882

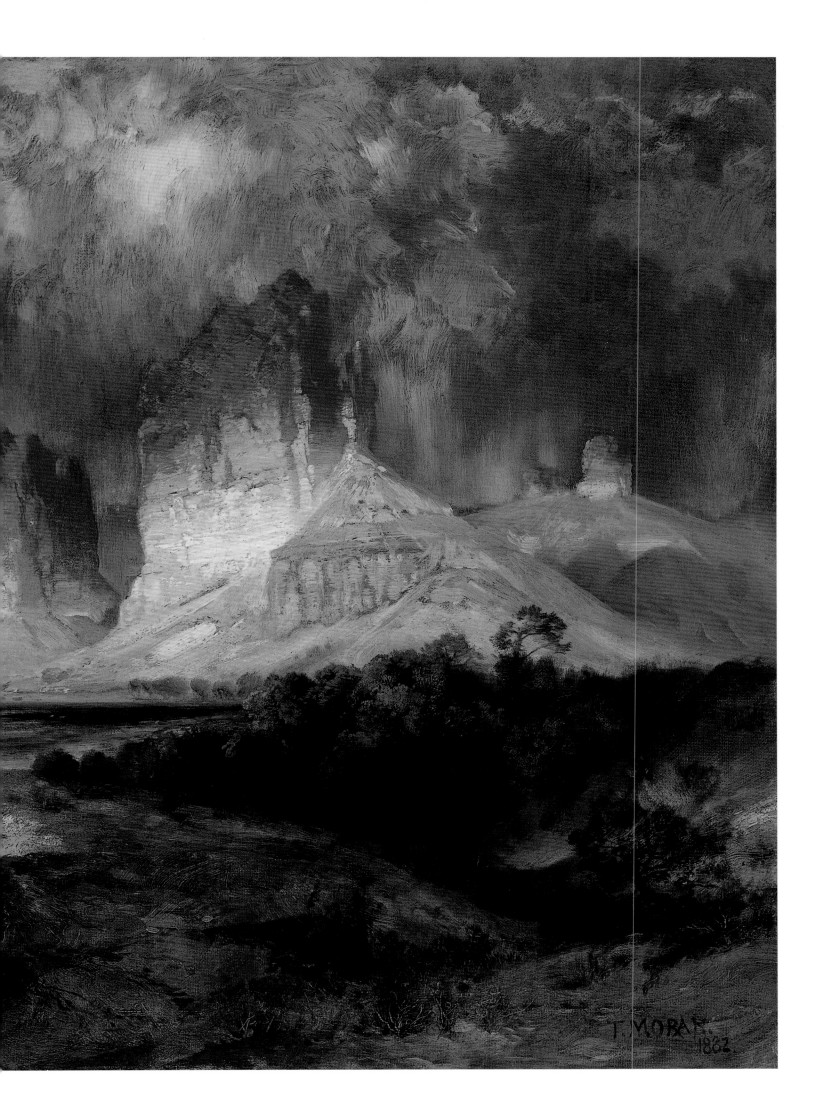

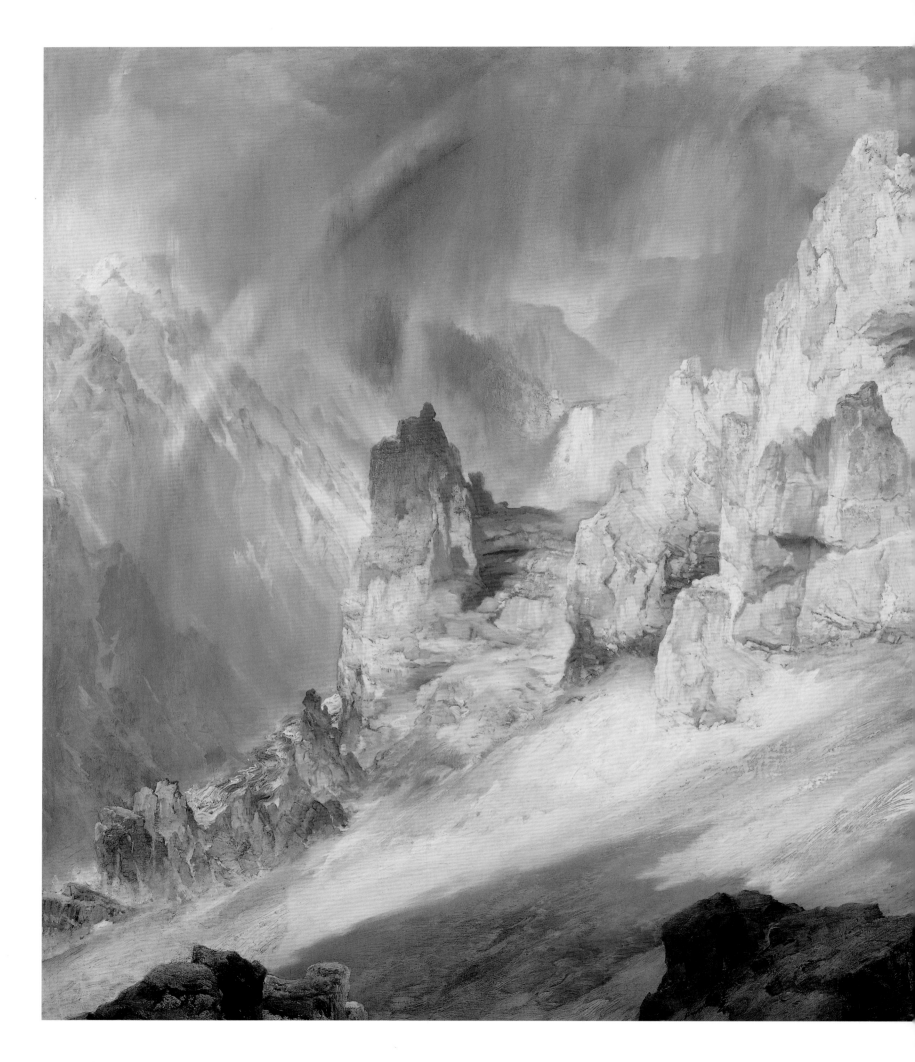

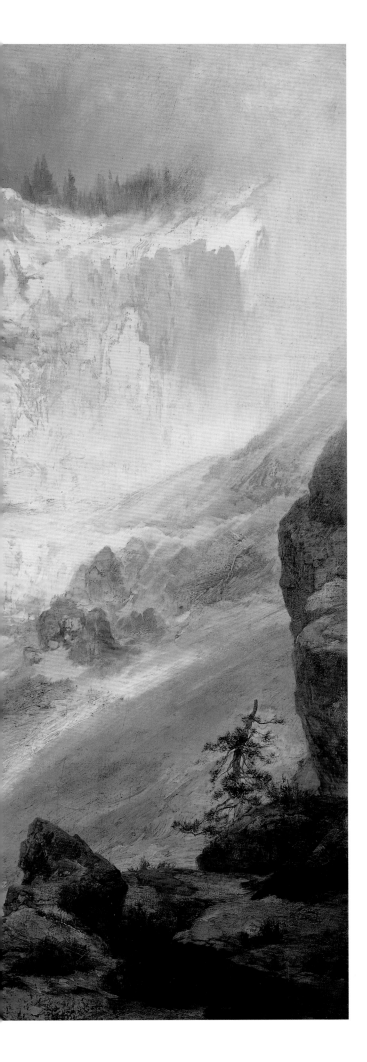

An eagle swooped down near my head, and then, soaring aloft with wildest screams, was lost in the rays of the setting sun. I knew that a great destiny waited for me in the West.

SAM HOUSTON
1839

▲

WILLIAM BELL

Cañon of Kanab Wash, Colorado River, Looking South (Wheeler Survey)
1872

◄

THOMAS MORAN

Rainbow over the Grand Canyon of the Yellowstone
1900

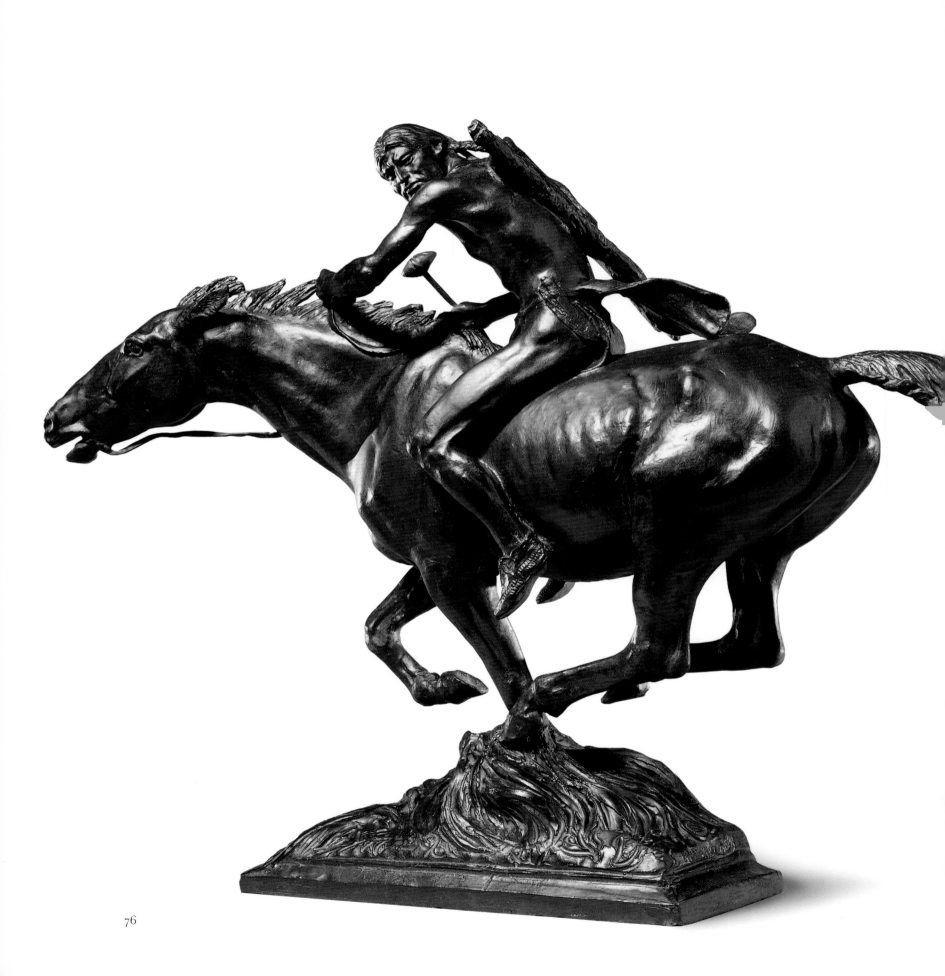

When I was a boy, the Sioux owned the world;
the sun rose and set on their land; they sent
ten thousand men to battle. Where are the warriors
today?… Where are our lands?

FREDERIC REMINGTON
Fired On
1907

SITTING BULL
1868

A. PHIMISTER PROCTOR
Pursued
modeled 1914, remodeled 1928

Hand to the Plow

When the British army left American soil, Washington and the Continental army were eager to return to peacetime pursuits. Washington's own eagerness to return to Mount Vernon was echoed in the desires of mechanics, farmers, and merchants who had spent some part of the past six years away from home and family. Images of solid barns filled with fodder, autumn plenty ready for harvest, and western lands filled with game and timber reminded Americans why they had broken with England and what they hoped for the future. But the Union formed in 1776 was a wartime alliance. As the army disbanded and soldiers turned homeward, the colonies began to think of repairing their economies. Under the Articles of Confederation, Congress had no authority to tax, issue currency, or regulate commerce.

Despite political limitations, Americans had grand visions. Thomas Jefferson foresaw a nation of educated yeoman farmers. In Jefferson's view, safeguarding democratic ideals would depend on getting land into the hands of solid citizens. When citizens became stewards of that land, they would rationally pursue long-term personal and national interests. Alexander Hamilton had a radically different vision and thought the nation's future strength and prosperity lay in trade and commerce. Both visions depended on territorial growth, and by 1787 Congress passed the Northwest Ordinances, which opened the Ohio Valley to settlement. Early work by surveyors led Congress to specify that the territory would be divided into townships six miles square, and subdivided into "lots" one mile square. Congress even tried to guard against profiteering speculators by dictating that alternate townships were to be sold whole, with the others sold by lots to individuals. The potential for enriching the national coffers was enormous, and in this context Jefferson's purchase of the Louisiana Territory and his sponsorship of expeditions

*Landscape (possibly of
Staten Island, New York)*
about 1850

by Lewis and Clark and Zebulon Pike to explore and map the West became drivers
of the American economy.

The Ohio Company had been formed in 1786; its idealistic goal was to
settle the territory; its practical method involved land speculators. In July 1787,
Congress passed an ordinance for the government of the Territory of the United
States northwest of the Ohio River, which stipulated that from three to five states
would be carved from the Northwest Territory, including present-day Ohio, Indiana,
Illinois, and most of Michigan. One section in each township would be set aside
to support public education; slavery was banned. One scheme to settle the western
lands, hatched by George Washington and surveyor Rufus Putnam, was to attract
Revolutionary War veterans from New England; their military experience and
proven hardiness would be invaluable in defending and developing frontier farms

NATHANIEL CURRIER

Preparing for Market
1856

The American is a new man, who acts upon new principles....
From involuntary idleness, servile dependence, penury, and
useless labour, he has passed to toils of a very different nature,
rewarded by ample subsistence.—This is an American.

J. HECTOR ST. JOHN DE CRÈVECOEUR

Letters from an American Farmer
1782

FRANCIS WILLIAM EDMONDS

The Speculator

1852

and towns. A military reserve was set aside; nearly twenty grants distributed land to states, religious, and other organizations. The original survey was rough, but by 1798 it was nearly complete, and land sales were held. A large portion of western lands, both in Ohio and elsewhere were purchased by speculators. The adventure of taming the wilderness attracted settlers to the West. The opportunity to build new fortunes attracted capital, while the regularity of the grid made it easy for capitalism and enterprise to thrive.

This vision of the frontier as a promised land persisted. There was a price to be paid, however. Frontiersmen had to be willing to face the risks inherent in migration—but had their parents not faced similar risks in coming to America? They had to

GEORGE HENRY DURRIE

Winter Scene in New Haven,
Connecticut
about 1858

be willing to do the backbreaking work required to turn a wilderness into prosperous farms and towns—but had their ancestors not done that as well? They had to be willing to break with the familiar and comfortable, and face hardship—perhaps even death. But had Americans not taken similar risks when they broke with England? For anyone who wanted to venture into the Ohio country, the answers to such questions were clearly written in the immediate and distant pasts. The exploding population and the crowding of cities on the Atlantic seaboard also pushed people to look and travel to the West. Images of prosperous farms, abuzz with activity, were popular and widely reproduced. The bountiful harvest promised a snug winter; wrapped within the house and barns was the promise of new life, new crops, and new opportunities in the spring.

Happy the man whose wish and care
A few paternal acres bound
Content to breathe his native air
In his own ground.

Whose herds with milk, whose fields
 with bread,
Whose flocks supply him with attire;
Whose trees in summer yield him shade,
In winter fire.

ALEXANDER POPE
"Ode on Solitude"
1717

◄

JOHN WHETTEN EHNINGER
October
1867

Those who labor in the earth are the chosen people of God,
if ever He had a chosen people,
whose breasts He has made his peculiar deposit
for substantial and genuine virtue.

1784

▲

EDWARD MITCHELL BANNISTER

Untitled

1880

▶▶

ANDREW W. WARREN

Long Island Homestead,
Study from Nature

1859

Brother against Brother

During the first half of the nineteenth century, America grew. The Louisiana Purchase roughly doubled the country's size. Within fifty years the U.S. population had multiplied four times over. Concurrently, the gross national product had increased sevenfold. A powerful entrepreneurial spirit and an almost ceaseless spate of new inventions drove the commercial engine ever faster. But progress was not smooth. Expansion, industrialization, and the shift from agrarian to urban life created social rifts and unemployment. Yet the most ominous threat in 1850 was the conflict between North and South over the future of slavery.

In the early 1800s, the religious revivals of the Second Great Awakening attracted thousands of followers who promoted a host of moral and cultural reforms. The most important and controversial of these was abolitionism. At the same time, the doctrine of Manifest Destiny justified the inexorable march of settlers through the Ohio Valley, across the Mississippi and the Great Plains to California; the discovery of gold at Sutter's Mill in 1848 accelerated that deliberate pace to a run. Territories, rapidly gaining population and economic power, vied for admission to the Union.

Congress walked a narrow line, balancing free and slave states to prevent political mayhem. The Missouri Compromise of 1820 prohibited slavery in lands remaining of the Louisiana Purchase north of 36°30' N latitude—the southern boundary of Missouri. With the annexation of California in 1850, the U.S. Congress struck another compromise to defuse growing North-South hostility. In 1854, Senator Stephen A. Douglas, an Illinois Democrat and land speculator, sponsored the Kansas-Nebraska Act, a bill designed to organize the new territory. Legislators assumed that Kansas would be slave, while Nebraska would be free. Douglas added an amendment

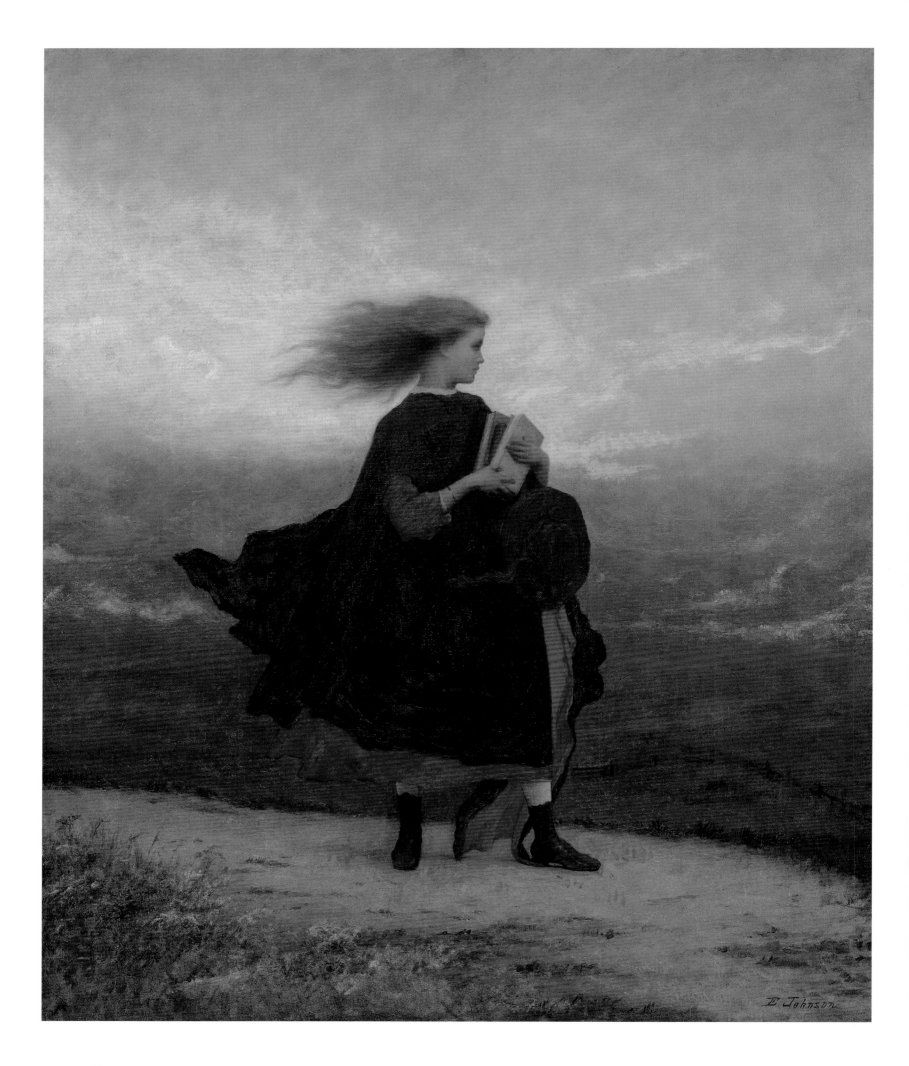

I'll sell my rack, I'll sell my reel,
I'll sell my only spinning wheel
To buy my love a sword of steel.
My Johnny's gone for a soldier!

FOLK SONG
"Johnny Is Gone for a Soldier"

EASTMAN JOHNSON

The Girl I Left Behind Me
1870–75

that repealed the Missouri Compromise, and when the bill became law, a firestorm destroyed the delicate balance between pro- and anti-slavery forces.

In his bid for reelection in 1854, Douglas faced a lanky Whig lawyer named Abraham Lincoln. This newcomer to politics quoted the texts of the Revolution—the Declaration of Independence and the Constitution—insisting that the principle that all men were created equal still prevailed. He declared that the first step was to prevent any further spread of slavery; the second was to begin gradual emancipation. Although Lincoln did not unseat Douglas, he earned his place on the national political stage.

Though politicians hoped they had settled the fight over Kansas, by 1856 Kansans were living under two territorial governments: one pro-slavery, the other for Free-Soil. Free-state activists resisted the fugitive slave law, and the violence that had begun in Kansas spread. By 1858, John Brown, who had earned his stripes among the Free-Soilers of Kansas, was making plans to lead a slave rebellion from Harper's Ferry, Virginia. He hoped to seize the U.S. armory there, arm the slaves, and lead them down the Potomac River toward Washington. His small band attacked on October 16, 1859, but the supporting uprising he expected never materialized. He and his tiny force were captured and hanged.

Brown's death became a rallying point for outraged abolitionists, and the fledgling Republican Party nominated Abraham Lincoln, who met his old opponent, Stephen Douglas, in the presidential race. Lincoln won the election, and with it the herculean task of trying to preserve the Union and abolish slavery.

The Civil War consumed every resource and thought for more than four years. After the second battle of Bull Run, Generals Robert E. Lee and Stonewall

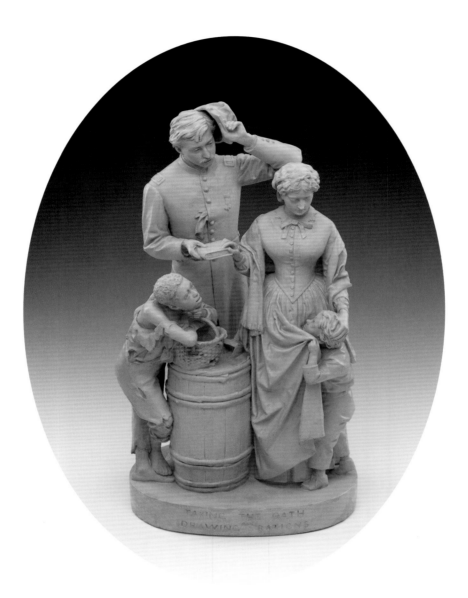

Jackson invaded Maryland in September 1862, planning to put the Union army on the defense. Their hopes were dashed at Antietam, where more than 23,000 men died. Confederate troops fled back into Virginia. Seeing Lee's defeat as a propitious moment, Lincoln discussed his recently drafted Emancipation Proclamation with his cabinet. The final text was issued in January 1863. In battles at Chancellorsville, Gettysburg, and across the nation, the Civil War claimed more American lives than did all the wars of the twentieth century. Sherman's March to the Sea left a swath of devastation from Atlanta to Savannah. In August 1861, Ralph Waldo Emerson wrote: "the war . . . has assumed such huge proportions that it threatens to engulf us all—no preoccupation can exclude it, & no hermitage can hide us."

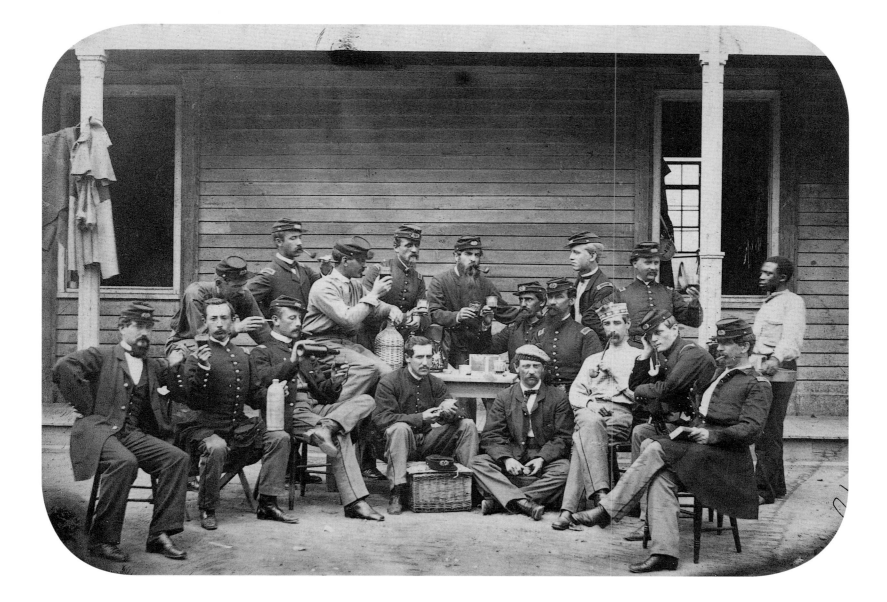

I will fight the Secession leaders
until Hell freezes over,
then fight them on the ice.

WILLIAM G. BROWNLOW
1861

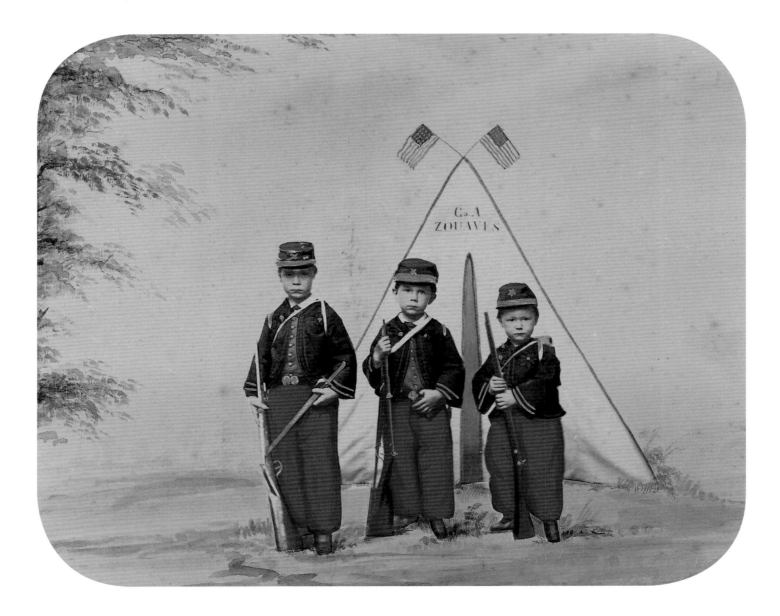

▲

UNIDENTIFIED ARTIST

Three Boys in Zouave Costume
about 1863

▶

TRUMAN HOWE BARTLETT

Carry Me and I'll Drum It Through
1874

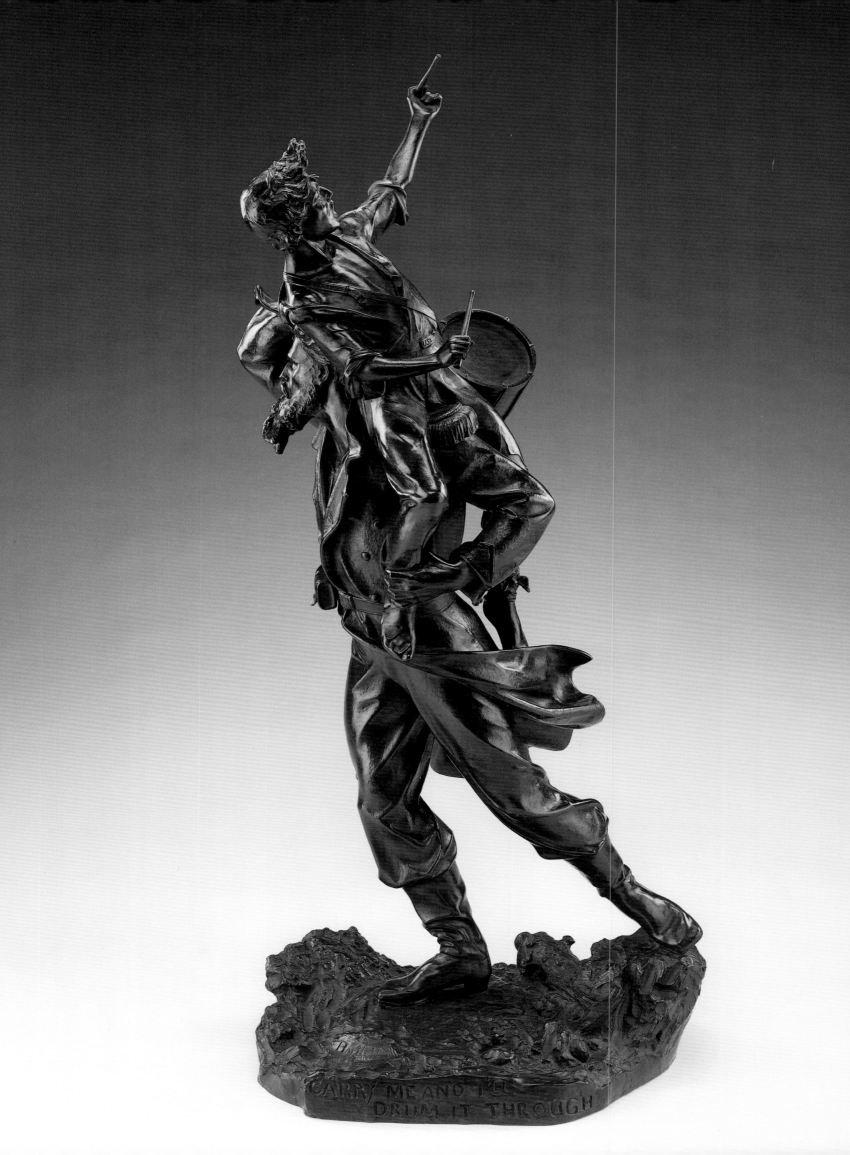

CARRY ME AND I'LL
DRUM IT THROUGH

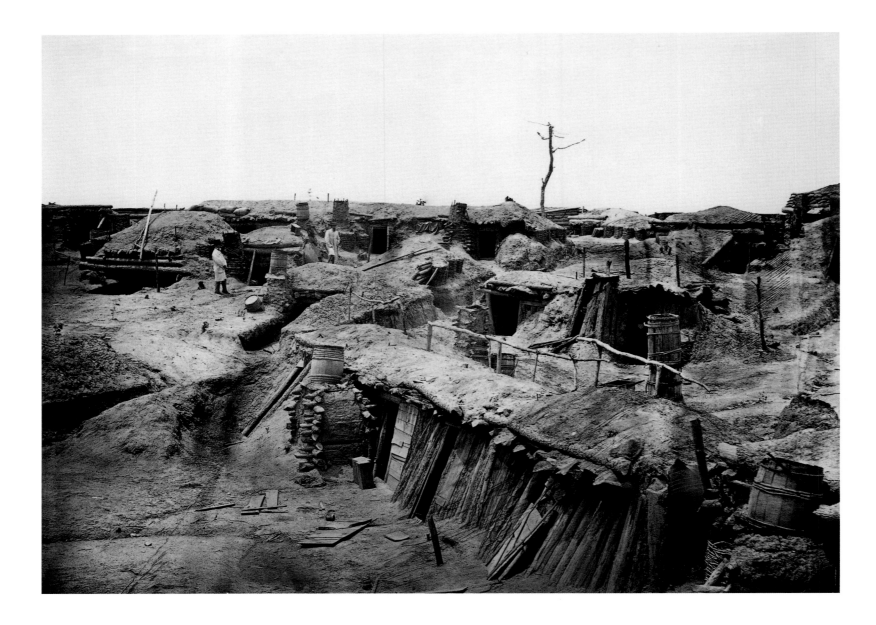

▲

TIMOTHY H. O'SULLIVAN

Quarters of Men in Fort Sedgwick,
Known as Fort Hell
1865

▶

STUDIO OF MATHEW B. BRADY

The Sick Soldier
about 1863

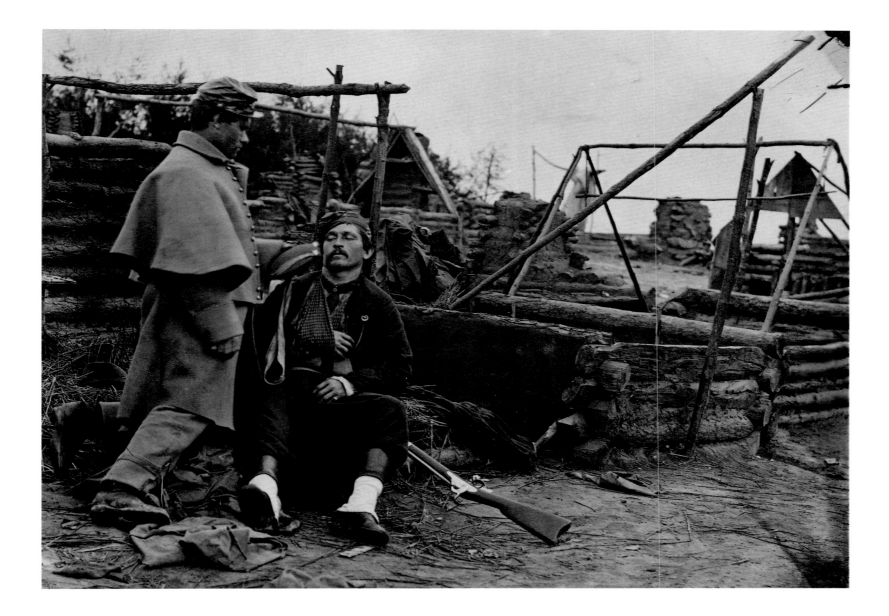

I know ... how great a debt we owe to those who went before us
through the blood and sufferings of the Revolution.
And I am willing—perfectly willing—to lay down all my joys in this life,
to help maintain this government, and to pay that debt.

MAJOR SULLIVAN BALLOU

Letter to his wife, Sarah

1861

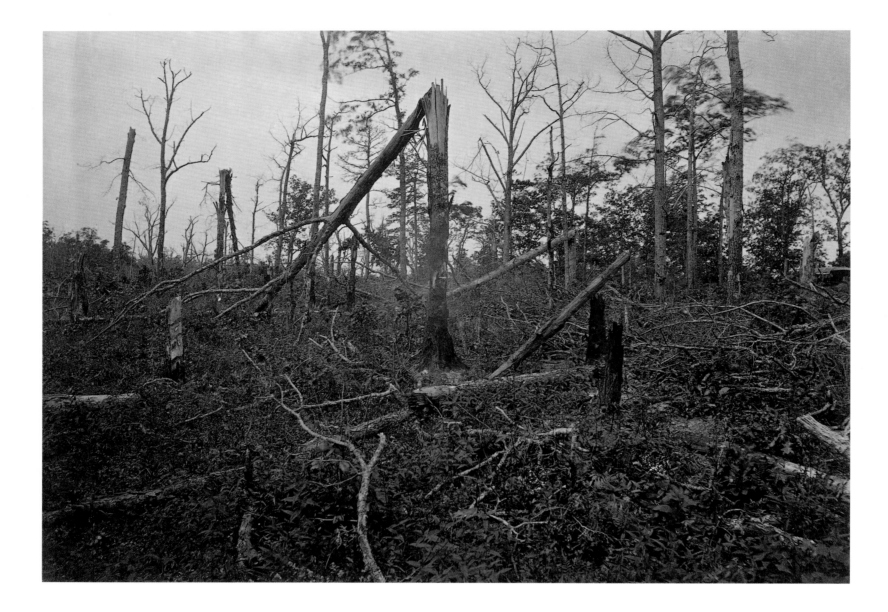

▲

GEORGE N. BARNARD

The "Hell Hole," New Hope Church,
Georgia, from *Photographic Views*
of Sherman's Campaign
about 1866

In the morning when I awoke, branches of trees, and trees
had been cut down during the night by the enemy's
shells and shot, cannons had been overturned, and soldiers
lay sleeping only to awaken to the bugle-call of heaven.

PRIVATE FRANCIS CORDREY

1894

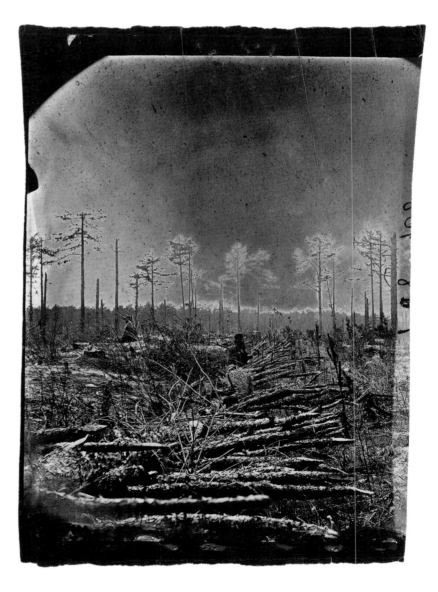

▶

UNIDENTIFIED ARTIST

Wilderness Battlefield
1864

In giving freedom to the slave, we assure freedom to the free—

honorable alike in what we give, and what we preserve.

We shall nobly save, or meanly lose,

the last best hope of earth.

ABRAHAM LINCOLN

1862

▶

EASTMAN JOHNSON

The Lord Is My Shepherd

about 1863

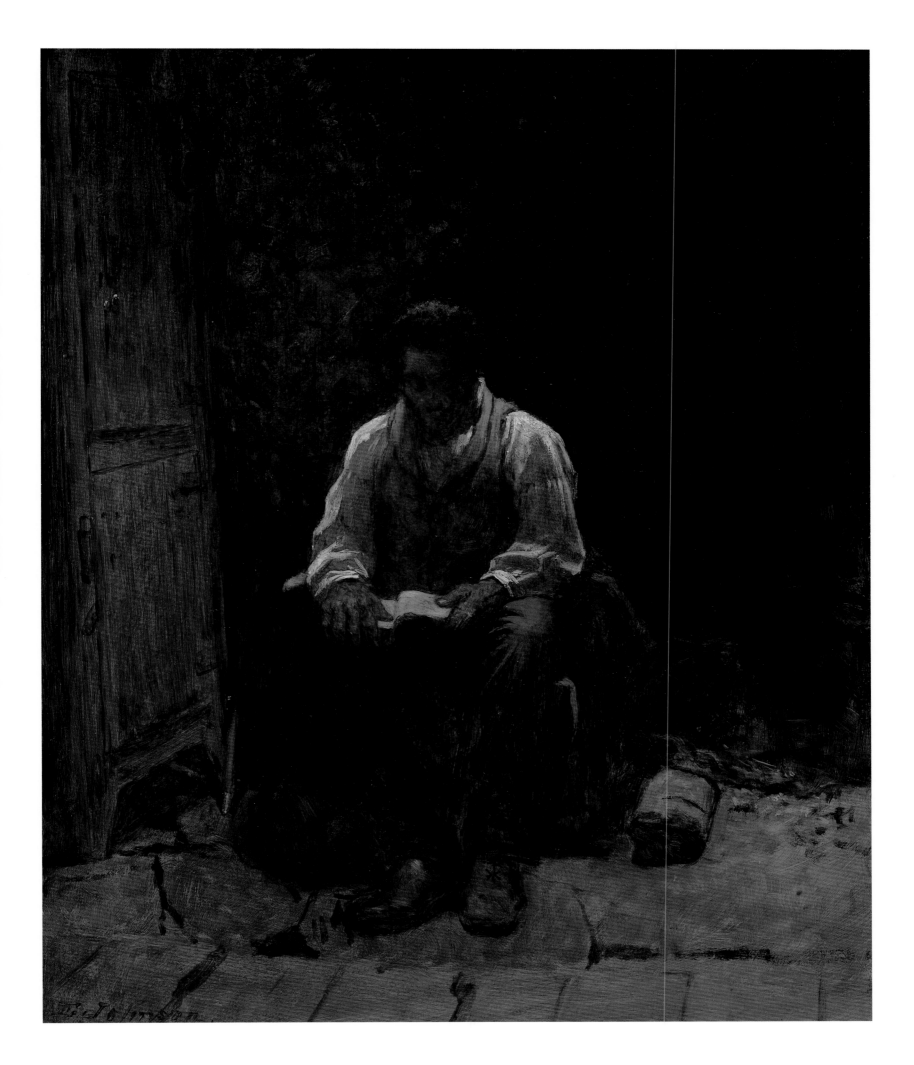

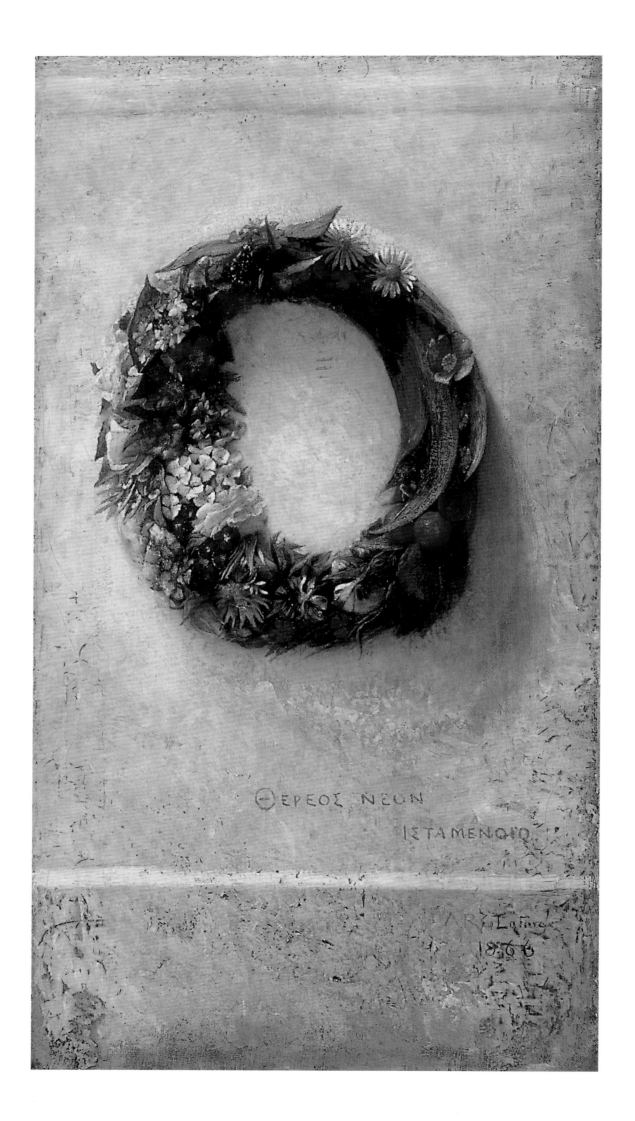

HEALING THE WOUNDS

Every family had been touched by death, and people who had lost friends and relatives on both sides of the conflict were not rare. Images of death and mourning capture the somber mood. Henry Adams, viewing the war from a distance in London wrote, "I wonder whether any of us will ever be able to live in contented times of peace and laziness. Our generation has been stirred up from its lowest layers and there is that in its history which will stamp every member of it until we are all in our graves. We cannot be commonplace."

Daily dispatches from the various fronts appeared in newspapers and magazines. The writers' words were powerful, but with the advent of new engraving and printing technology, they were almost always accompanied by images. Winslow Homer, one of many artists so occupied created hundreds of illustrations for *Harper's Weekly*. The advent of photography just before the war made it impossible even for noncombatants to avoid the horrors of death and battle. Images of fallen soldiers from both sides, the burned shells of houses and businesses in Richmond and Atlanta, prisons at Elmira and Andersonville, and the dead and wounded laid out in rows like cordwood could not be ignored or romanticized. Photographs of battlefields still leave us struggling to take in the facts. How could any man have survived on a field where nearly every tree was felled by cannon and gun fire?

But hopeful images emerged as well. Eastman Johnson paints a slave—or perhaps a recently emancipated slave—reading his Bible. Richard Norris Brooke's *A Dog Swap* shows a family group at leisure. Although they have not gained status or wealth comparable to their former masters, they have gained both time and freedom to debate the finer points of a pair of hunting dogs.

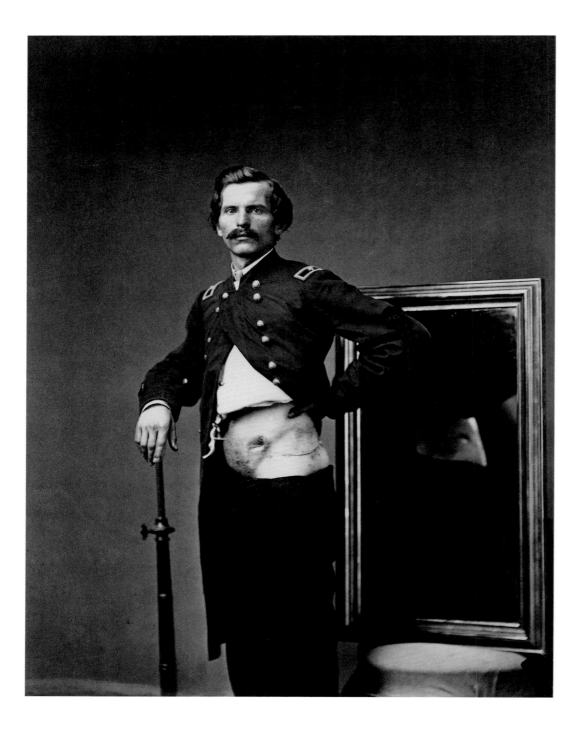

WILLIAM BELL

Major H. A. Barnum, Recovery after a Penetrating Gunshot Wound of the Abdomen with Perforation of the Left Ilium, from the *Photographic Catalogue of the Surgical Section*
1865

On December 23, 1864—closely following two important Union victories—
millions of Northerners witnessed a striking display of the aurora borealis. Many
interpreted this as a sign of the North's inevitable victory; Frederic Church's paint-
ing by that name, though rich with associations of exploration, was probably partly
inspired by that event. The colors of the northern lights in the sky certainly evoke the
American flag, while the dogsled seems to be bringing hopeful news to the icebound
ship. But not all the news was good. Within five days of Lee's surrender, which took
place on April 9, 1865, at Appomattox, and a month before the final truce, Lincoln
was shot at Ford's Theatre in Washington by John Wilkes Booth. His funeral train,
which traveled from Washington back to Illinois, was a focus for the nation's sorrow.
Though the war was ended, the deep divisions could not be easily healed, and the
mourning would continue for generations.

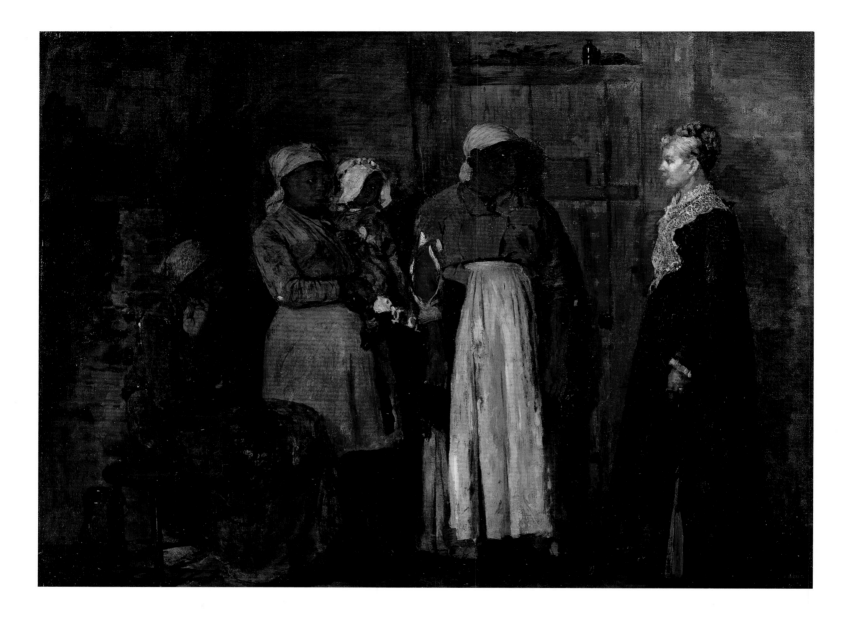

WINSLOW HOMER

A Visit from the Old Mistress
1876

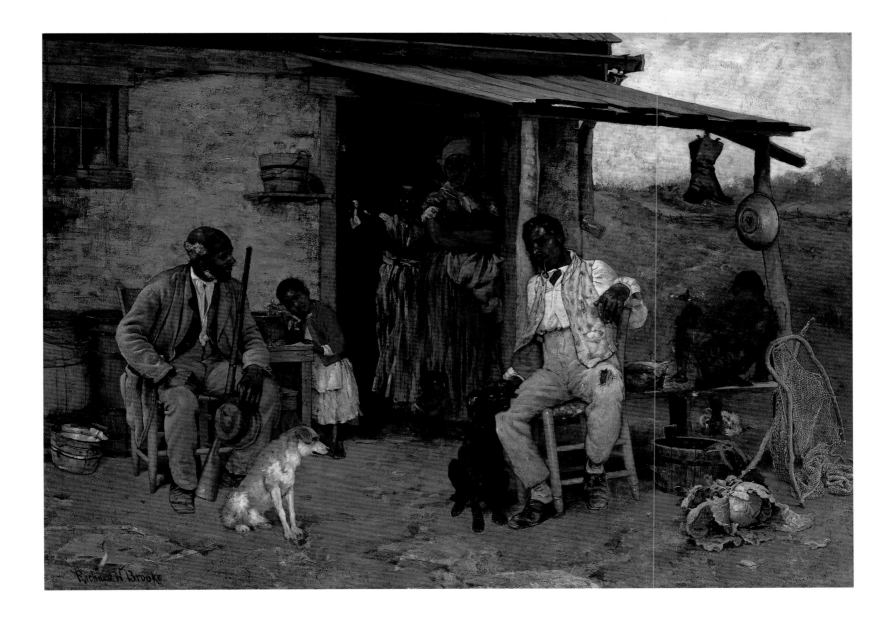

RICHARD NORRIS BROOKE

A Dog Swap

1881

O Captain! my Captain!
our fearful trip is done;
The ship has weather'd every rack,
the prize we sought is won

WALT WHITMAN
Leaves of Grass
1865

▶

AUGUSTUS SAINT-GAUDENS
Abraham Lincoln
modeled 1887

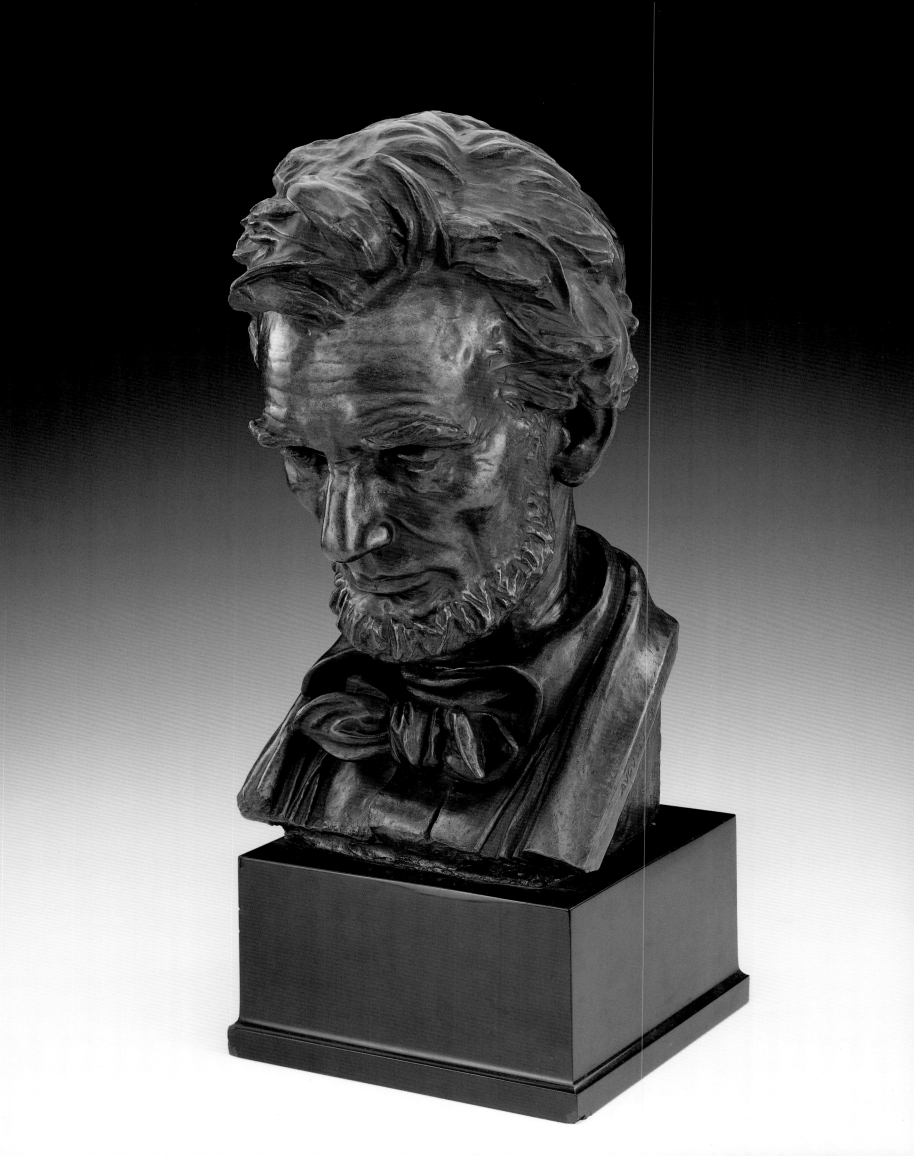

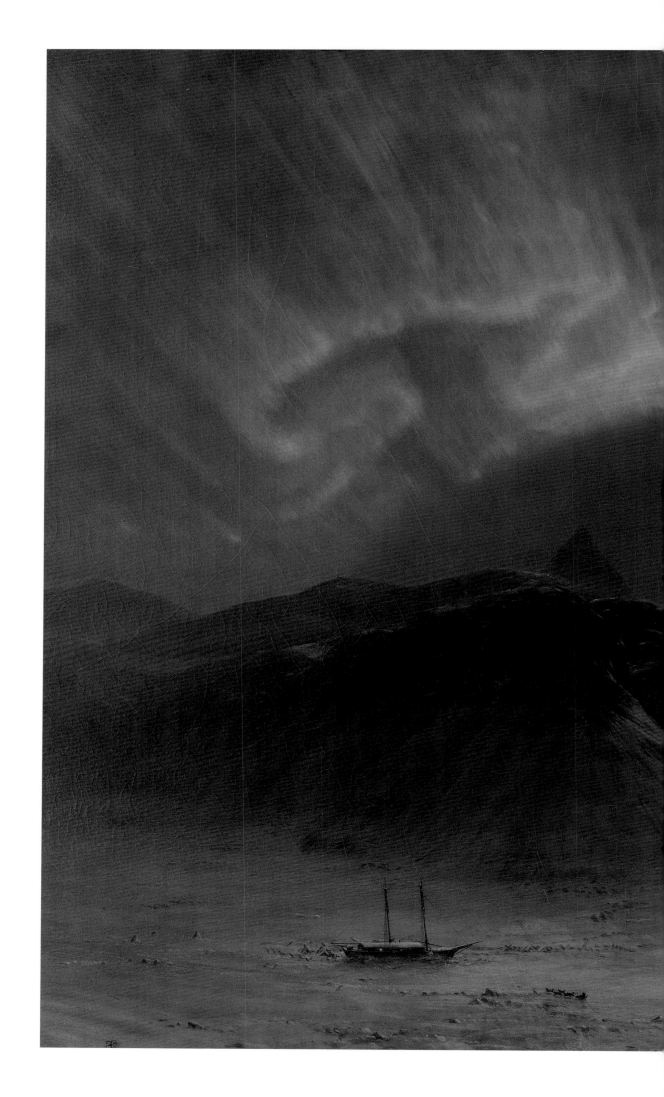

FREDERIC EDWIN CHURCH

Aurora Borealis
1865

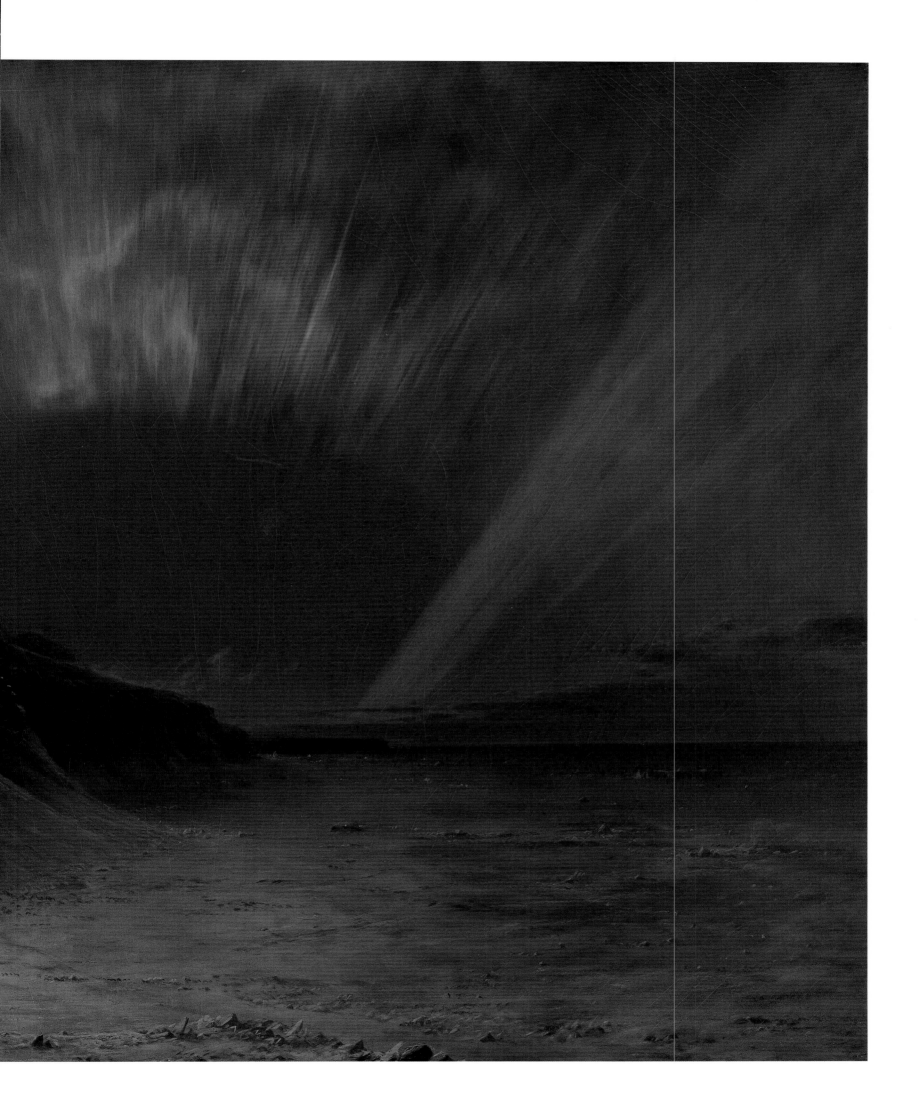

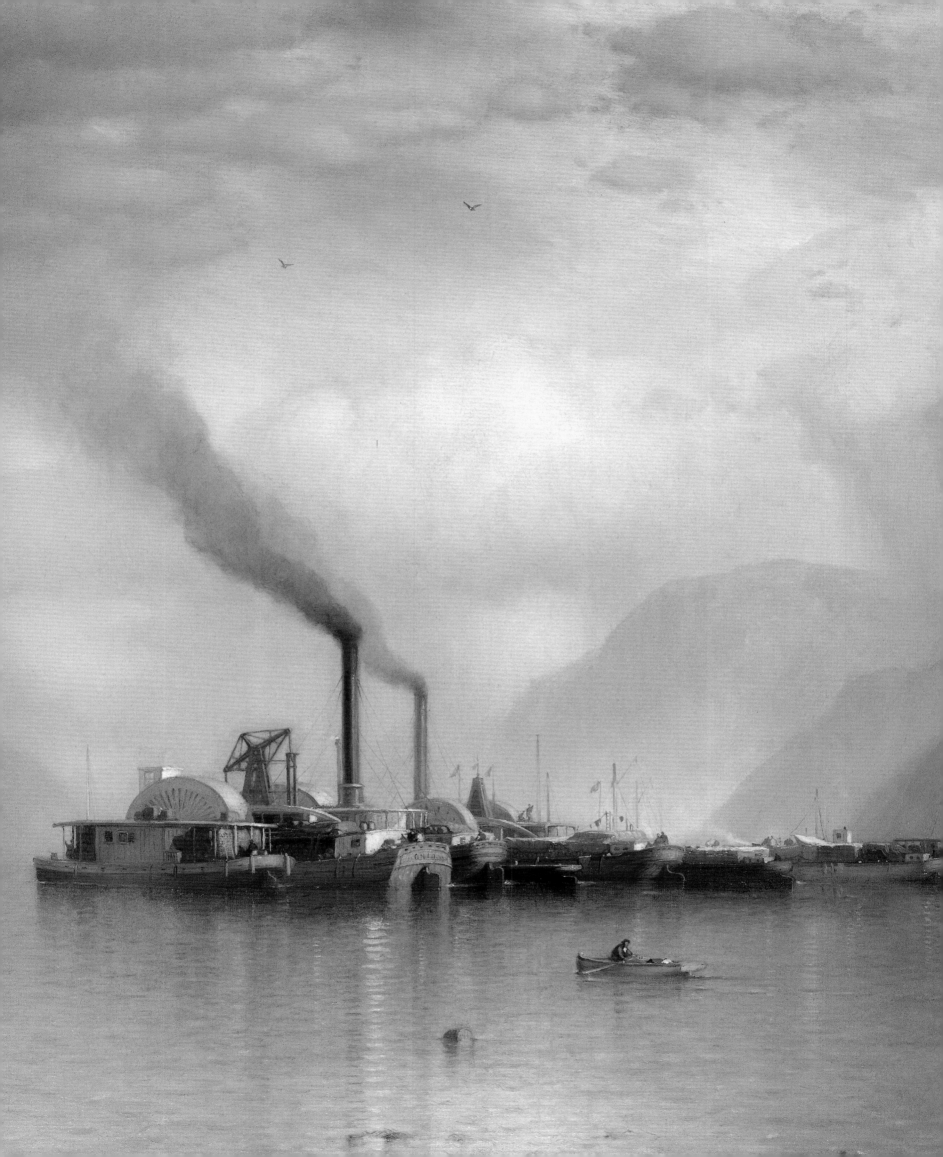

The Rise of Industry

hrough the Civil War and the difficult years of Reconstruction, the ideas of the American Revolution were, in a sense, vindicated. Despite secession and a terrible and bloody war, the Union had prevailed—and what was more, regular elections were held, foreign trade and diplomacy were conducted, and Congress passed a great deal of legislation, including the first system of national taxation and funding for the completion of the transcontinental railroad.

The Pacific Railway Act of 1862 settled the route for a transcontinental railroad. The Central Pacific was to build eastward from California, while General Grenville Dodge, who had shown his engineering and organizational abilities under William Tecumseh Sherman in the Atlanta campaign, led the Union Pacific's engineers building westward from Council Bluffs, Iowa. Like many soldiers who survived the war, Dodge had proven his abilities and had come to appreciate the value of competence and professionalism. An understanding of the mechanics of battle was a greater asset to the soldier himself and to the army than the greatest enthusiasm or lofty political ideals. Soldiers were tempered by their own wounds and the deaths of so many comrades. They were torn away from local concerns and customs, for which many substituted national views. In these decades, technology, engineering, economic growth, and immigration wrought change faster than people could absorb it.

During the 1870s, the Kansas Pacific Railway began to reach across the Plains. "Cow towns" like Abilene and Wichita were established, and the "long drive" brought cattle from the south and west to the rail heads for shipment back east. Goods of every sort were shipped by train in every direction. People found that their hometowns bore small resemblance to what they remembered from before the war;

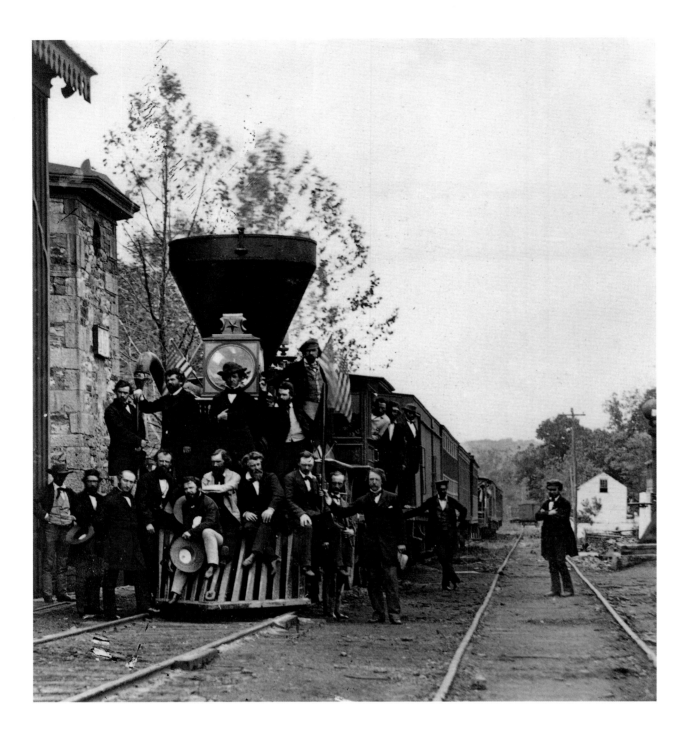

UNIDENTIFIED ARTIST

Artists' Excursion, Sir John's Run,
Berkeley Springs
1858

many migrated, often in wagons, but sometimes on trains. Railroads carried not only goods and emigrants, but advertised to attract tourists; even visitors from foreign shores sang the praises of the railways.

When I think how the railroad has been pushed through this unwatered wilderness and haunt of savage tribes and now will bear an emigrant for some twelve pounds from the Atlantic to the Golden Gates; how at each stage of the construction roaring, impromptu cities, full of gold and lust and death, sprang up and then died away again; how in these uncouth places pigtailed Chinese pirates worked side by side with border ruffians and broken men from Europe,... and then when I go on to remember that all this epical turmoil was conducted by gentlemen in frock coats with a view to nothing more than a fortune and a subsequent trip to Paris, it seems to me, I own, as if this railway were the one typical achievement of the age in which we live, as if it brought together

into one plot all the ends of the world and all the degrees of social rank, and offered to some great writer the busiest, the most extended, and the most varied subject for an enduring literary work.
—Robert Louis Stevenson, *Across the Plains,* 1892

At the end of the Civil War the country was largely agrarian. More than half of men worked on farms or had their own businesses. By 1920, only about twenty percent of men were self-employed and only about twelve percent were farmers. Many went west, some remaining in the army to fight the Indian wars, others seeking economic opportunity. One of the first working oil wells, drilled in western Pennsylvania in 1859, provided an alternative to increasingly scarce and expensive whale oil in lamps, and later gasoline to power Henry Ford's new horseless carriage. Mining towns—not only gold, but silver, lead, and copper—sprang up in Colorado, New Mexico, Alaska, Nevada, and Utah.

By 1881, there were fourteen smelters and reduction plants operating in the Leadville, Colorado, district alone. Prospectors benefited from lessons learned on the Sierra slopes during the California gold rush, and many of the miners in New Mexico, Colorado, Utah, and Montana came from California. But the merchants, teamsters, packers, and suppliers of food and equipment were most often local, so the mining industry fed both local and national economies. In 1874 the Colorado School of Mines opened its doors. A place that combined the application of old-world skills and new-world experience to engineering problems, it transformed mining, bridge construction, and road building.

Transportation was vital to sustaining manufacturing and construction, and railroads were only part of the story. The first steamboats designed by Robert Fulton

made their debut transporting agricultural and industrial supplies and products on American canals and rivers early in the nineteenth century. The demand for transport grew rapidly, and by the mid-1830s, New Orleans docks were accommodating more than 1200 steamship arrivals each year. Goods were also transported between the East and West coasts, to China, Japan, Europe, and Australia in swift, beautiful clipper ships. These sleek-hulled vessels with their vast expanses of sail were built for speed; previous generations of cargo ships could cover four to five nautical miles with a good wind behind them. Fully loaded clipper ships could sustain speeds between sixteen and eighteen knots for hours on end. The yacht *America* had crossed the Atlantic in 1851 to challenge British superiority on the seas. When she crossed the finish line in a race around the Isle of Wight, none of her competitors was in sight.

F. Jay Haynes

Gloster Mill, 60 Stamps,
24 Pans, 12 Settlers
about 1885

Steamships, cheaper to operate, supplanted clippers as the century waned; but the romance of the age of sail lived on in the yachts that followed *America.*

 The Port of New York was the busiest in the world. Manhattan's perimeter measured forty-three miles, but its developed waterfront, measuring along the piers and slip-heads, was nearly twice that. All along the west side of the island, lines of piers extended into the Hudson River, while the East River's traffic never ceased. In 1860, fifty-two percent of the nation's combined imports and exports came through the Port of New York, where customs revenues were enough to finance the federal government. By 1900, two-thirds of the nation's imports and one-third of its exports still came through the harbor.

 Beginning in 1889, the Republican Party settled in for nearly three decades of legislative control. Their probusiness policies encouraged capitalism and industry.

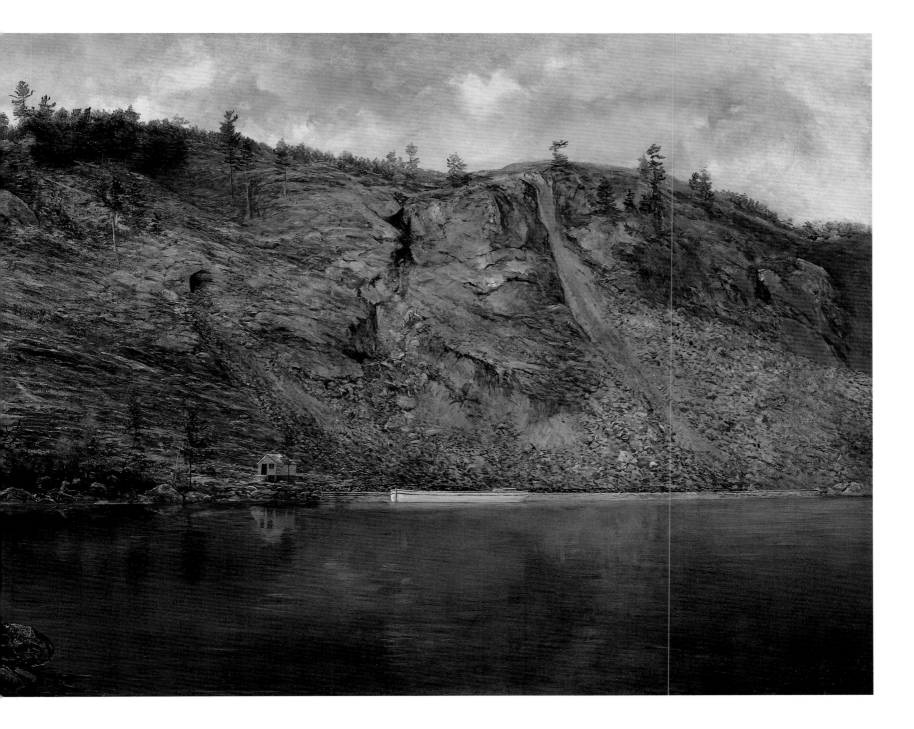

HOMER DODGE MARTIN

The Iron Mine, Port Henry,
New York
about 1862

Ports were busy with commerce, import and export. Factories were in full swing twelve hours a day, six days a week, producing goods for a rapidly expanding population. In the second half of the nineteenth century, Americans were more intent on what they produced than on what they would buy. The work they did, though it might today be dismissed as menial, required strength, skill, and expertise. The tintype portraits of common laborers, firemen, soldiers, and seamstresses, posed with the tools of their various trades, commemorate not only the individuals, but the strength found in the hands of the common working men and women. Their images recall the pride they took in their work and their contributions to the growth and prosperity of the nation.

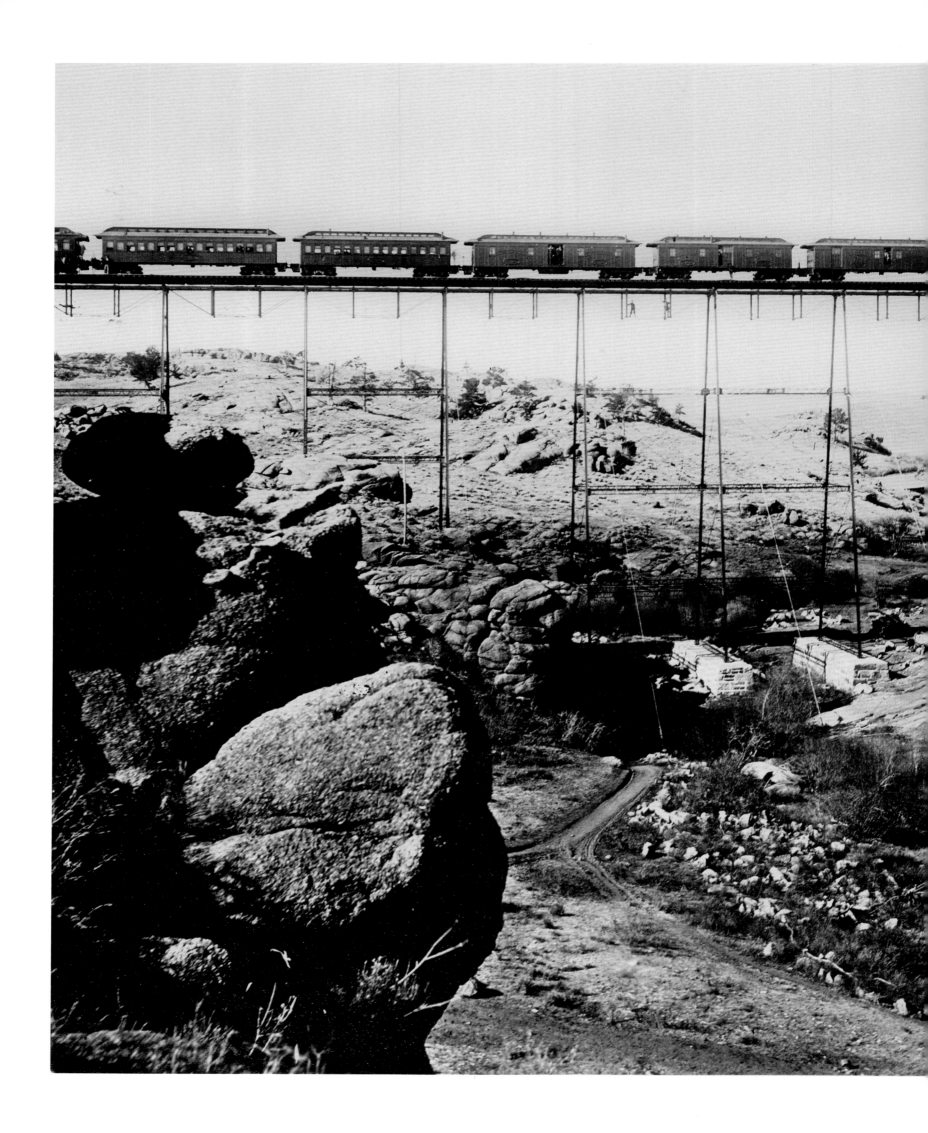

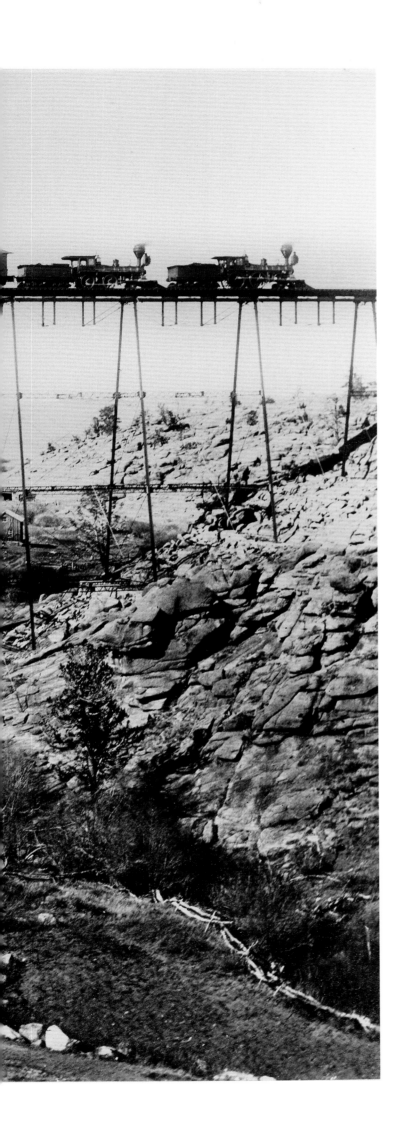

The project for construction of a great Railroad through the United States of America ... has been in agitation for over fifteen years. It is the most magnificent project ever conceived. ... It connects these two great oceans. It is an indissoluble bond of union between the populous States of the East, and the undeveloped regions of the fruitful West. It is a highway which leads to peace and future prosperity. An iron bond for the perpetuation of the union and independence which we now enjoy.

THEODORE DEHONE JUDAH
1857

◄

CHARLES ROSCOE SAVAGE
Dale Creek Bridge
about 1885

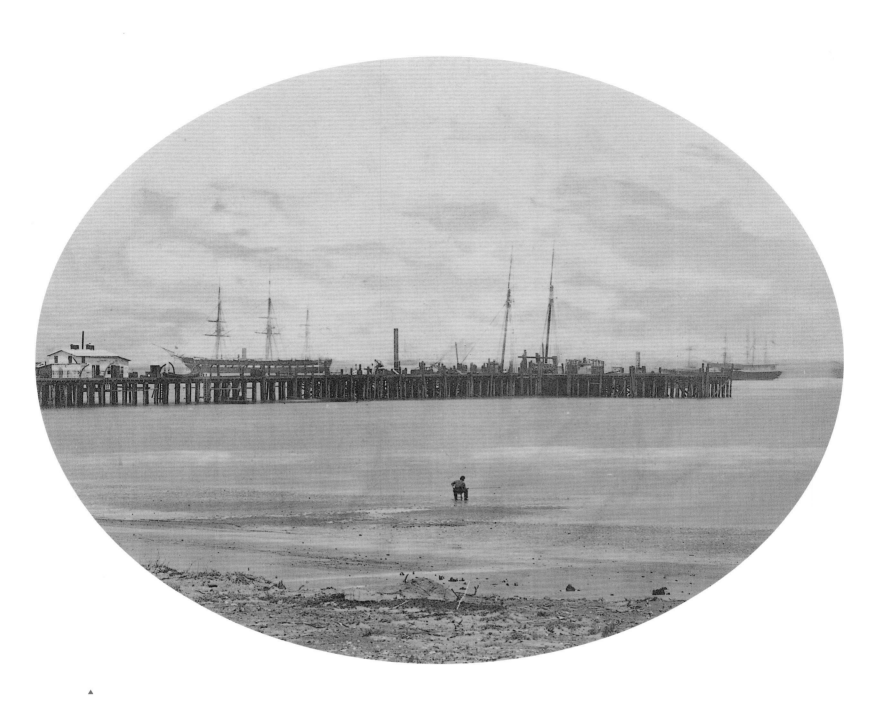

HENRY P. MOORE

Long Dock at Hilton Head,
Port Royal, South Carolina
1862

Give me the shores and wharves
heavy-fringed with black ships!

WALT WHITMAN
Leaves of Grass
1865

▲

SAMUEL W. SAWYER

River Drivers, Maine
about 1867

▶

UNIDENTIFIED ARTIST

Lighthouse and Harbor
about 1895

▶▶

JAMES BARD

Sarah A. Stevens
1873

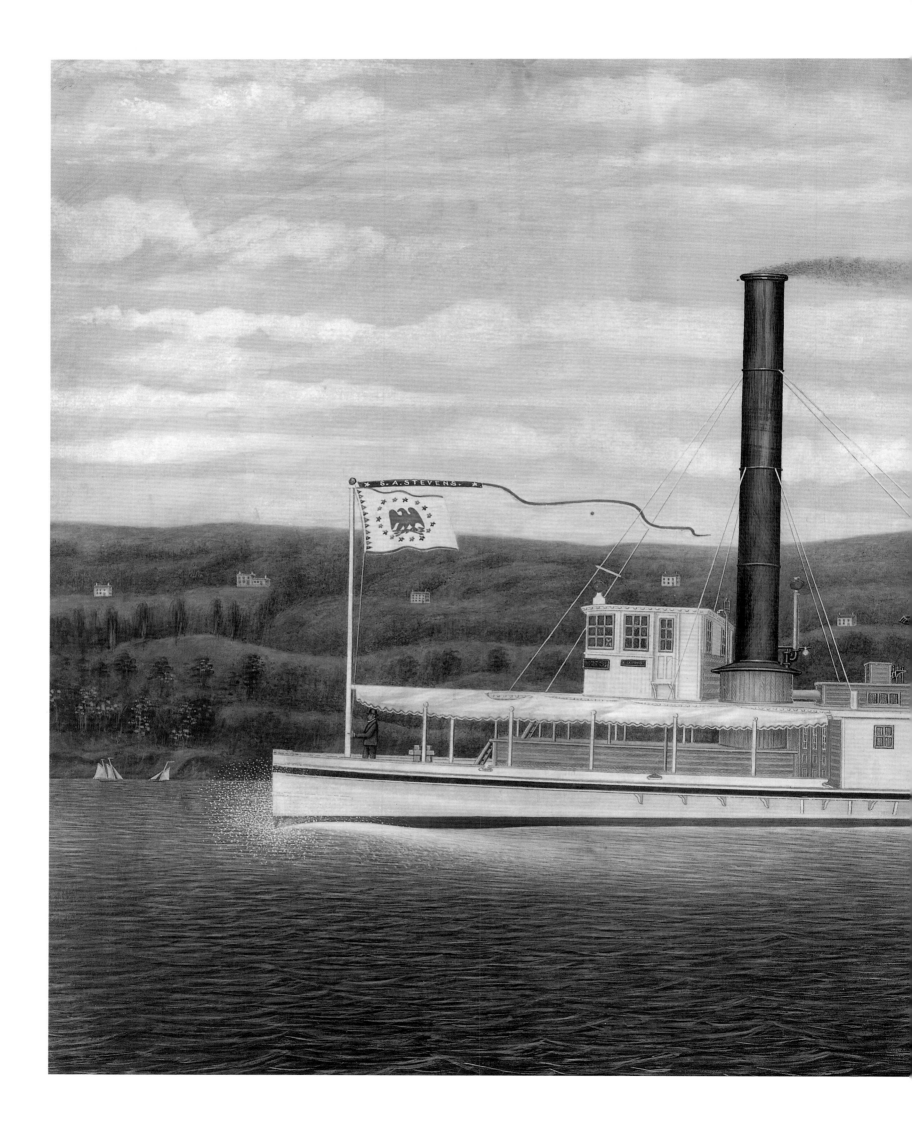

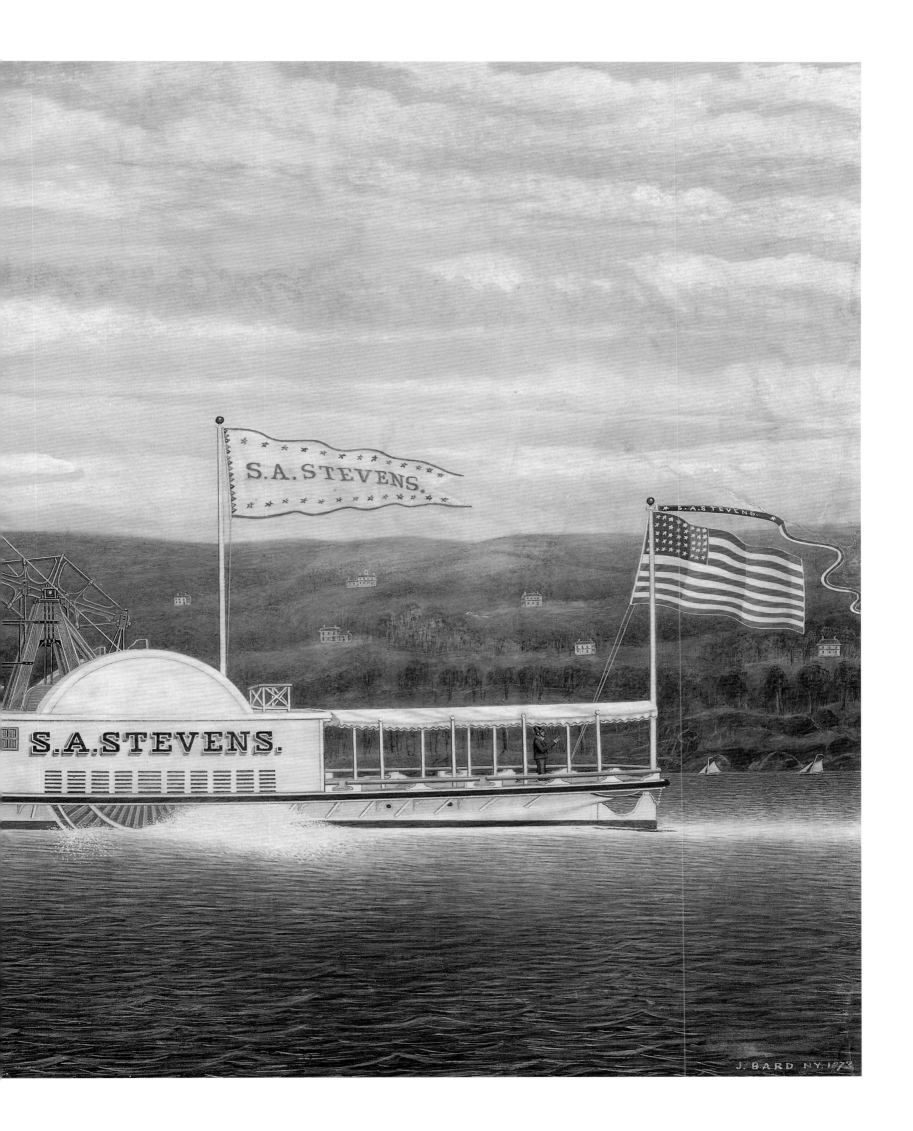

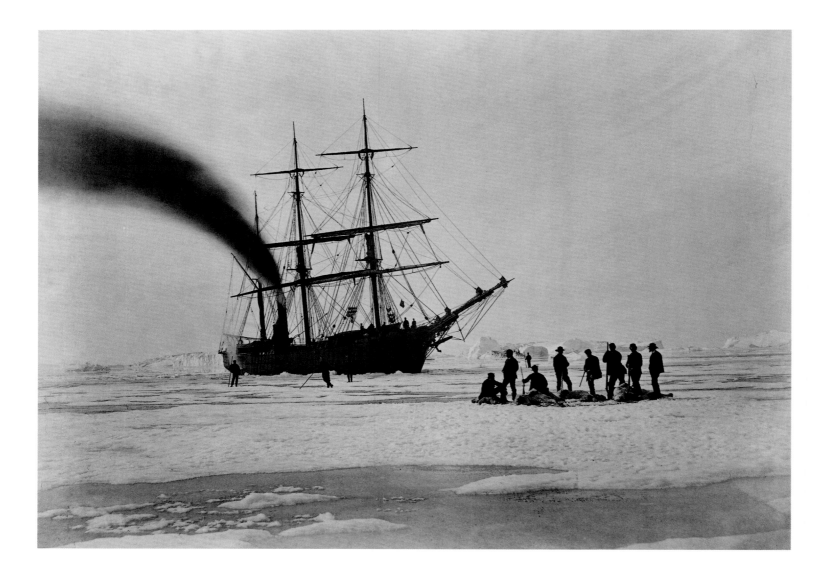

DUNMORE AND CRITCHERSON

Arctic Regions: Hunting by Steam
in Melville Bay, The Party after
a Day's Sport Killing Six Polar Bears
within the Twenty-Four Hours
1869, published 1873

. . . a whale-ship was my
Yale College
and my Harvard.

HERMAN MELVILLE
Moby-Dick
1851

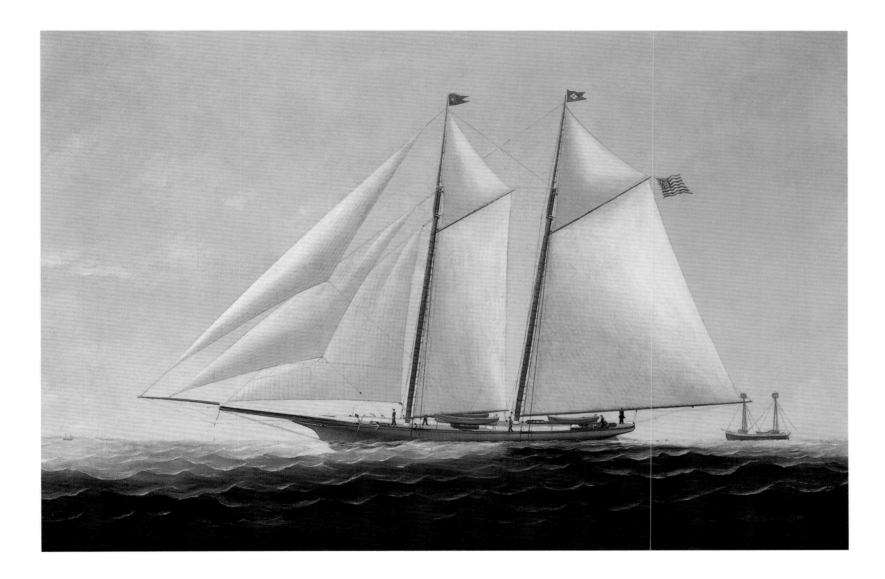

CHARLES S. RALEIGH

The Yacht America

1877

▶▶

SAMUEL COLMAN

Storm King on the Hudson

1866

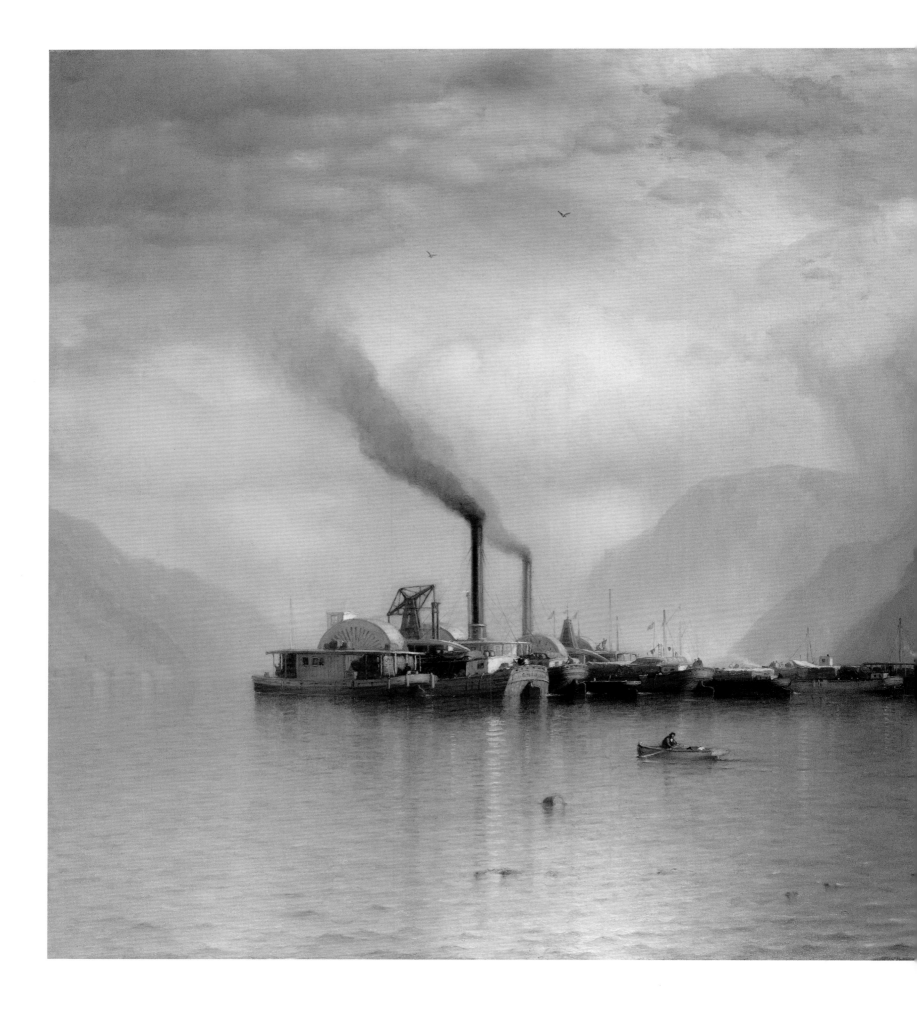

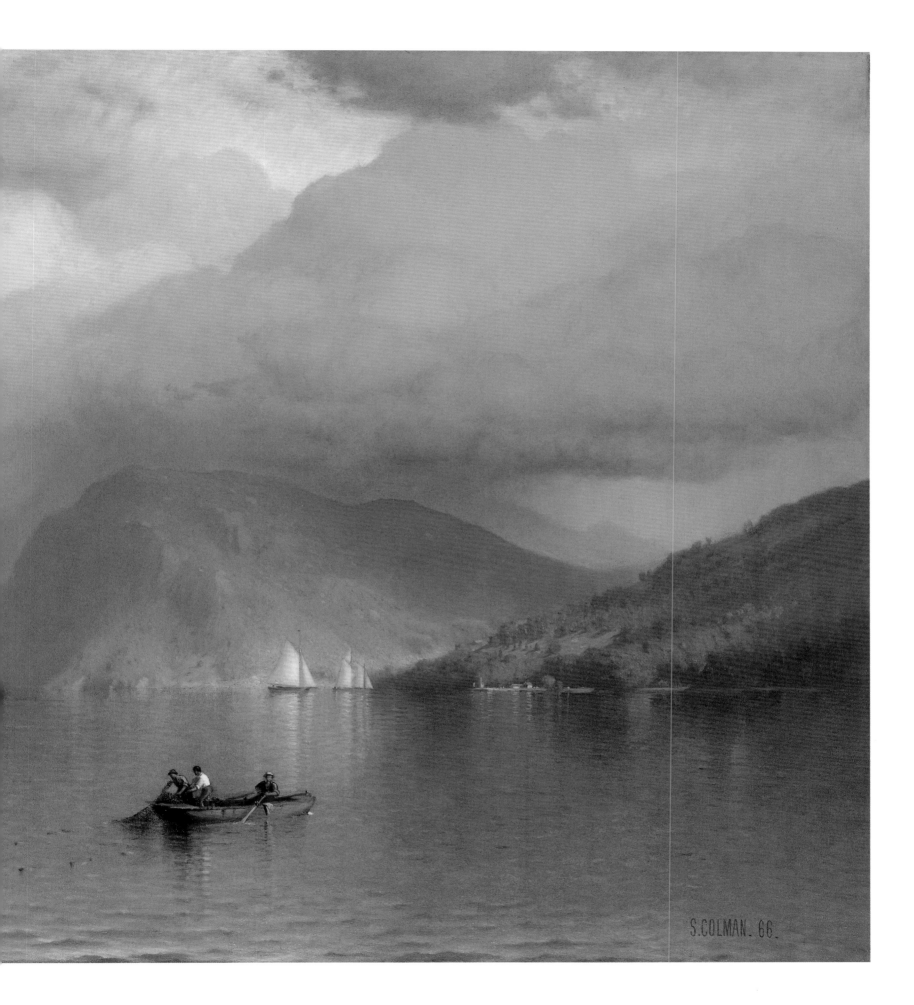

An Eye for Beauty

The second half of the nineteenth century saw the United States taking an increasingly important role on the international stage. It was a time of rapid economic growth; entrepreneurs made immense fortunes in railroads, coal, steel, and oil, and even in the infant financial markets of Wall Street. As the United States flexed its military muscle, the accumulation of wealth gave members of Boston and New York society the chance to expand their horizons. Businessmen who amassed enormous fortunes built great houses that needed furnishings and decoration. In the 1880s, George B. Post designed a palatial house for Cornelius Vanderbilt; he and his brother architects combined the Rococo, Gothic, and Renaissance styles in all their European variations with Middle Eastern and Asian elements with no apparent regard for historical or architectural accuracy. Such houses could not display too many crests, brackets, scrolls, finials, colors, or glazes. Interiors were crammed with Oriental carpets, gilded mirrors, tapestries, velvet drapes, upholstery, and chandeliers—and art.

Affluent young men and women made the "grand tour," acquiring some European polish along with a Parisian wardrobe, a journal full of impressions of foreign cities and scenes, and a sketchbook full of illustrative watercolors. These travelers were often seeking an antidote for daily life filled with the realities of business and commerce. In books and magazines, home life was idealized as a feminine sphere where in the evenings, comfort and beauty would renew the exhausted spirit that had spent its day toiling in the service of material gain. Travel was essential to the cultured individual; a home filled with beautiful objects acquired on a European trip signaled both the owners' cultural sophistication and their social status. Artists were happy to meet the demand of a new group of wealthy patrons.

I believe it is my duty

 to make money and still more money

 and to use the money I make

 for the good of my fellow man

 according to the dictates of my conscience.

JOHN D. ROCKEFELLER

1905

FREDERICK MACMONNIES

Venus and Adonis

1895

A lavish ball was emblematic of the accumulation and display of wealth at the turn of the century. Seven hundred guests of Bradley and Cornelia Martin assembled at the Waldorf-Astoria Hotel on February 10, 1897, for a fancy dress ball. Fifty of the guests came dressed as Marie Antoinette; the hostess wore a necklace that had belonged to that unhappy queen, and the host was dressed as Louis XV. Caroline Astor had gems worth $250,000 sewn into her dress, and J. P. Morgan attended dressed as Molière. Such ostentation did not go unnoticed by working-class New Yorkers; threats of violence prompted the police to hire Pinkerton detectives in case they needed reinforcements, and the windows of the hotel were nailed shut. Though the evening was a social success, comments in newspapers signaled a deepening divide between the socially prominent and the working classes.

In the last generation of the nineteenth century another chasm had opened between culture and the materialism of the business world. In fact, the role of women could be seen as both serving business through social relationships but also as civilizing and refining. In an idealized view of gender roles, women were assumed to exert power over men, urging them to acquire wealth and directing how money should be spent. Popular ladies' magazines assured women that their feminine role, to acquire culture for their families and safeguard it for the larger society, would be realized through the decisions they made as they created perfect homes and raised children.

The generation of painters that came of age at that time was also attracted to the cosmopolitan flair of European cities, which offered the chance to see and copy centuries' worth of painting and sculpture in great museums. Many began their studies in Philadelphia, Boston, Cincinnati, and New York, but many used American schools as stepping stones to European study. John White Alexander, Frank

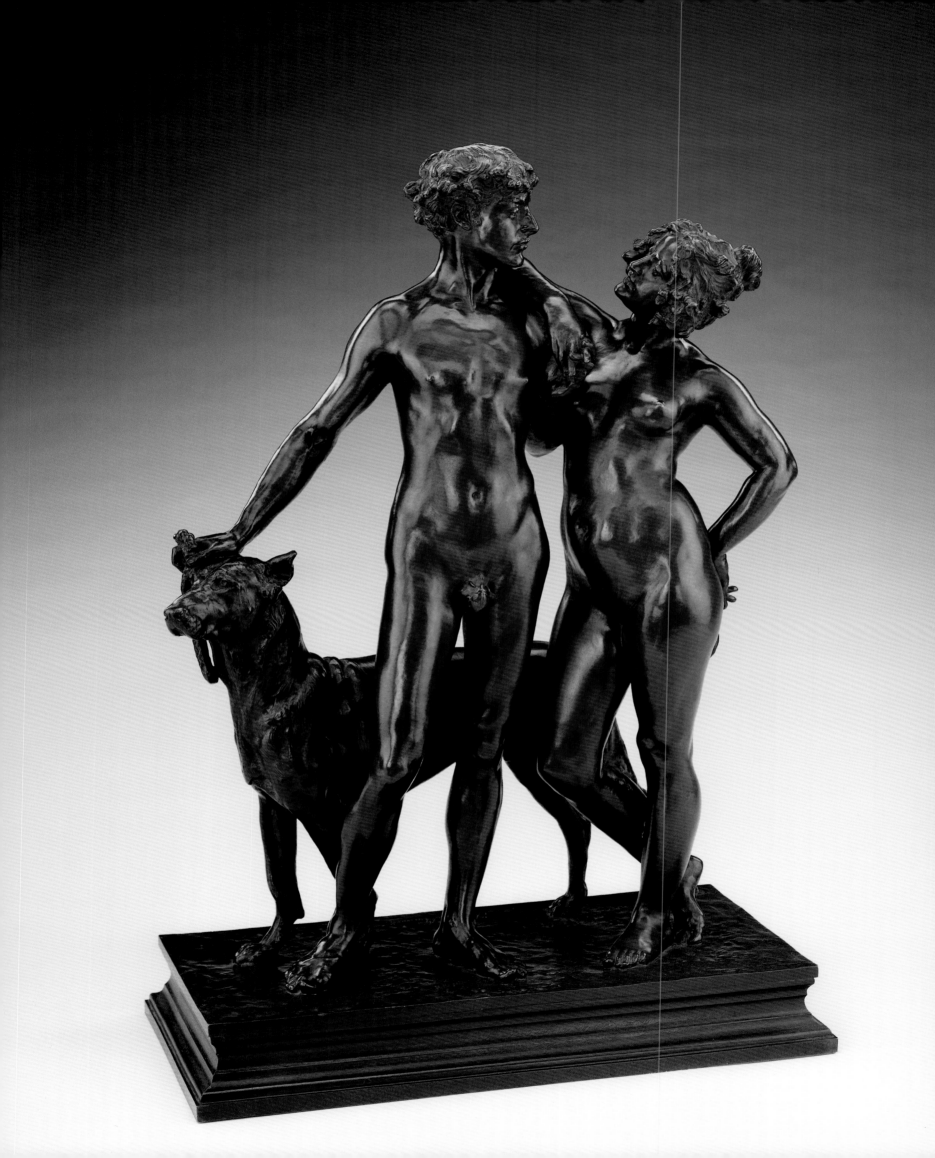

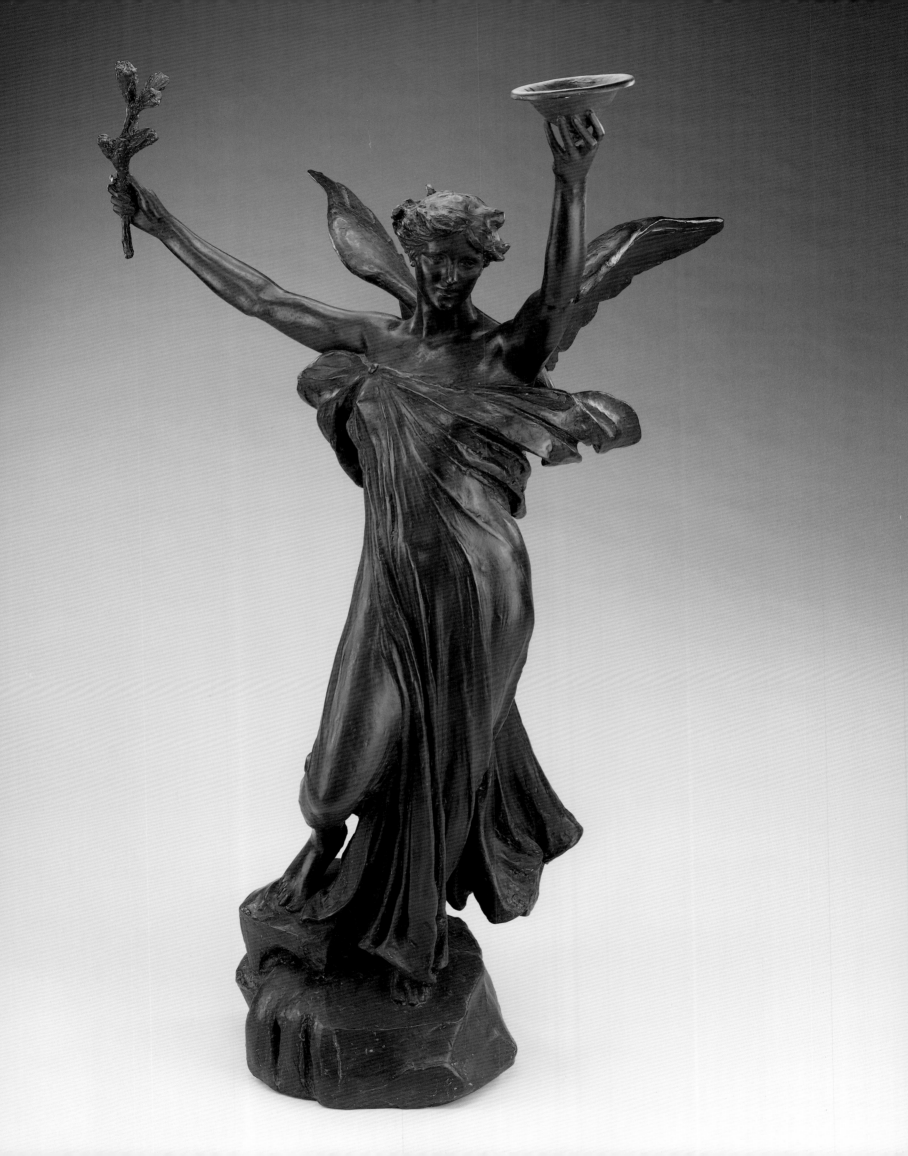

DANIEL CHESTER FRENCH

Spirit of Life

1914

Duveneck, William Merritt Chase, and John Twachtman all studied in Munich. Frank Benson, Edmund Tarbell, Childe Hassam, and George Hitchcock gravitated to the Académie Julian in Paris, which attracted many promising American painters; another group, including Birge Harrison and Julian Weir found places in the École des Beaux-Arts, also in Paris. Artists such as Kenyon Cox, William Merritt Chase, Thomas Dewing, and Abbott Thayer had gone to Paris and Munich, where they studied under masters who idealized the beauty of the female nude. When they returned to America in the 1880s, they continued this emphasis, which marked a shift from the portrayal of men in American painting. Women were alone or in groups, never working, rarely conversing—almost always in interiors or pale, diffuse landscapes. The exception was Mary Cassatt, who settled in Paris in 1866; her women are often caring for children.

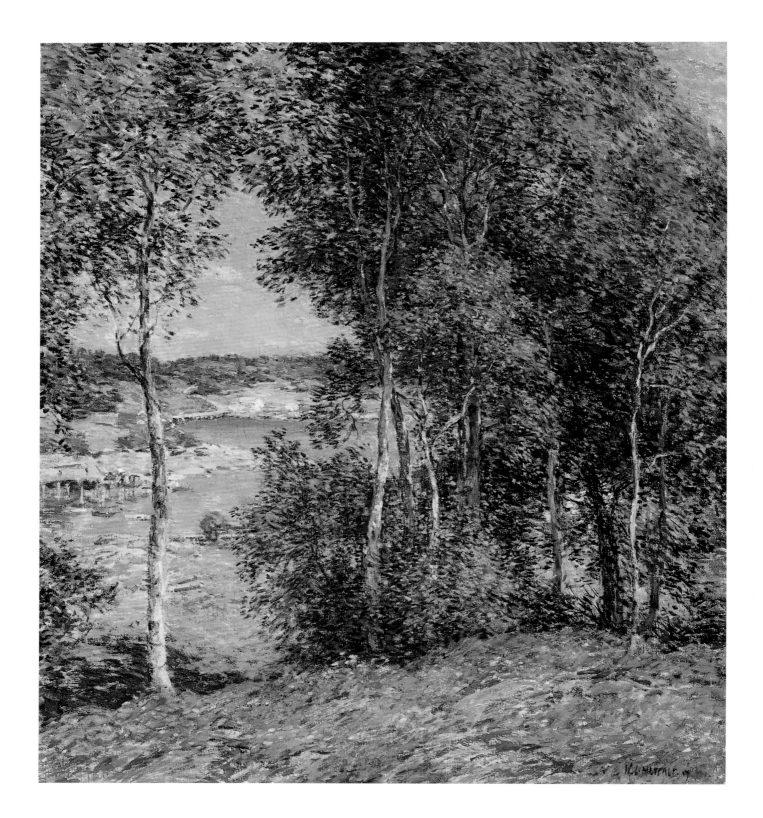

WILLARD L. METCALF

A Family of Birches

1907

These painters loved the romantic ideals of female beauty they encountered in Europe; but just as wealthy tourists made their sketches of the scenic landscapes from Brittany to the Swiss Alps to the Italian countryside, American painters offered idealized European landscapes to their patrons. They created romantic images of nature, portrayed as an eternal fountain that could refresh the parched soul. These landscapes were sometimes peopled by peasants, usually depicted as innocent, capable, and healthy—suggesting that a simple life lived in harmony with nature would lead to a utopian ideal.

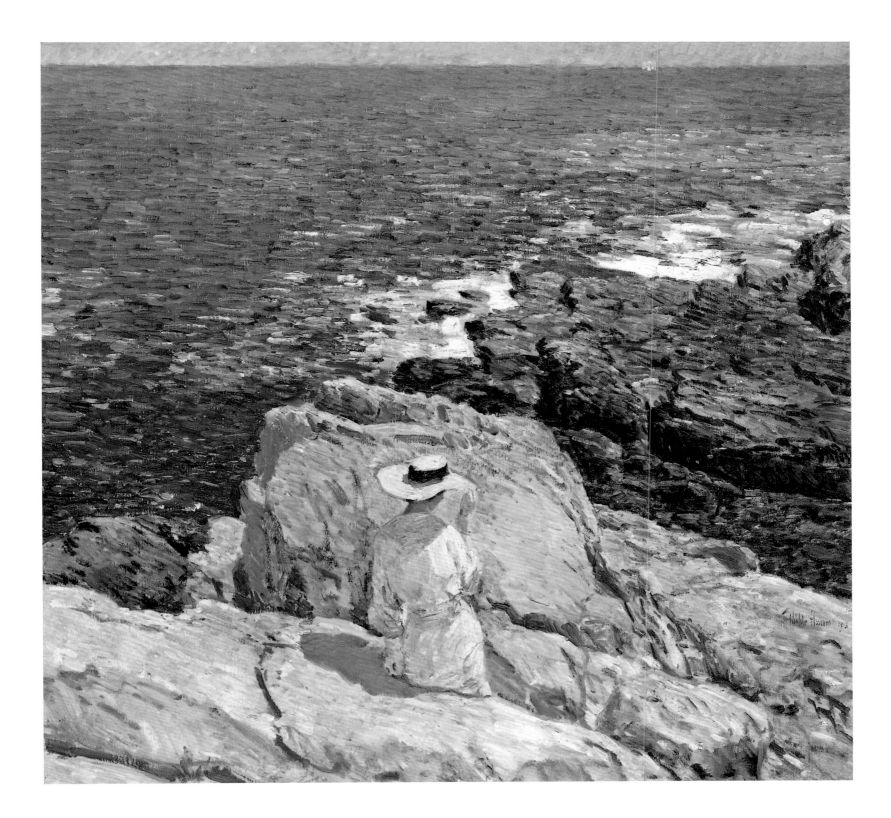

CHILDE HASSAM

The South Ledges, Appledore

1913

It is art that makes life, makes interest, makes importance ... and I know of no substitute whatever for the force and beauty of its process.

HENRY JAMES

Letter to H. G. Wells

1915

139

Tell them, dear, that if eyes were made for seeing,
Then Beauty is its own excuse for being:

▲

ABBOTT HANDERSON THAYER

Roses

1890

RALPH WALDO EMERSON

"The Rhodora"

1839

▶

ROBERT REID

The Mirror

about 1910

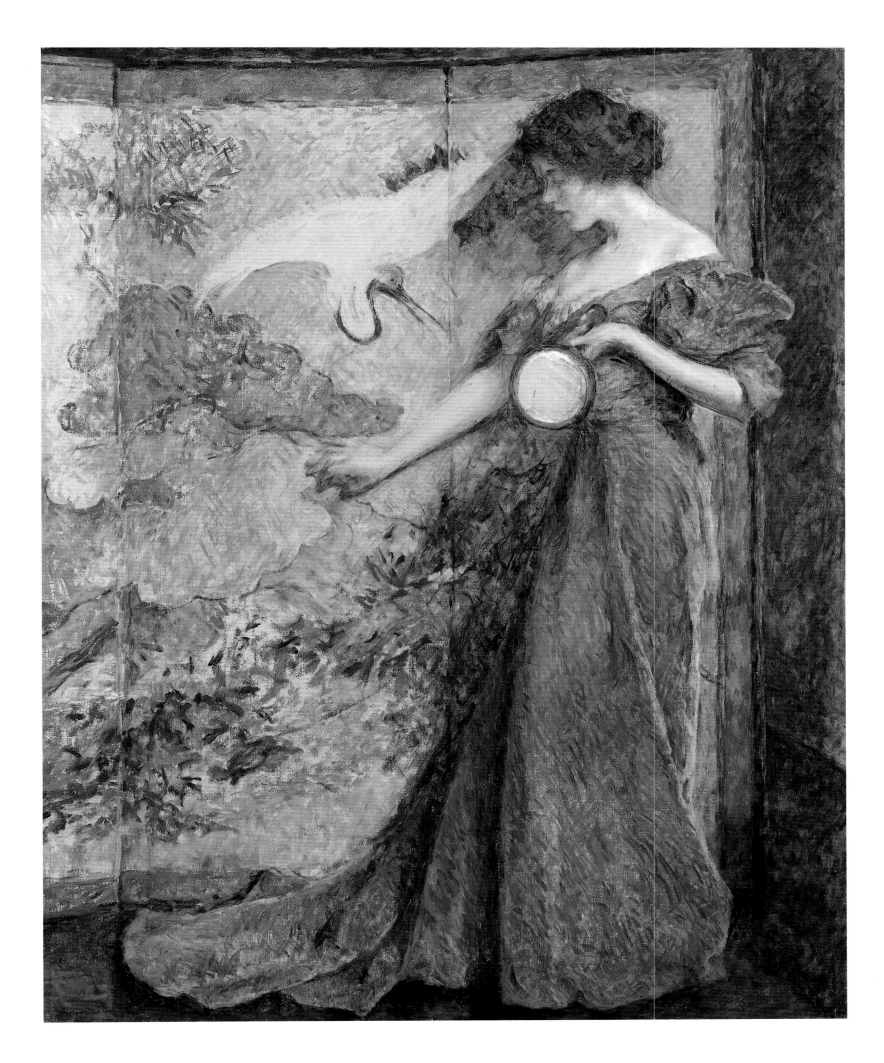

Augustus Saint-Gaudens
Diana
1889

▸

John Singer Sargent
*Elizabeth Winthrop Chanler
(Mrs. John Jay Chapman)*
1893

142

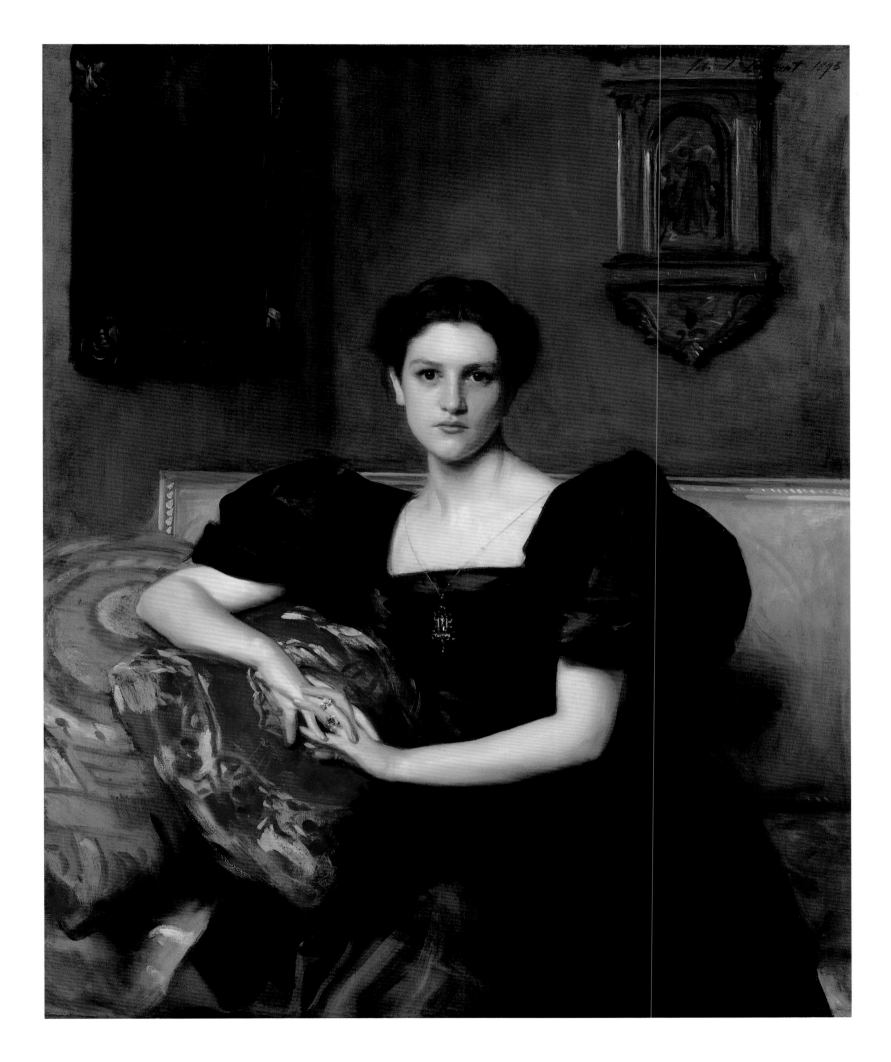

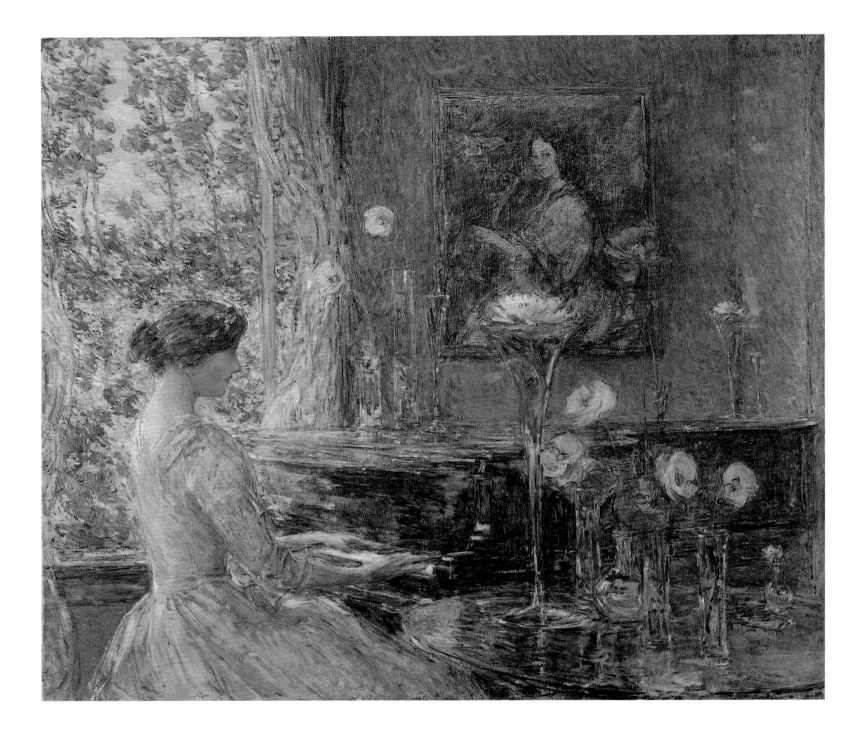

CHILDE HASSAM

Improvisation
1899

CECILIA BEAUX

Man with the Cat
(Henry Sturgis Drinker)
1898

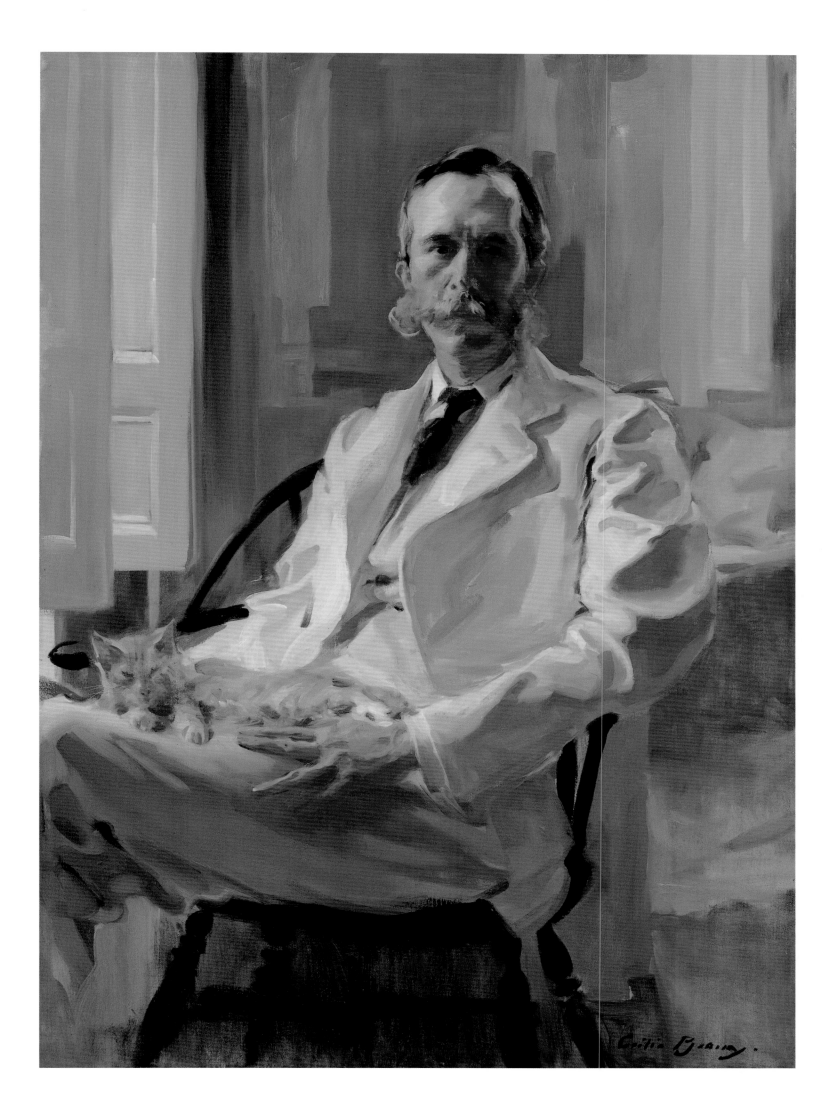

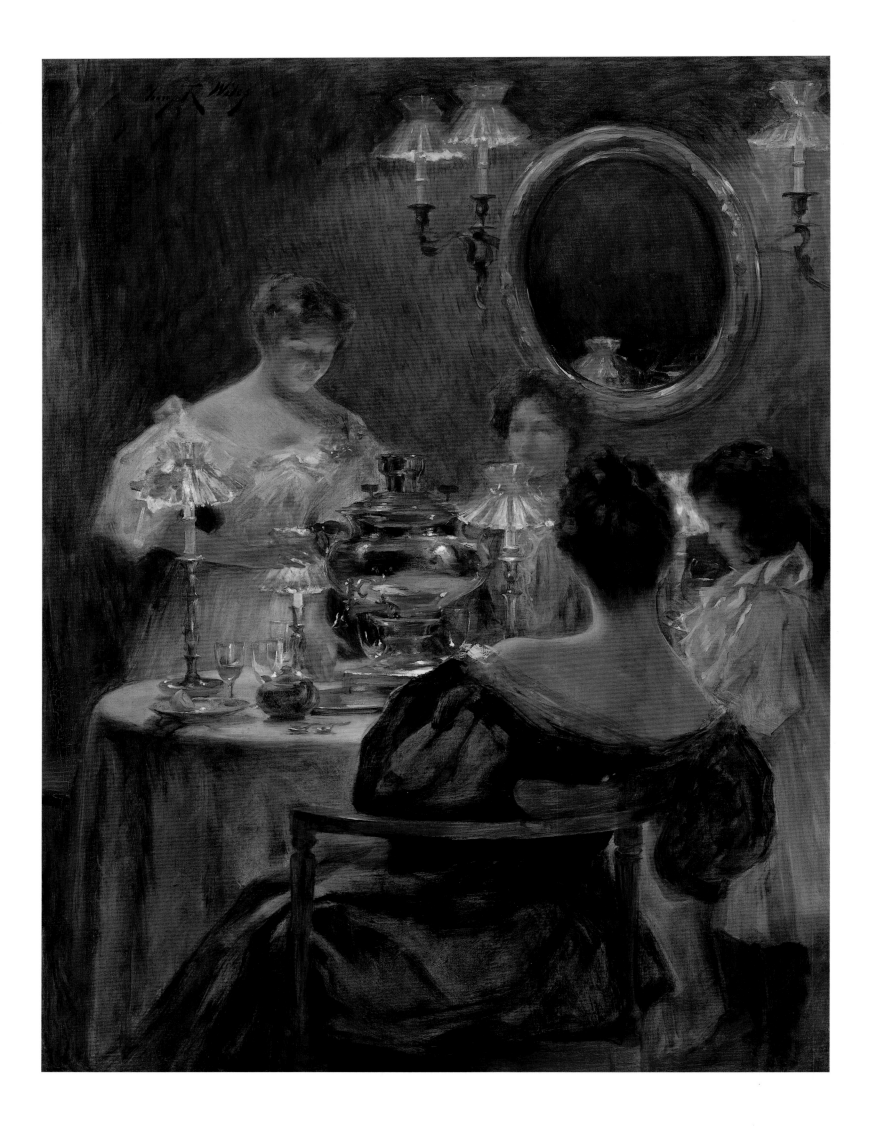

Tangier is a foreign land if ever there was one, and the true spirit of it can never be found in any book save The Arabian Nights.

MARK TWAIN
Innocents Abroad
1869

◄

LOUIS COMFORT TIFFANY
Market Day Outside the Walls of Tangiers, Morocco
1873

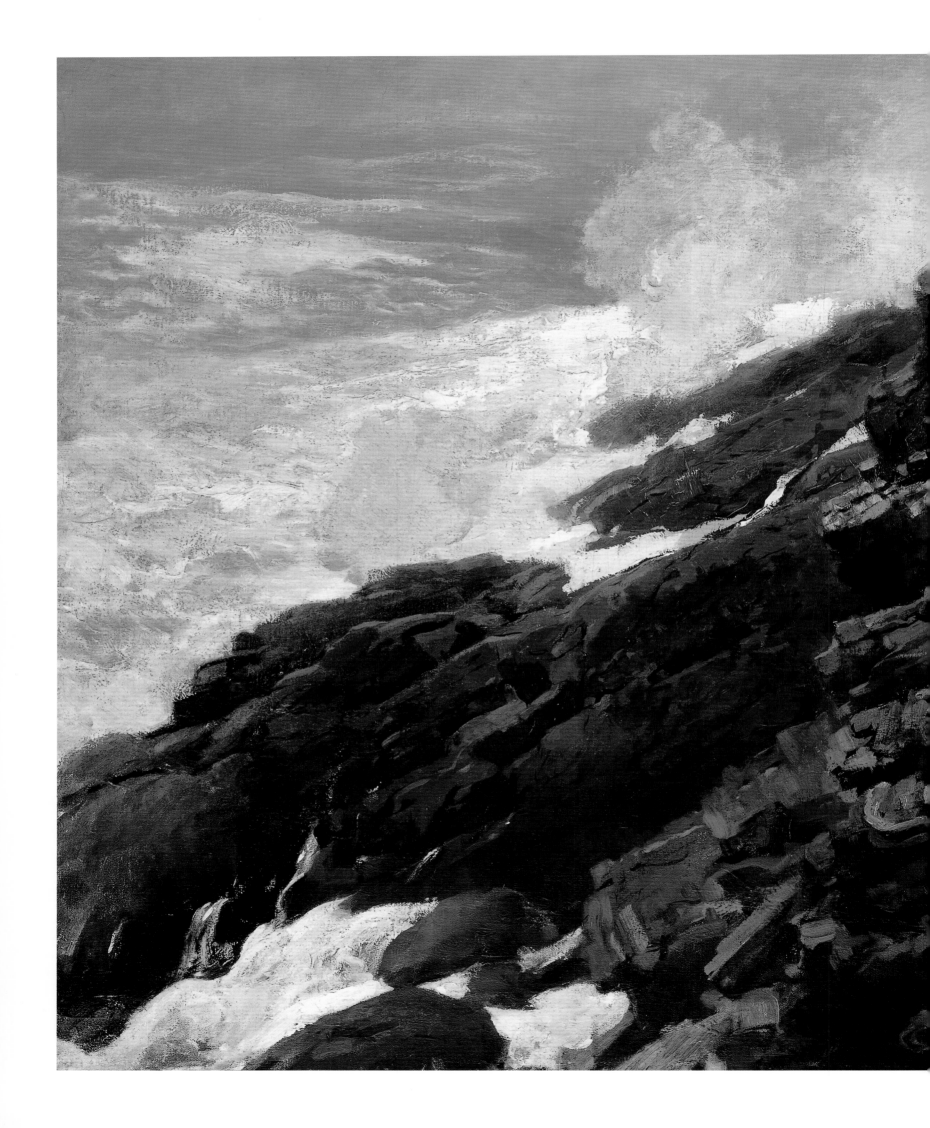

but it was only
the usual gray rock
turning the usual green
when drenched by the sea.

ROBERT LOWELL
"Water"
1956

◄

WINSLOW HOMER
High Cliff, Coast of Maine
1894

Seeing the City

During the early decades of the twentieth century, American cities, like their citizens, were completely transformed. From 1890 until about 1920, big business and progressivism waged a battle for the American soul against a backdrop of continuing immigration, labor unrest, urbanization, and enormous technological progress. Filled with new opportunities, electric lights, and a variety of entertainments, cities were more attractive than they had ever been.

Two inventions were critical to the birth of the vertical city: iron frame construction and the safety elevator. Iron frames, used to build huge single-story structures in Europe, were adapted in America to support multistory buildings. Asking businessmen to climb three stories was reasonable; six stories might be just possible; but the prospect of climbing twenty flights of stairs every day would have been daunting to the most fit. In 1851, Elisha Otis invented a ratchet device that prevented the cabin from falling if a cable failed—a mechanism that was soon a part of every safety elevator. The skyscraper was perfected not in New York but in the steel-framed office blocks designed by Louis Sullivan in Chicago. But East Coast cities quickly caught on. Urban life, which had existed almost entirely on a horizontal plane, reached skyward.

One of the tenets of capitalism proposed that the proper application of money, labor, and science would realize glorious projects, including factories, bridges, dams, railroads, and subways. Social theories of the time argued that the engineers who designed such projects, combining their understanding of physical laws with some Yankee ingenuity, were fulfilling their natural destinies even as they put capital to work for the benefit of their fellow man. The laborers who built these projects would find meaning in the work and became part of the system that would harness nature's power. The engineer's contributions were essential, but the power and glory

Send these, the homeless, tempest-tossed, to me;
I lift my lamp beside the golden door.

EMMA LAZARUS
"The New Colossus"
1883

rested with capital and the men who decided where to use it. Investment bankers and financiers, headquartered at the southern tip of Manhattan, saw to it that their city was among the first to benefit.

Not surprisingly, New York was itself the site for a spectacular public works project. The Brooklyn Bridge, completed in 1883, was the longest suspension bridge in the world. Its central span stretched for 1,595 feet between colossal buttresses pierced by Gothic arches, while webs of steel cable supported the spans. Its beauty inspired painters, poets, and photographers; but the transformation of New York was only beginning.

New York's five boroughs were incorporated under one authority in 1898. The city's powerful financial community was interested in creating a new kind of city, and they went to work. The first subway opened in 1904; its tunnels had to be hacked out of clay and rock, largely by Irish, Italian, and German immigrants, beneath an existing city. A cathedral worthy of the aspirations of modern commerce, Pennsylvania Station, completed in 1907, would welcome millions of rail passengers on the west side of Manhattan. By 1913, major streets and buildings were illuminated by electric lights, while automobiles mingled with pushcarts and horse-drawn carts.

Fashion magazines offered the latest in Paris and New York couture clothing and luxury goods. Along "Ladies' Mile" on Sixth Avenue, new shops stretched between Fourteenth and Twenty-third streets and offered a wealth of consumer goods, food, and clothing. Working-class women may have visited the stores on the Ladies' Mile, but they also frequented the ethnic stores and pushcarts of the Lower East Side. Upper Fifth Avenue north of Fiftieth Street was lined with the town houses of millionaires; every afternoon, well-bred horses drew impeccable carriages

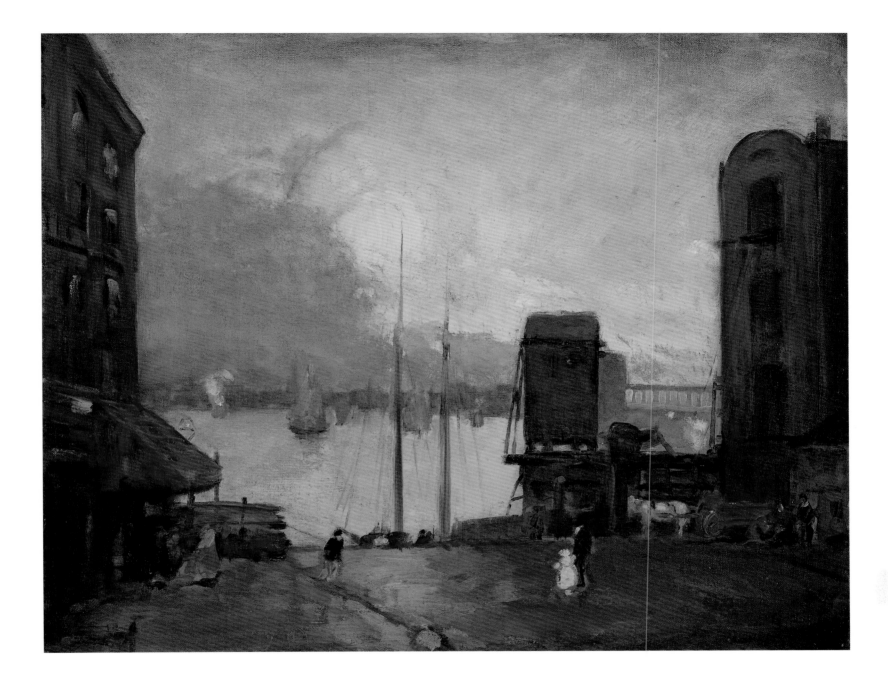

filled with beautiful women and well-dressed men through the east side of Central Park. Working men and women could not avoid seeing the affluence so proudly displayed, nor longing for a greater share of the fruits of their labors.

The city offered entertainment for every taste. Free concerts in the park were great favorites among German and Jewish immigrants, while rich and poor alike took the train to Coney Island to escape the heat of the city. Vaudeville appealed to the broadest range of immigrants, workers, and merchants; it combined comedy, melodrama, and ragtime piano with Tin Pan Alley tunes, popular song, and the occasional bit of parlor music or light opera. Audiences brought up on vaudeville quickly became avid consumers of moving pictures when they appeared in 1900.

The gulf between rich and poor had widened over the second half of the nineteenth century. Industrial accidents that took workers' lives were routine; hours

were long, wages were low, and working conditions were deplorable. In May 1902 the United Mine Workers called a strike in the anthracite coal fields of Pennsylvania. More than 140,000 workers laid down their tools; they struck for an eight-hour day, better pay, and recognition of their union. By autumn, rising prices and public pressure led President Theodore Roosevelt to try to arbitrate the dispute. Under a commission appointed by Roosevelt, the miners won a nine-hour day and half the pay increase they had demanded, and Roosevelt won credit for using the power of government to realize a public good.

This limited success was uncommon enough to be remarkable. Progressive reformers worked vigorously to address injustice and inequity where they saw it. Muckraking journalists such as Jacob Riis and Lincoln Steffens exposed the poverty common in tenements, the corruption of big business, and the filthy conditions in which meat was prepared for sale to an unsuspecting public. Settlement house workers provided training and practical help for new immigrants; they protested the dangers of work in steel mills, public works construction sites, and in cloth mills and clothing sweatshops. Their work was associated with the rise of socialism and unions, and also had roots in Christian principles. Theodore Roosevelt, who walked a line between sympathy with progressive ideals and a reverence for property, offered his take on the reformers in 1906: "So far as this movement of agitation throughout the country takes the form of a fierce discontent with evil, of a firm determination to punish the authors of evil, whether in industry or politics, the feeling is to be heartily welcomed as a sign of healthy life."

Reformers were outraged by the practice and implications of child labor. Even the youngest could carry bundles and messages from one factory or business

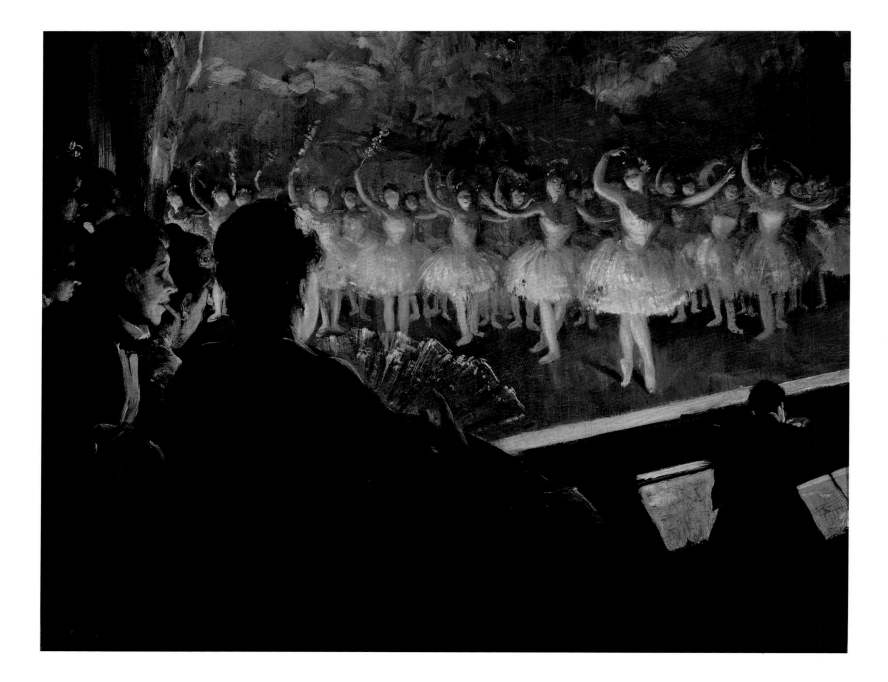

EVERETT SHINN

The White Ballet
1904

to the other; cloth mills employed children as young as five and six years old, valued for their small and nimble fingers. For more than a decade, progressives struggled to pass child labor laws that would get children out of factories and into schools. Jane Addams defied convention when she left the genteel comfort of the parlor to live among the poor. She worked to improve the lives of Russian Jews, Greeks, Italians, and Bohemians in the Chicago neighborhood surrounding Hull House, which she founded in 1899. The infamous Carrie Nation led a nation-wide campaign against the devil drink. She was arrested more than thirty times for smashing saloons, but her crusade succeeded when Prohibition went into effect in January 1920.

The progressive movement also included the women who marched to demand suffrage. They hoped to transform society, to realize an American utopia. The

ELIE NADELMAN

Dancer
about 1918–19

reformers accomplished a great deal: during Woodrow Wilson's administration, while World War I was being fought in Europe, they managed to enact Prohibition, gained the vote for women, and expanded the income tax. These reformers all believed that national problems could be solved with the application of a judicious measure of ingredients, including modern science, education, regulation, elbow grease, and soap.

Artists captured the transformation of the cities and took their subjects from every corner of urban life. Known retrospectively as the Ashcan school, several of them had cut their artistic teeth illustrating popular newspapers. Assignments took them to every neighborhood, and the ability to work on the street and rapidly produce faithful sketches was invaluable. Such training affected their painting style and the subject matter. The new generation of politically conscious painters portrayed the city in all of its grit and glorious beauty.

GUY PÈNE DU BOIS

Shovel Hats

1923

MAHONRI YOUNG

Right to the Jaw

1926–27

163

While there is a lower class, I am in it, while there is a criminal element, I am of it, and while there is a soul in prison, I am not free.

EUGENE V. DEBS
1918

▲

JOHN FRANK KEITH

Boys on Steps, Kensington, Philadelphia
about 1925

◄

EVERETT SHINN

Eviction (Lower East Side)
1904

▲

OSCAR BLUEMNER

Evening Tones

1911–17

▶

MAX WEBER

Foundry in Baltimore

1915

166

Max Weber 1915

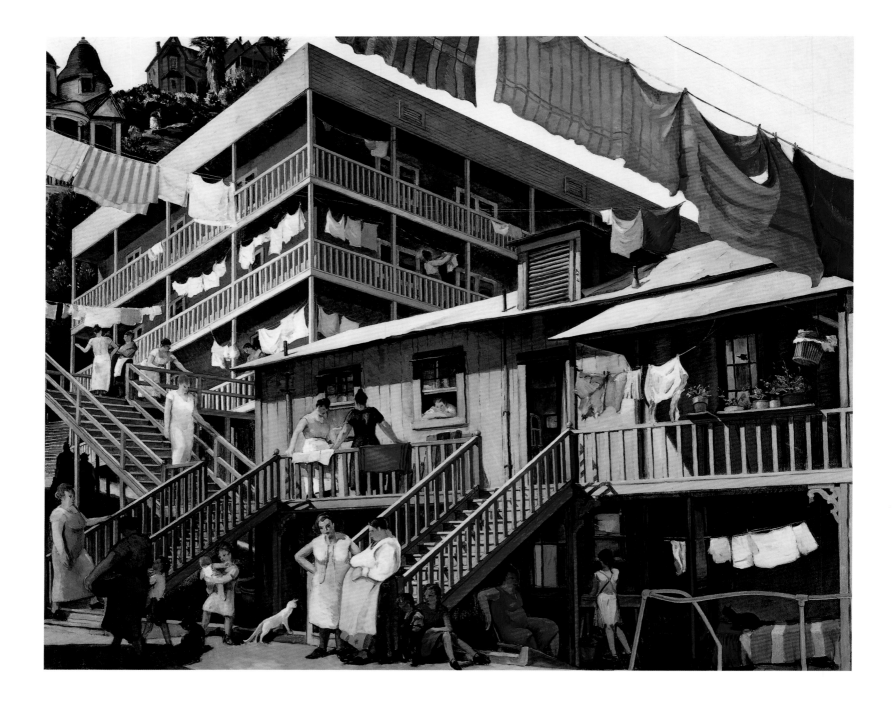

MILLARD SHEETS

Tenement Flats

about 1934

The true line to be drawn between pauperism
and honest poverty is the clothesline.
With it begins the effort to be clean
and the best evidence of a desire to be honest.

JACOB RIIS
How the Other Half Lives
1890

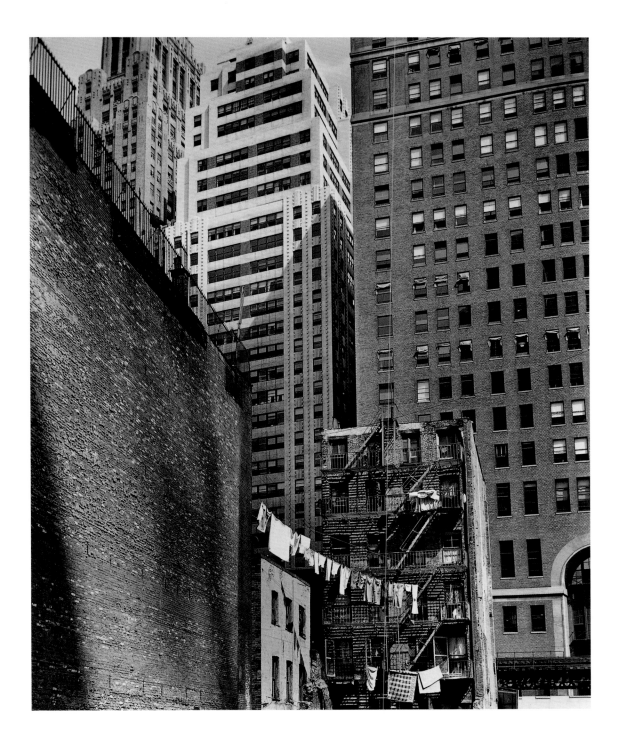

▸

BERENICE ABBOTT

Washington Street no. 37
Manhattan, from the series
Changing New York
1936

169

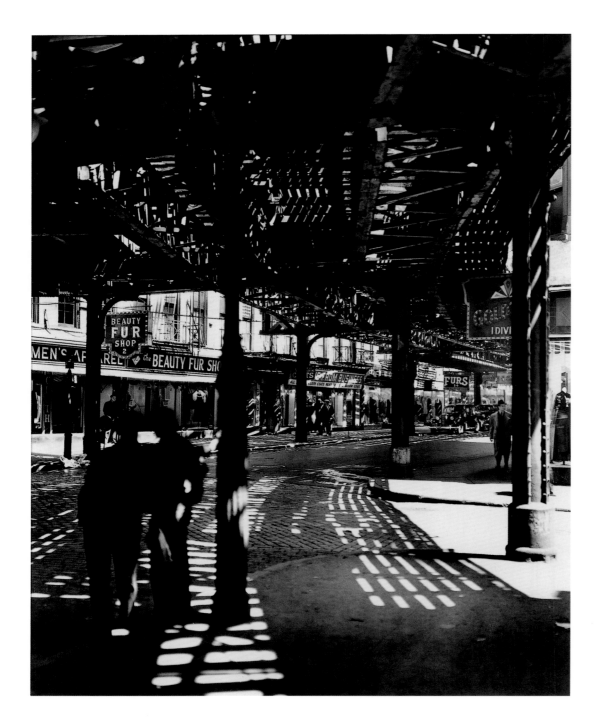

BERENICE ABBOTT

"El" Second and Third Avenue
Lines; Bowery and Division Street,
Manhattan, from the series
Changing New York
1936

▶

GEORGIA O'KEEFFE

Manhattan
1932

Grab your coat and get your hat,
Leave your worry at the doorstep
Just direct your feet
To the sunny side of the street

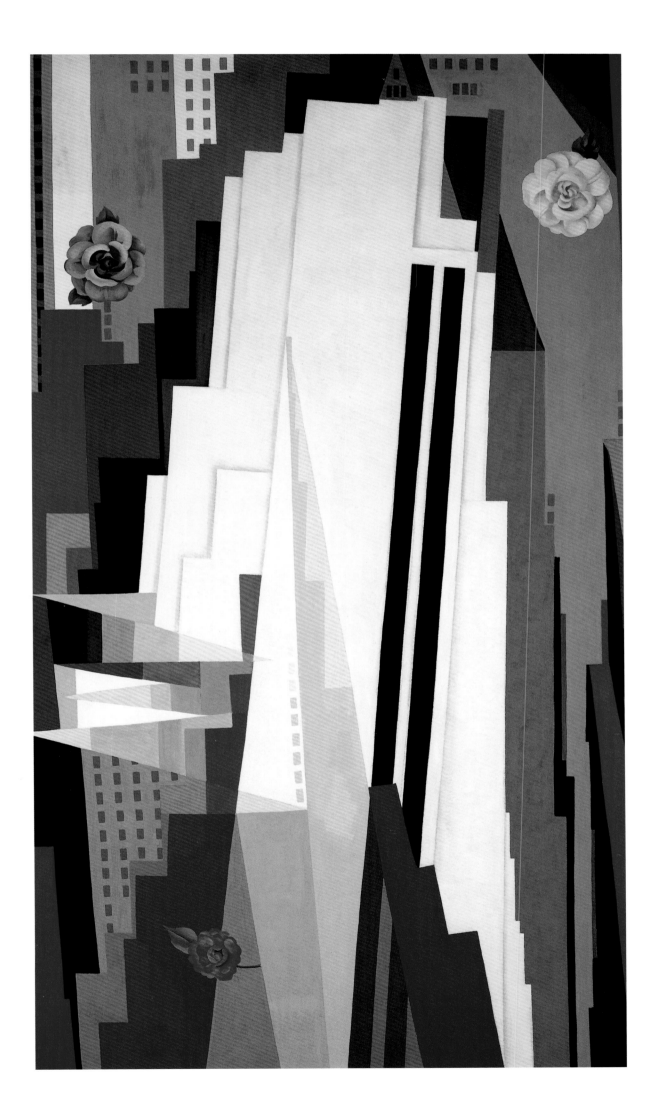

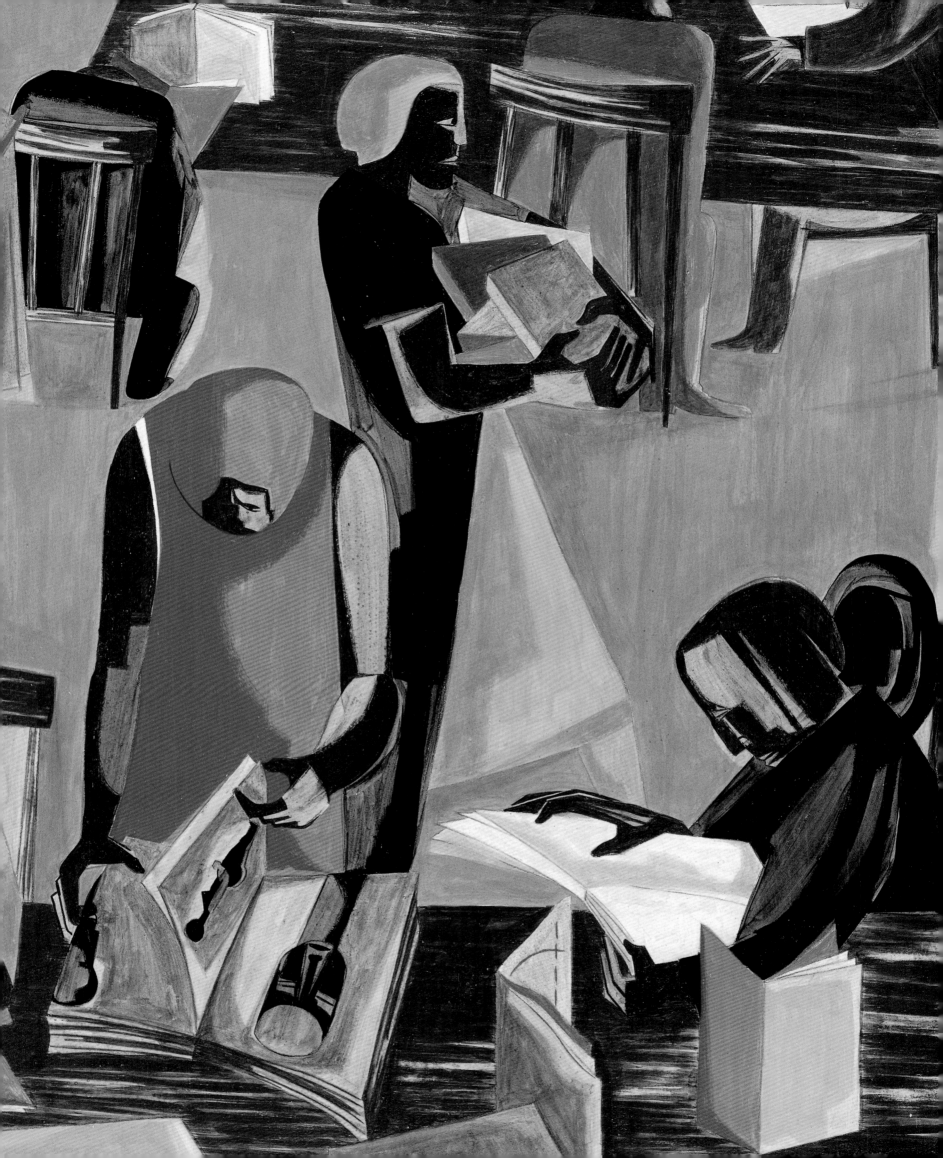

The Harlem Renaissance

CHAPTER TEN

Harlem was the place to be in the 1920s and 1930s. New York was the destination of tens of thousands of migrants from the South, but it was more than just a physical location—it was a racial haven, a place of self-discovery, cultural awareness, and political activism. It nourished an artistic flowering of unprecedented richness. It was literature, painting, and music; it was movies, poetry, and jazz. And for white visitors from downtown, Harlem offered a touch of the exotic close to home.

In the generation following Reconstruction, black political leaders emerged in the South. The civil and economic oppression of former slaves through a harsh and weighted legal system and through the informal terror imposed by such organizations as the Ku Klux Klan cried out for redress. Booker T. Washington, determined to end the conditions that kept many Southern blacks illiterate and poor, founded the Tuskegee Institute in Alabama and wrote his great manifesto, *Up From Slavery*, in 1901. Washington believed that African Americans would change their circumstances only through education, and that white prejudice would melt away in the face of self-improvement and quiet success. Two years later, in 1903, W. E. B. Du Bois published his own summary of racial struggle, *The Souls of Black Folk*. In his writings Du Bois explored urban and rural sociology and propounded a social theory of race. He articulated "the problem of the color line" as one of the major issues of the twentieth century. Whether they stayed in the South or migrated northward, blacks could be seen as defining themselves according to Washington's vision of agricultural enterprise or Du Bois's modern urbanism.

In 1905 the apartment blocks and brownstones of Harlem were opened to black residents. Between 1900 and 1940, the black population of the five boroughs of Manhattan rose from 60,000 to more than 400,000. Black soldiers returning from

Let the blare of Negro jazz bands and the bellowing voice of
Bessie Smith singing Blues penetrate the closed ears
of the colored near-intellectuals until they listen
and perhaps understand.

LANGSTON HUGHES
1926

World War I flocked to Harlem—perhaps initially as a stopping off point on their way back home. In their travels abroad they had experienced the freedom offered in European cities and had seen the popularity of American jazz in Paris and London. The excitement of this new life was unimaginable in the small towns of the South, so many remained in New York. This largely transplanted community faced two enormous tasks: to explore the cultures and civilizations of Africa, and to redefine the black experience in the United States.

The 135th Street Library was the cultural linchpin of Harlem. It was a resource for artists and thinkers, a meeting place, the site of fierce intellectual debates, and a venue for plays and musical performances. Just a few blocks away, in offices at 70 Fifth Avenue, Du Bois edited *The Crisis*, a magazine for the National Association for the Advancement of Colored People, which had been founded in 1909. He was also busy writing sociological studies, preparing lectures and, through *The Crisis*, suggesting art as a supplement for direct political action. The magazine's writers and editors hoped that black artists, offering something both modern and primitive, would be embraced by an American culture that had until now either ignored them or relegated them to stereotypical roles, such as that of faithful servant.

The concentration of black men and women in Harlem produced a lively scene. The accumulation of books, journals, and ideas sparked interest in African music, images, and history. In a cosmopolitan community people expressed their enthusiasm for this new life through jazz, dance, theater, art, and writing. Some, like the poet Countee Cullen, were Harlem born; others like James Weldon Johnson came from the South or even, in the case of Claude McKay, from the West Indies.

Aaron Siskind

Parade, from the Photo League
Feature Group project *Harlem
Document*
1937, printed later

Langston Hughes, born in Joplin, Missouri, became one of Harlem's principal
voices. When Alain Locke published *The New Negro* in 1925, Harlem's political and
cultural facets gained a sharper focus. Contributions by Jack W. Johnson, Countee
Cullen, and Zora Neale Hurston spoke of the black experience, but the book offered
far more than a record of daily life with its joys and sorrows. Locke, influenced by
Alfred Stieglitz, sought to reestablish art as the core of Negro life. He argued that
African Americans should express an African art uncontaminated by the industrial
age, rooted in pure ethnic craft and tradition. Through *The New Negro*, he called on
African Americans to accomplish this task.

AARON SISKIND

Market, 8th Avenue and 135th Street, Harlem
before 1936, printed later

An important political alternative to Locke's vision was that of Marcus Garvey, whose Universal Negro Improvement Association insisted on race pride and advocated that African Americans return to Africa. His rallies and marches were both a political and social focus for Harlem in the early years of the 1920s. Though the divide between black and white in America seemed too deep to overcome, a complete transplant of the race was even more unlikely, and Garvey's UNIA collapsed in 1924.

James VanDerZee was the semiofficial photographer of Harlem's life and people. His images traveled throughout the country in magazines and book illustrations. VanDerZee had a portrait studio, but he also worked on the street, recording the details of everyday life, both political and personal. His images helped disseminate the concepts articulated by Du Bois, Locke, and Garvey, both in Harlem and beyond.

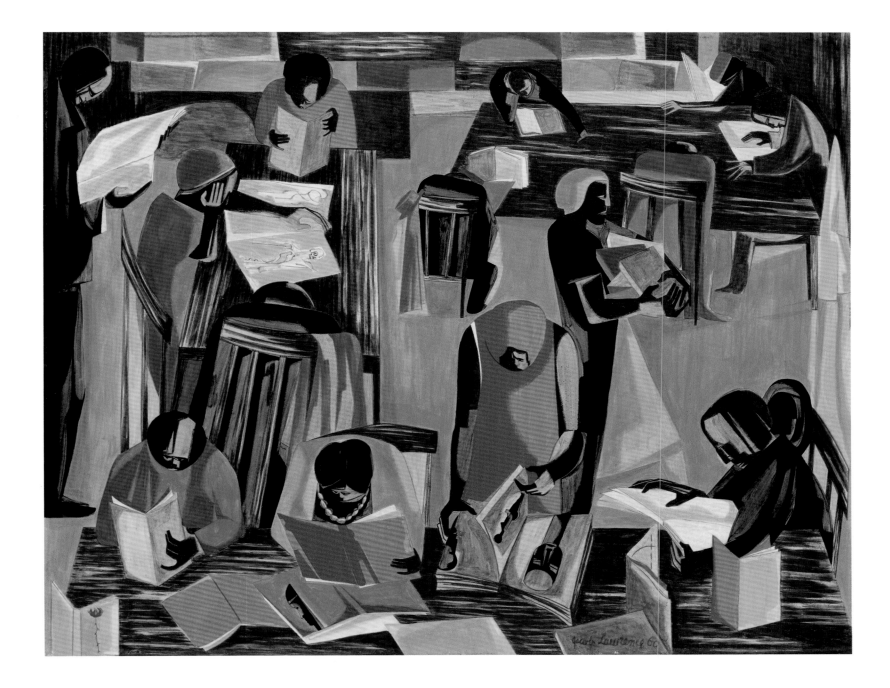

JACOB LAWRENCE

The Library

1960

Harlem attracted not only writers, but innumerable dramatists, musicians, sculptors, and painters. Aaron Douglas arrived in Harlem in 1924; Peyton Cole Hedgeman, also known by the pseudonym Palmer Hayden, produced a large body of work that combined references to Africa and America. Malvin Gray Johnson, who migrated north from Greensboro, North Carolina, emphasized the resemblance of his features to those of an African mask in his self-portrait. Augusta Savage produced images that ranged from street urchins to idealizations of the African muse, and ran a series of schools for budding artists over more than a decade. In addition to references to African motifs, these artists produced work infused with rhythm and sensuality. Their influence resonates far beyond the place and time in which they worked; it has been felt throughout the century and the whole of American culture.

I've known rivers:

I've known rivers ancient as the world and older than the flow
 of human blood in human veins.

My soul has grown deep like the rivers.

LANGSTON HUGHES

"The Negro Speaks of Rivers"

1921

◄

CARL VAN VECHTEN

PRINTED BY RICHARD BENSON

Fredi Washington, from the series
*Noble Black Women: The Harlem
Renaissance and After*

1933

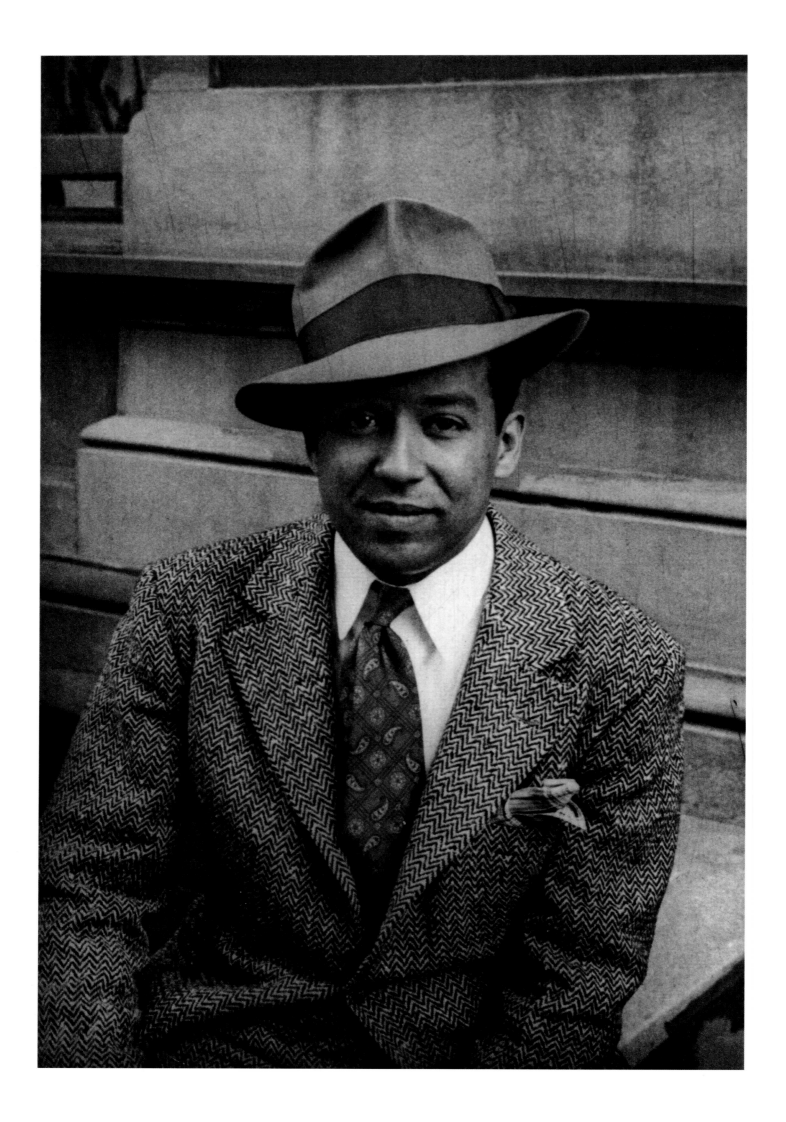

I am a man of substance, of flesh and bone, fiber and liquids—and I might even be said to possess a mind. I am invisible, understand, simply because people refuse to see me.

RALPH ELLISON
Invisible Man
1952

▶

AUGUSTA SAVAGE
Gamin
about 1929

◀

CARL VAN VECHTEN
PRINTED BY RICHARD BENSON
Langston Hughes, from the series
*O Write My Name: American
Portraits, Harlem Heroes*
1939

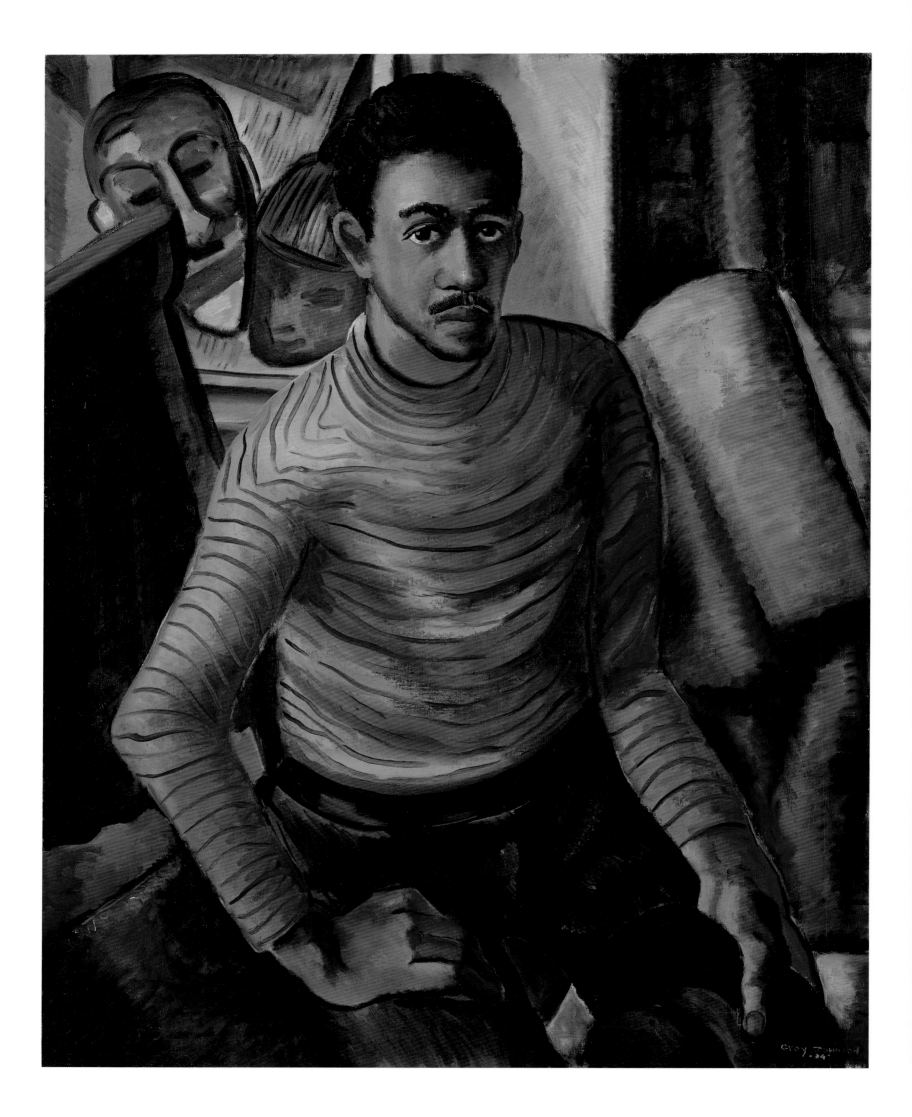

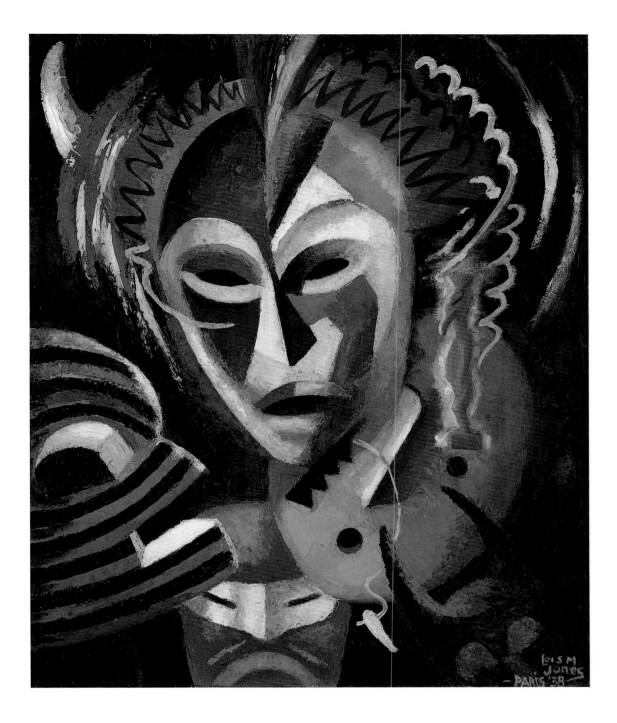

▶

Lois Mailou Jones

Les Fétiches

1938

◀

Malvin Gray Johnson

Self-Portrait

1934

One three centuries removed
From the scenes his father loved,
Spicy grove, cinnamon tree,
What is Africa to me?

Countee Cullen

"Heritage"

1925

183

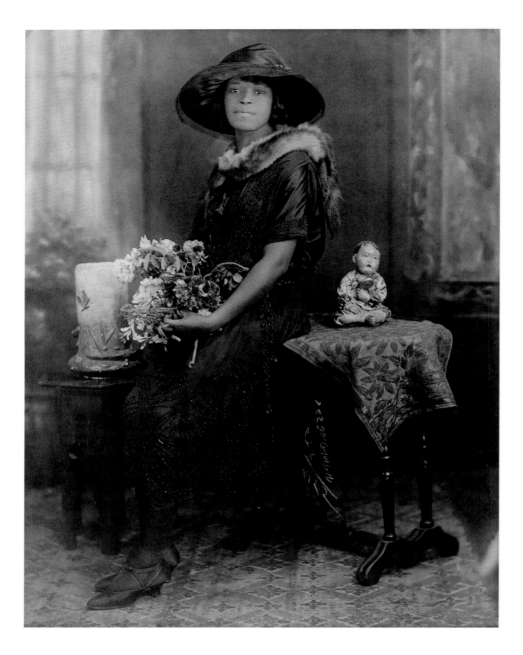

▲

JAMES VANDERZEE

Evening Attire

1922

▶

WILLIAM H. JOHNSON

Café

about 1939–40

This is mine...Listen! How sad and gay it is.
Blue and happy—laughing and crying...
How white like you and black like me...
These are the blues.

LANGSTON HUGHES

"The Blues I'm Playing"

1934

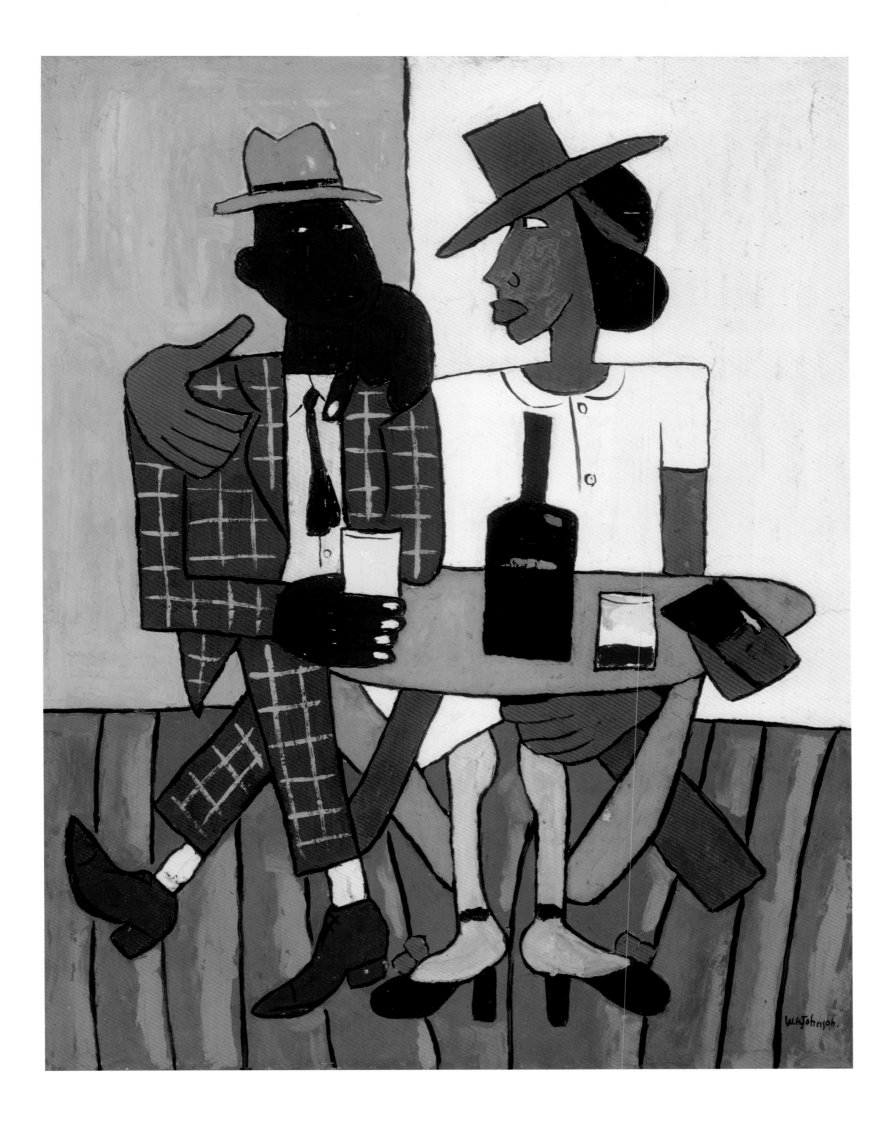

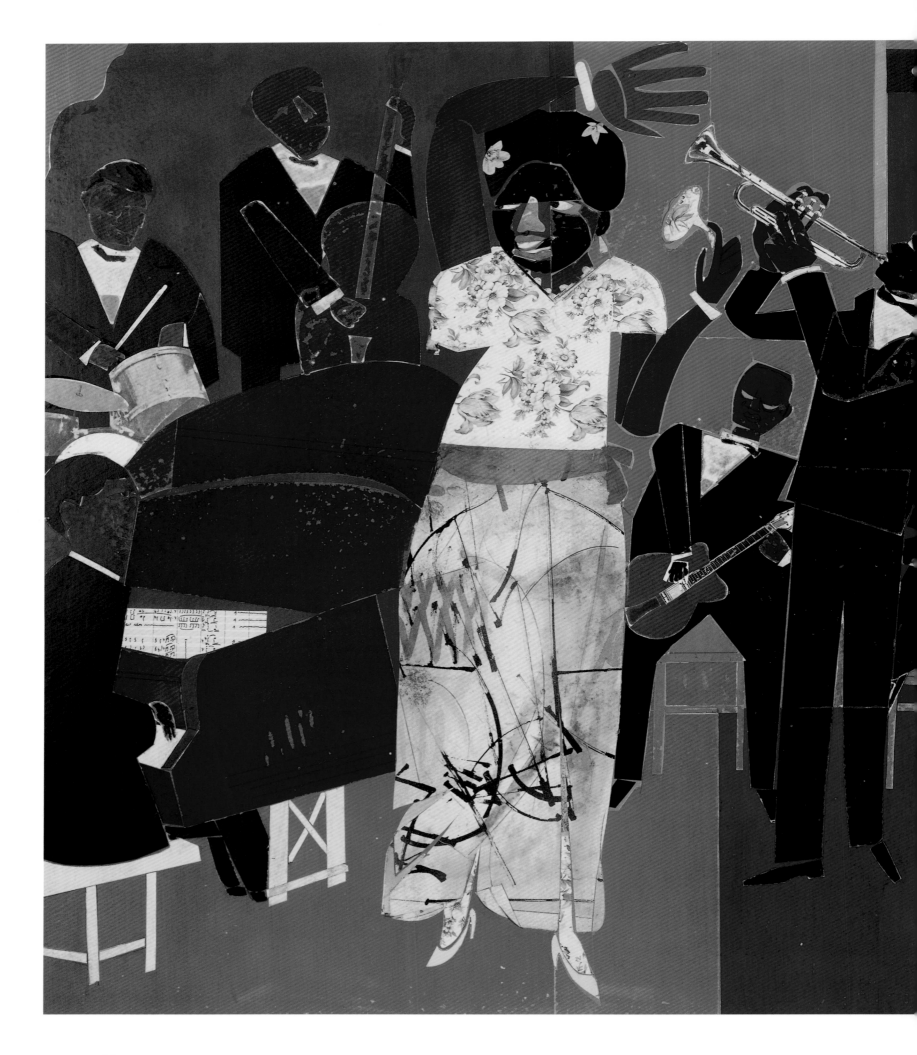

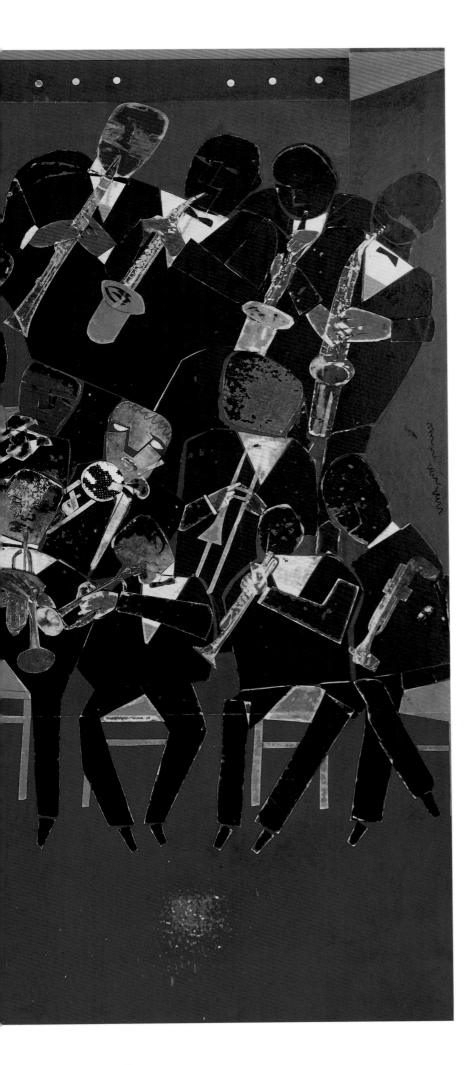

*The trouble with
white folks singing the blues
is that they can't
get low down enough.*

◄

ROMARE BEARDEN

Empress of the Blues

1974

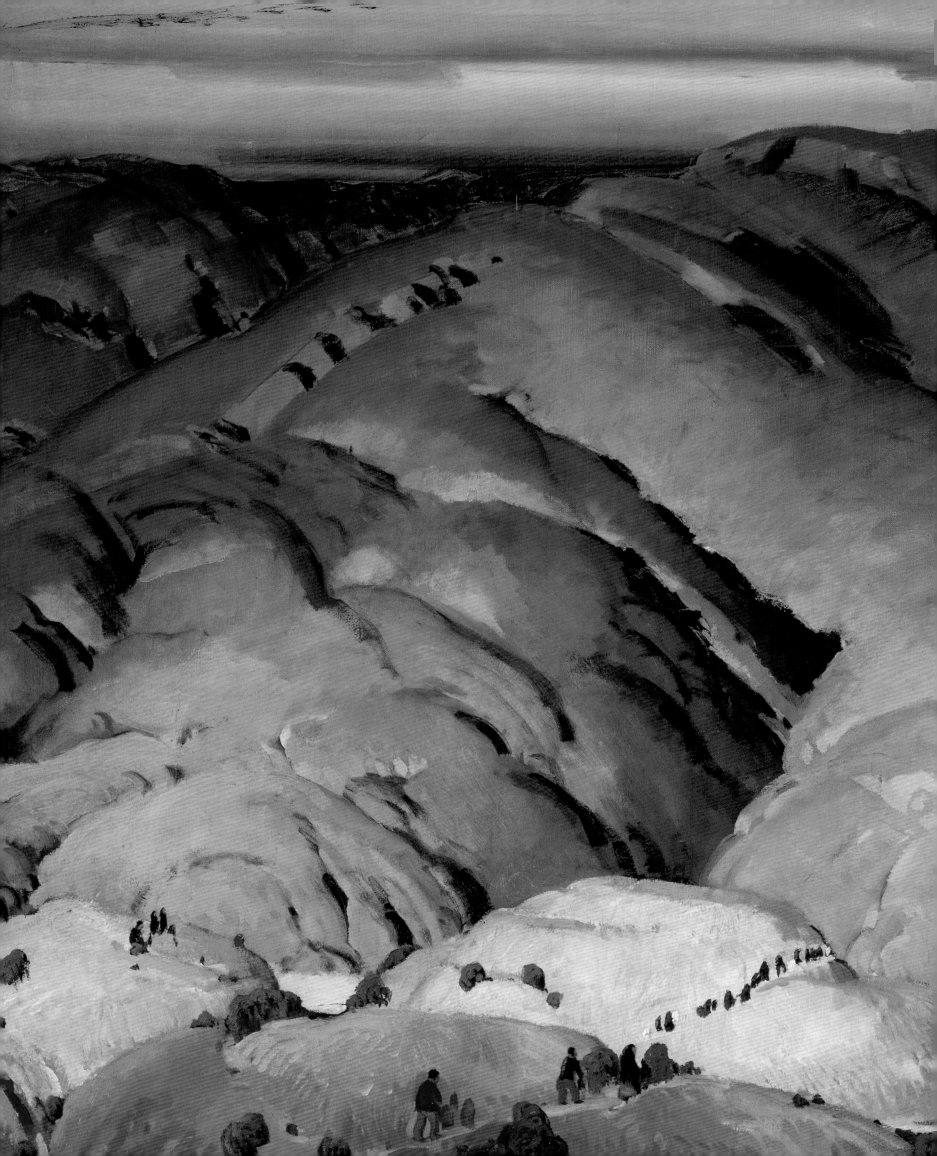

South by Southwest

By the turn of the twentieth century the two coasts of the continent were tied together by many bonds—by railroad lines that cross-hatched the western Plains, mountains, and even the great American desert, as well as by commerce and finance. The economy was truly national: goods were shipped by rail to and from every corner of the nation. Beef from Montana, milk from California, wheat from Oregon's Willamette Valley, potatoes from Idaho, and melons from California were daily fare on tables in St. Louis, New York, and Chicago, while printing presses and pianos manufactured in New York or St. Louis were purchased in Portland and San Francisco.

New Mexico was annexed and subsequently enlarged through the Gadsden Purchase with a southern route for the transcontinental railroad in mind. After the golden spike joined the Central and Union Pacific railroads in Utah in 1869, settlement in southern California boomed. Businessmen demanded access to the mineral resources and markets of this region, and residents of the Southwest wanted access to goods from the East and from California. Engineers had advised James Gadsden that the most practical route for a southern transcontinental railroad would be south of the United States boundary. Under President Franklin Pierce, Gadsden served as U.S. minister to Mexico; during his tenure he promoted a plan to acquire from Mexico enough territory for a railroad to the Gulf of California.

While the dry, fragile land of the Southwest may have looked empty to Anglo eyes, it supported a largely nomadic native population who used various territories for hunting grounds, gathering food and raw materials, and farming small plots near rivers or springs that provided much-needed water. During the early nineteenth century, Navajo and Hispano shepherds had displaced Pueblo tribes. Migrants came north from Mexico and settled in small clusters on slices of land suitable for winter

A Pueblo Indian takes his part ... with the clouds,
winds, rocks, plants, birds, and beasts:
with the drum-beat and chant and symbolic gesture
keeping time with the seasons.

EDGAR L. HEWETT
Ancient Life in the American Southwest
1930

▶

EANGER IRVING COUSE
Elk-Foot of the Taos Tribe
1909

farming; during the summer, families were often itinerant, following the grass with their sheep over the Plains and mesas. By the 1870s this system was under intense pressure from Texas cattlemen, land grant speculators, Mormon farmers, and California stockmen; their increasing numbers forced Hispanic populations onto poorer land.

Other events drew the territories of the Southwest toward American interests. Bishop Jean Baptiste Lamy, a French priest who had worked in the Ohio Valley, came to New Mexico in 1850 and revitalized its religious communities. Under his tenure, the number of priests in the state went from ten to fifty; he founded 135 churches and missions, with their complementary schools, convents, and hospitals. In 1875 he was made archbishop of the metropolitan see of Santa Fe, and through his work, the church became a major instrument of Americanization throughout the Southwest.

During the 1870s, New Mexico was dominated by the Santa Fe Ring—a group of lawyers, businessmen, and politicians who united to run the territory. The unique feature of this consortium was that its primary means of building wealth was not manufacturing or finance, but land. Speculation spelled the end of the older Hispanic tradition of landholding. For earlier Spanish settlers, a relatively small piece of land could provide all that was basic to a comfortable existence—a few crops, pasture for stock, ground to hunt on, and some wood for fuel—and that land passed from generation to generation. Eastern land speculators rejected the Hispanic tradition of small holdings supplemented by common lands essential to a grazing economy, with the whole regulated by a complex system of water rights. For Anglos, land was a commodity, and speculation was the quickest way to create huge fortunes. What the Anglo system failed to note was that the assumptions about settlement and family farms that had been formed in the humid East would prove ruinous in the

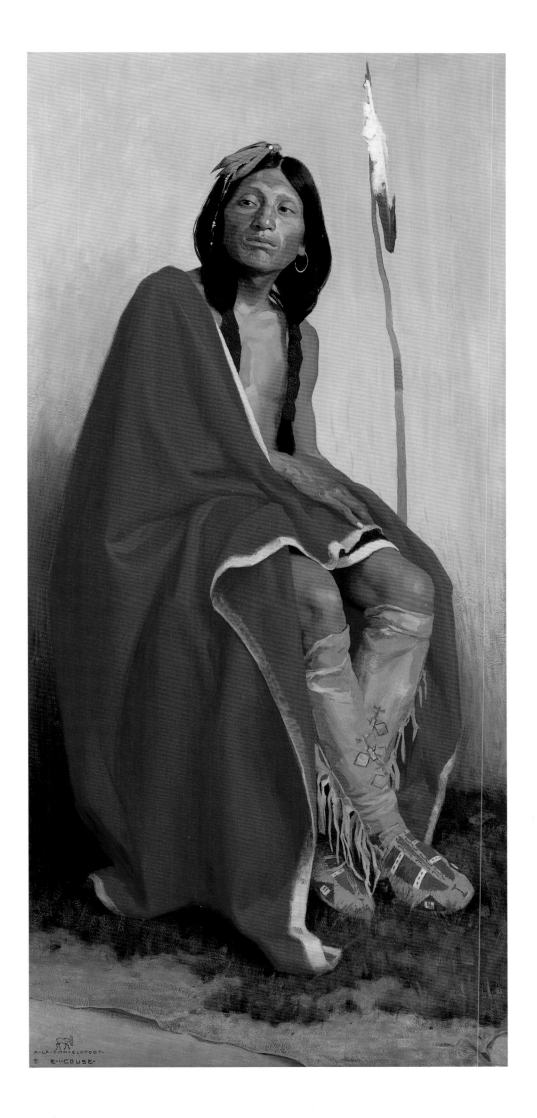

JULIAN MARTINEZ AND
MARIA MARTINEZ

Plate

about 1930s

arid Southwest. In one bright spot, the first territorial New Mexico legislature confirmed the Pueblo tribes in their right to the lands immediately around their towns, granting them a kind of political legitimacy. This allowed the Zuni and Hopi to survive more or less intact into the 1880s. They were treated not as Indians on reservations, but as communities of citizens. They mastered the art of cultural isolation; to the extent possible, they continued to live as if the white man did not exist.

The railroad companies sent expeditions of surveyors and photographers throughout the Southwest. Besides recording landforms for engineering purposes, Timothy O'Sullivan and John K. Hillers returned with magnificent images of ancient ruins and pueblos that were still occupied. By the 1880s the rich archaeological remains had attracted such anthropologists as Adolph Bandelier and Franz Boas, whose studies forced a more complex appreciation of non-Anglo cultures and a less hierarchical view of race.

As rail lines proliferated, the competition for freight and passengers increased. The Santa Fe Railway, distinguished for its success in marketing, churned out photographs, lantern slides, and calendars, all depicting the mountains, mesas, and blue skies of the Southwest. The calendars were distributed free throughout the nation; they hung in gas stations, diners, and kitchens from coast to coast, fueling dreams of travel. The railroads knew the value of enticing images; they offered free travel to artists, and purchased their images for use in promotion. Ernest Blumenschein came to Taos in 1898, followed by E. Irving Couse, Victor Higgins, and Walter Ufer. They were equally attracted to the land and its tribal and Hispanic peoples; all possessed qualities that Anglos, concentrating on industrial and economic progress, had lost sight of. The colonies they founded at Taos and Santa Fe

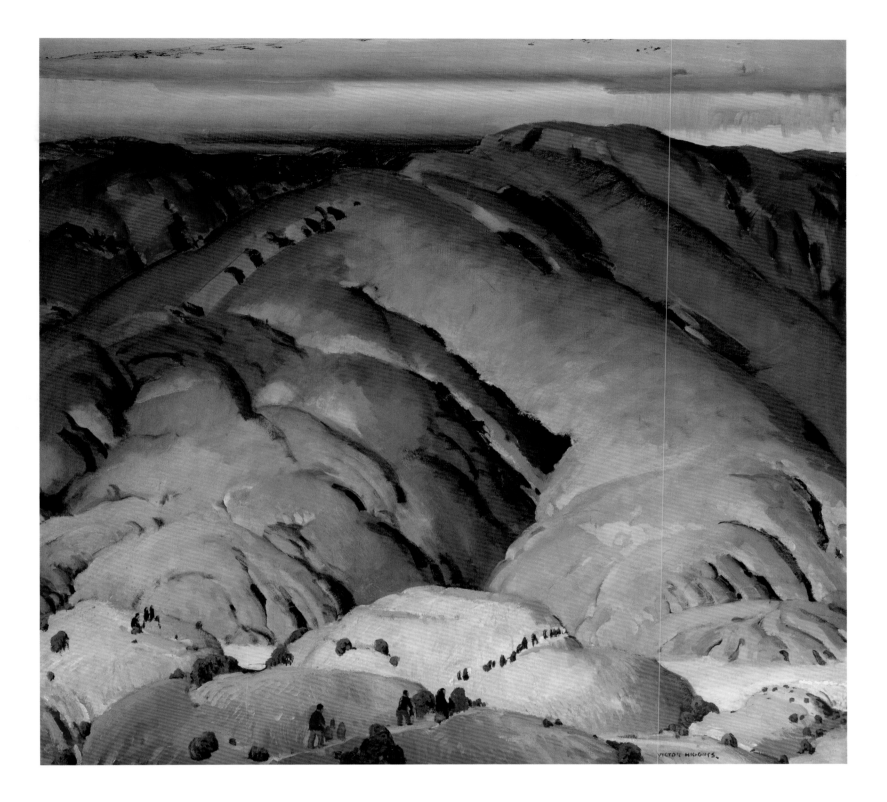

VICTOR HIGGINS

Mountain Forms #2

about 1925–27

soon attracted a larger universe of artists and writers. By 1907 they were producing the images for the Santa Fe Railway's calendar; that year images of native people, tall and noble, living in a preindustrial world predominated. But they also depicted Spanish plazas, dwellings tucked into rock faces or perched on cliffs, and the interwoven ceremonial and daily lives of native people.

As attractive as the landscape and climate were, artists and tourists who came to the Southwest were also drawn to colorful textiles and sophisticated silver and turquoise jewelry. Native crafts were marketed as works of art, and soon as souvenirs for visitors. Work by potters such as Maria Martinez and Nampeyo and

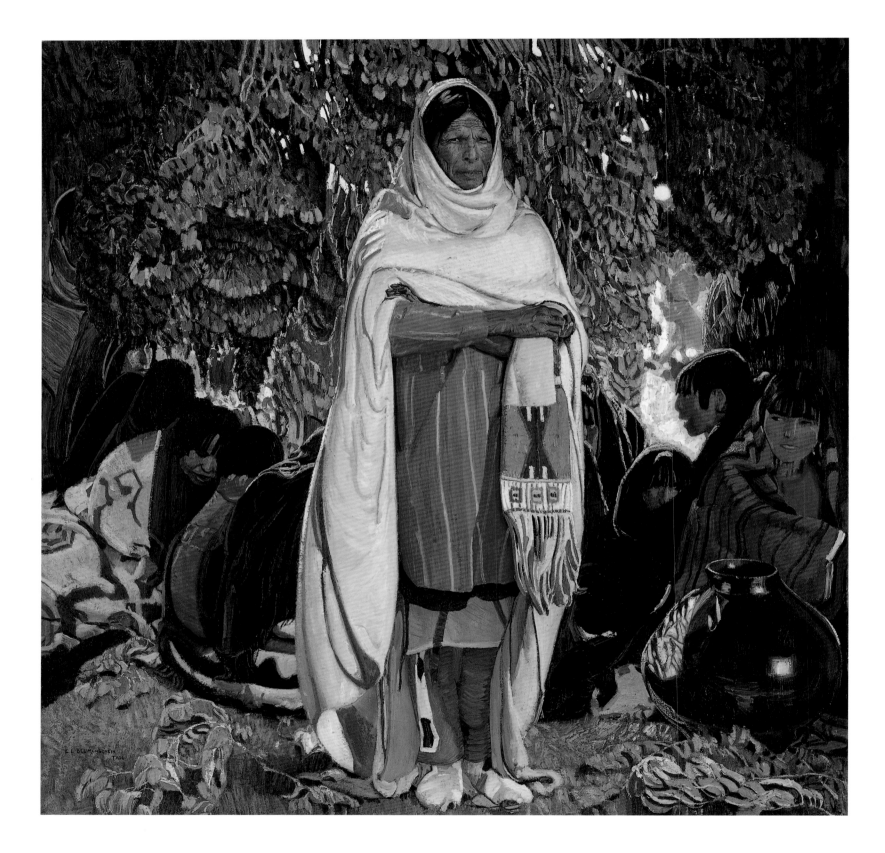

basketmaker Dat So La Lee were snapped up. As their names became familiar as far away as New York, the value of Zuni and Hopi baskets, pottery, and jewelry soared. Mabel Dodge, a Buffalo heiress who had been involved in the New York Armory Show in 1913, came to Taos in 1918 and built a house where she entertained such figures as D. H. Lawrence, Georgia O'Keeffe, Robinson Jeffers, and Ansel Adams. By 1931, Indian art, free of the didactic emphasis of "scientific" displays, was shown as fine art at New York's Grand Central Galleries.

The anthropologists, artists, and writers who came to the Southwest between the 1890s and 1930s promoted the place for its exotic beauties and helped document, preserve and, for a time, revive Indian art and culture. The artists who painted at that place and time offered viewers gorgeous landscapes, the romance of ancient places and ways, and a soul-satisfying connection to nature.

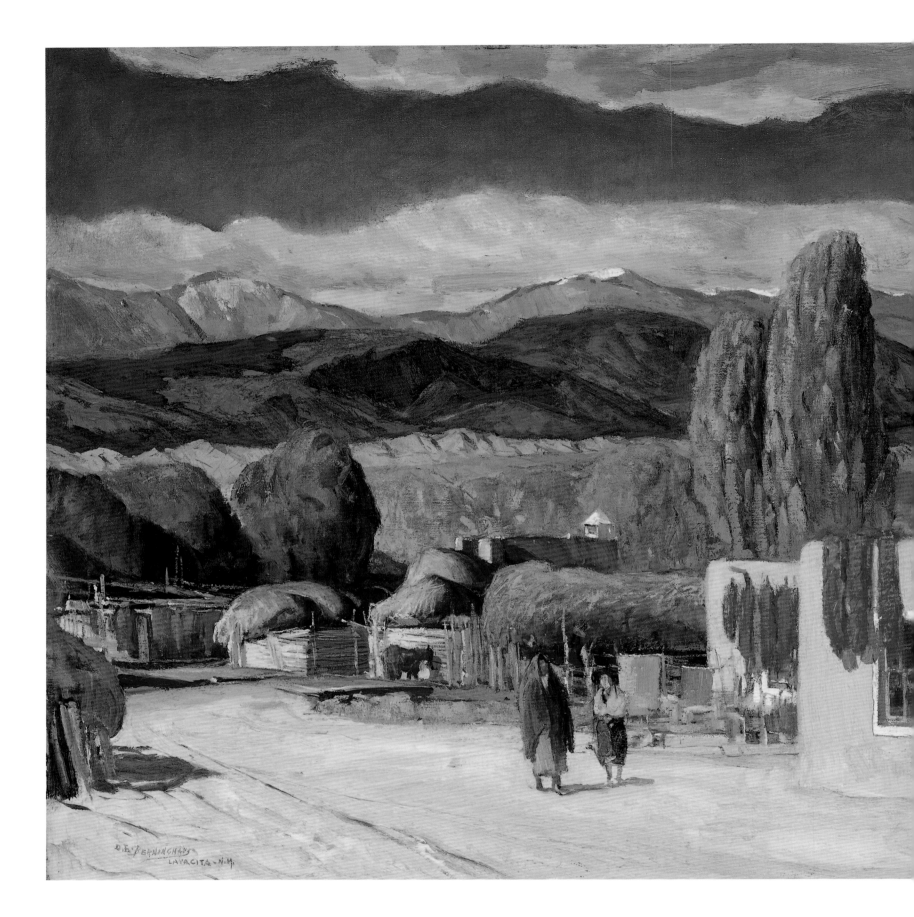

▲

GENE KLOSS

Midwinter in the Sangre de Cristos

about 1936

◄

OSCAR EDMUND BERNINGHAUS

Red Pepper Time

about 1930

... the children of the soil ... for ages have been building

their habitations and sanctuaries out of the earth

from which they were born.

EDGAR L. HEWETT

Art and Archaeology

1916

▲

E. MARTIN HENNINGS

Riders at Sunset

1935–45

◄

WALTER UFER

Callers

about 1926

... the Indians as a race, already shorn of their tribal strength and stripped of their primitive dress, are passing into the darkness of an unknown future.

▲

EDWARD S. CURTIS
The Kiva Stairs—San Ildefonso,
from the portfolio *The North American Indian*
1925

EDWARD S. CURTIS
The North American Indian
1907

▶

JOSEPH HENRY SHARP
The Voice of the Great Spirit
1906

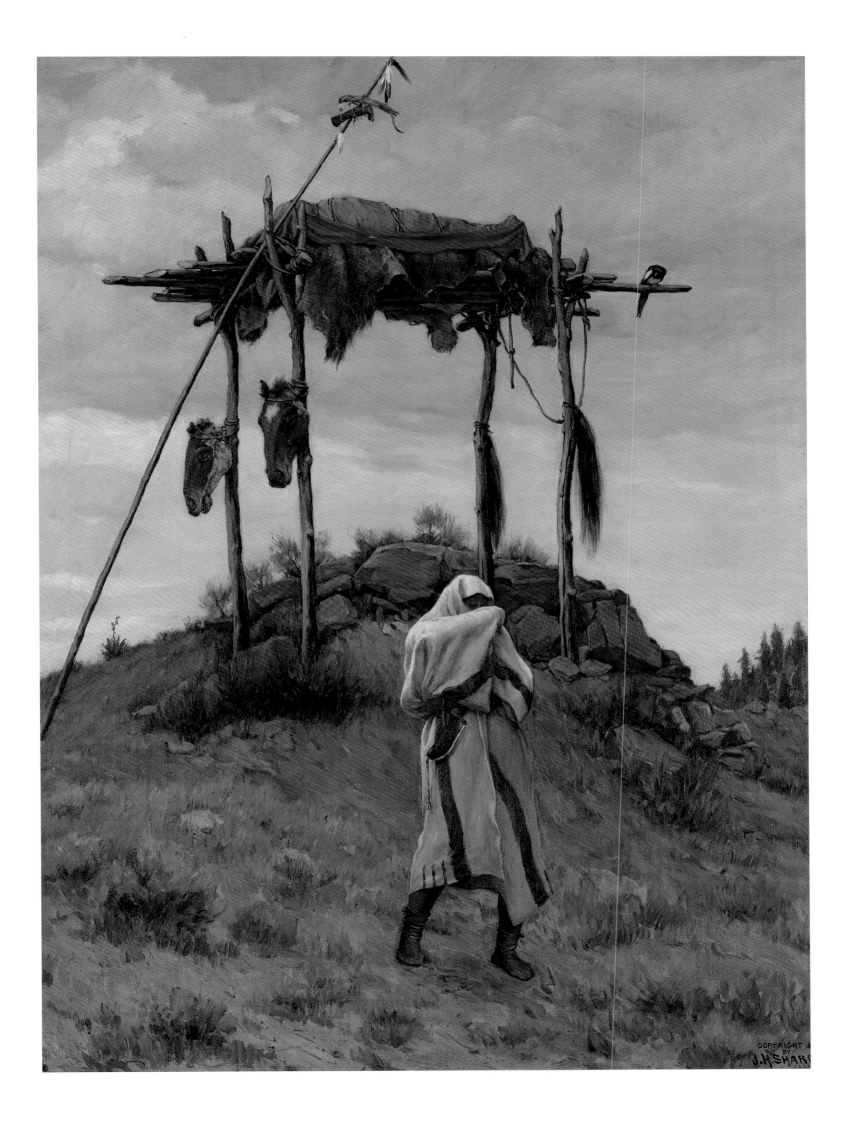

JOSEPH HENRY SHARP

Sunset Dance—Ceremony to
the Evening Sun
1924

ANSEL ADAMS

Winter Sunrise, Sierra Nevada
from Lone Pine, California
1944, printed 1978

Against the last lingering light in the west

that marked where the day had gone,

the mountains lifted their vast bulk in solemn grandeur

as if to bar forever the coming of another day.

HAROLD BELL WRIGHT

The Winning of Barbara Worth

1911

The Great Depression

The industrial expansion that had, with relatively brief intermissions, roared along since the Civil War, came to a crashing halt in 1929 and remained paralyzed for nearly half a generation. President Herbert Hoover, whose faith in progressive ideals had been nurtured by his relief work during World War I, and whose sense of technical mastery over the government had been nurtured by his successes as a mining engineer and international businessman, was unprepared for the change.

The first decades of the twentieth century had also seen the Great War, continuing high rates of immigration, and rapid urbanization. The tenor of society was tightly strung by rapid change. The population had doubled in the generation since 1890, and a third of that increase was due to immigration. These new immigrants settled across the continent, but most heavily in the northern industrial belt. This wave came not for land, but for jobs in construction, the garment trades, and heavy industry. They fed the furnaces and manned the production lines for industrial behemoths like U.S. Steel, Ford Motor Co., and General Motors; the power of these companies reflected the dominance of business interests over those of labor.

In eastern cities, national and ethnic groups clustered in neighborhoods. Cities had their Little Italies, Chinatowns, and Little Warsaws, where immigrants read newspapers in their native languages, and shopped and banked in their neighborhoods speaking Yiddish or Polish or Greek. New Yorkers spoke at least thirty-seven different languages. During the 1920s, nearly a third of Chicago's 2.7 million residents were foreign-born; the numbers of immigrants began to stabilize, but cities continued to grow. During that decade about six million American farmers quit the land and moved to the city.

By 1924, a new Model T rolled off the assembly line at Ford's Highland Park plant every ten seconds. Once a cottage industry with great reliance on hand skills,

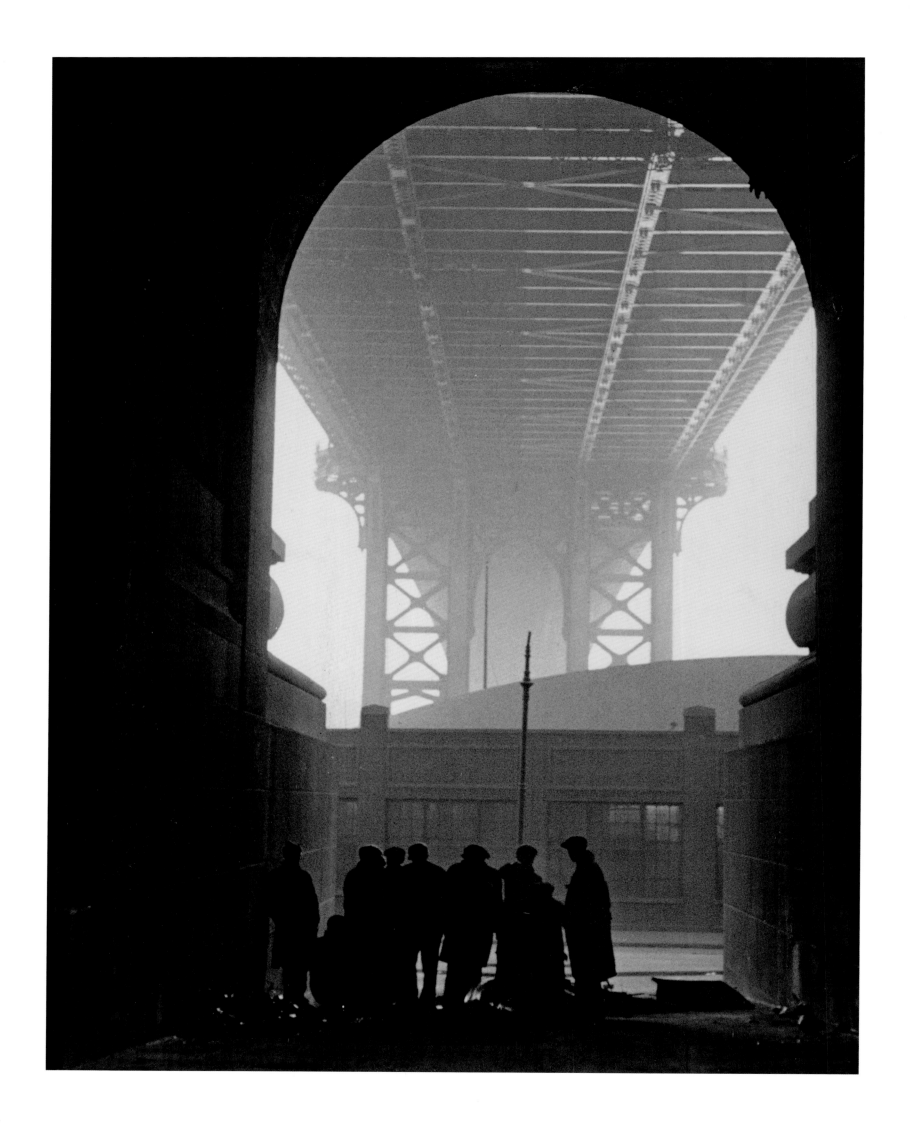

Once I built a tower up to the sun
Brick and rivet and lime.
Once I built a tower, now it's done.
Brother, can you spare a dime?

EDGAR "YIP" HARBURG
"Brother, Can You Spare a Dime?"
1932

ROBERT DISRAELI

Cold Day on Cherry Street
1932

DORIS ULMANN

Woman on a Porch (detail)
about 1930

during the 1920s cars accounted for ten percent of the nation's income and employed four million workers. Mass production assumed mass consumption. Workers' wages, though rising, were not keeping pace with the nation's industrial output. When times were good, many companies offered benefits sought by organized labor—bonuses, life insurance, even pensions. But these programs were offered at the discretion of the company and could be terminated at will.

The character of rural life was also changing. For the forty-five million citizens still living in the country in 1930, most had no electricity or indoor plumbing; they heated their homes and cooked on wood stoves, and lit their houses with kerosene lamps. During the Great War, in response to the call for food to feed Europe, Americans put ever more land into production, and with the tractor and other mechanized equipment, yields increased. By the end of the war farmers had purchased nearly 85,000 motorized farm vehicles. As work animals were replaced, yet more land was released from pasture to be planted in wheat or cotton or used for dairy production. In response to the demands of wartime, farmers had taken on debt to mechanize. As the war ended, huge surpluses quickly accumulated, prices plummeted, and farm foreclosures increased. The Great Depression of the 1930s was presaged by the agricultural depression of the 1920s.

The first rumblings of disaster were heard in September 1929—stock prices fell, then quickly recovered. On Wednesday, October 23, 1929, more than six million shares changed hands, and about $4 billion in stock value was wiped out. Thursday was worse—more than twelve million shares traded, and by noon, losses had reached $9 billion. The following Tuesday, 16,410,000 shares changed hands, a record that stood for thirty-nine years. For two weeks, stock prices continued to fall, and by mid-November, roughly one-third of the value of stocks listed in September was lost. It

207

an optimist is a guy
that has never had
much experience

DON MARQUIS
"certain maxims of archy"
1927

was becoming clear that recovery would be neither swift nor easy, and that company promises of wages and pensions had been ephemeral.

Herbert Hoover had been inaugurated in March of that year. In reaction to the stock market crash, he met with business leaders during the winter of 1929 and 1930. Hoover's administration asked businesses to maintain wage levels in the hope that recovery would be swift. During much of 1930, the banks held their ground, and while unemployment was at 4.9 million, it was only about half a million more than it had been during the slump of 1921. Most Americans, Hoover included, hoped for the best.

By the end of 1930, such illusions were over. During the 1920s, banks failed at a rate of more than 500 per year. In the first ten months of 1930, America saw 659 closures; during the last two months of the year, sixty more, many of them woefully undercapitalized to begin with, closed their doors; New York City's Bank of the United States—despite its name, not a federal institution but rather a favorite among Jewish immigrants and garment workers on the Lower East Side—collapsed on December 11, and the savings of 400,000 workers, nearly $286 million, were gone.

American disasters were amplified by European difficulties. In a time of terrible depression, nations tried to maintain the value of their currencies by controlling the export of capital. In September 1931, England defaulted on payments of gold to foreigners, and dozens of other governments quickly followed suit. The United States and Great Britain huddled behind barriers of protectionism, hoping to weather the storm. The value of global trade shrank from nearly $36 billion in 1929 to about $12 billion in 1932. During 1931, 2,294 banks failed—almost twice as many as in 1930. Hoover chose not to release the U.S. economy from the gold standard—he would leave that to his successor to implement after the election of 1932.

▶

DORIS ULMANN

Man Leaning against a Wall

about 1930

208

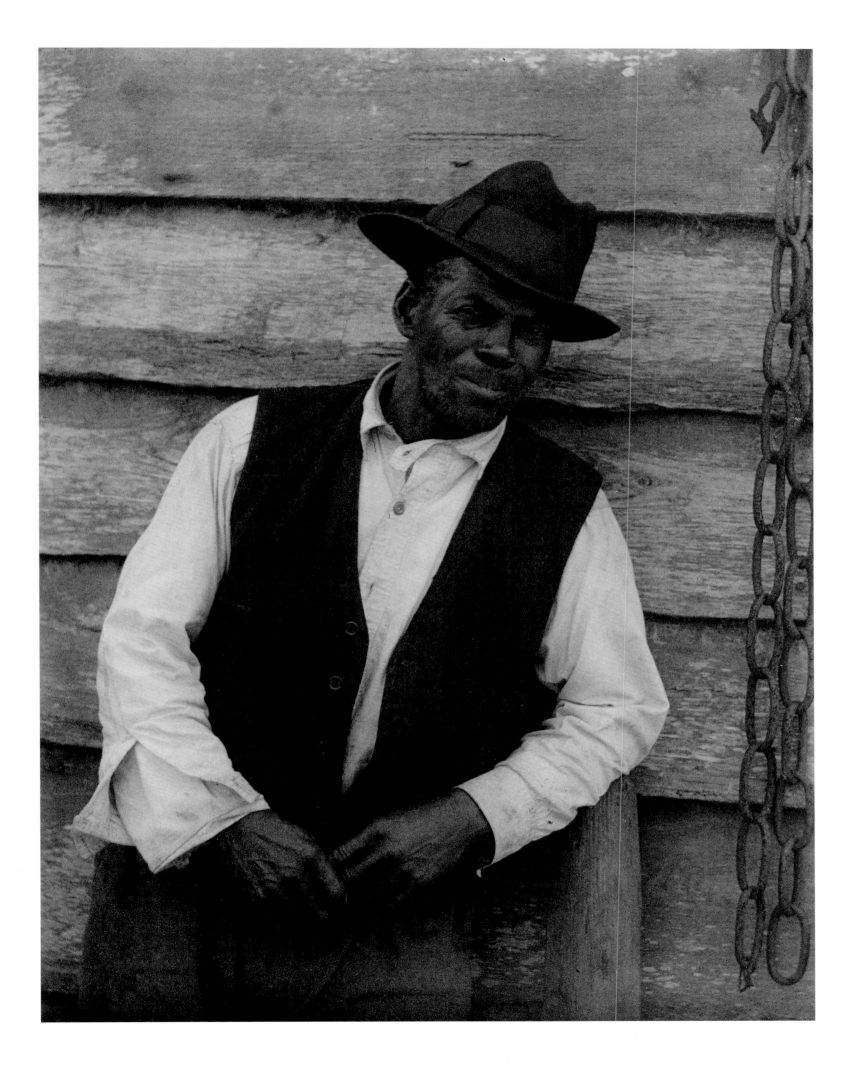

Rich man took my home
 and drove me from my door
And I ain't got no home
 in this world anymore.

WOODY GUTHRIE
"I Ain't Got No Home"
1938

▸

ALEXANDRE HOGUE
Dust Bowl
1933

▸

JACKSON POLLOCK
Going West
about 1934–35

During Hoover's last winter as president, the picture was bleak. Tens of thousands of unemployed lined up at soup kitchens, rode the rails in every direction of the compass hoping to find work, or hitchhiked wherever the roads might take them. While people in cities scavenged in trash cans for food, crops in the blighted agricultural states rotted in the fields for lack of buyers. By early 1932, more than ten million were unemployed; in important industries like steel and automobiles that had fueled the economic boom of the 1920s, the rate was as high as fifty percent. Those who held on to their jobs took shorter hours or reduced wages. Hoover barely ran for reelection in 1932, and was beaten by Franklin Delano Roosevelt.

Immediately after his inauguration, Roosevelt called Congress into special session, declared a four-day bank holiday, and suspended transactions in gold. A banking bill was ready for Congress by 1:00 p.m. on Monday, March 9. Both houses passed it, and the president signed it that evening. On Sunday evening Roosevelt gave the first of his famed fireside chats, telling citizens that their money was safer in the banks than under a mattress. When the banks reopened their doors on Monday, deposits were up. While the Depression would linger for another eight years, the American economy would begin to show signs of promise over the coming year.

The agricultural disaster of the dust bowl was brought on in part by poor farming practices as well as drought and a depressed economy. Farmers struggled to remain solvent by putting ever more marginal land into production as commodity prices fell. When drought struck in 1930, the ceaseless prairie winds lifted the dry topsoil off the land and bore it eastward in storms that reached altitudes of eight thousand feet, known as "black blizzards." The Okies, immortalized in Dorothea Lange's photographs and John Steinbeck's *Grapes of Wrath*, left Texas, Kansas, and Colorado

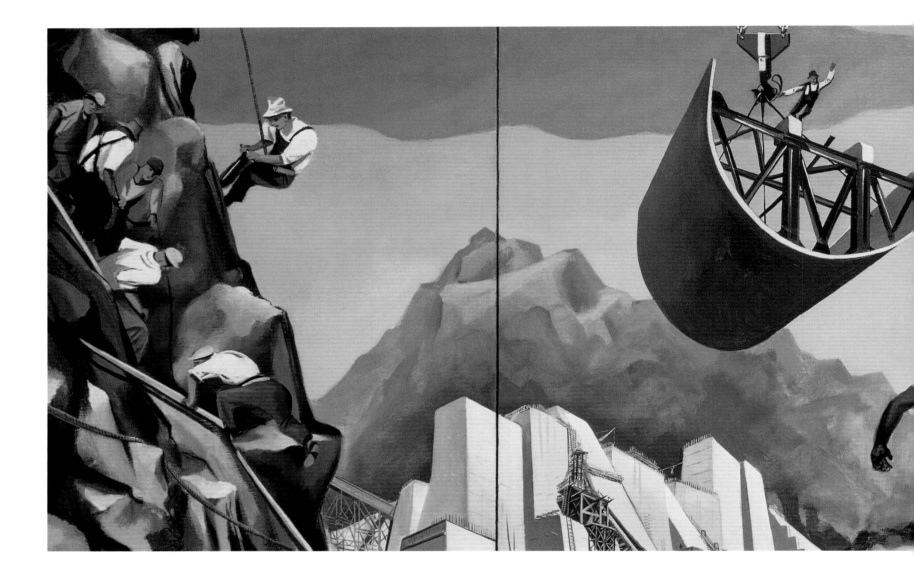

for California by the thousands, victims of the broken pioneer promise. Artists such as Doris Ulmann, Tyrone Comfort, and Frank Kirk show the incredible resilience of farmers, coal miners, and day laborers, whose strength of character sustained them through agricultural disaster, mine closures, strikes, and poverty.

In the early days of his first administration, Roosevelt created the Tennessee Valley Authority and called for a National Industrial Recovery Act. This bill legitimized the right of workers to unionize and created the National Recovery Administration, the Public Works Administration, and the American Agricultural Administration. In November 1933 the Civil Works Administration was launched; it used army tools and materials to execute federal projects. By January of that winter, this precursor of the Civilian Conservation Corps had put 4.2 million men and women to work on light construction and maintenance projects improving bridges,

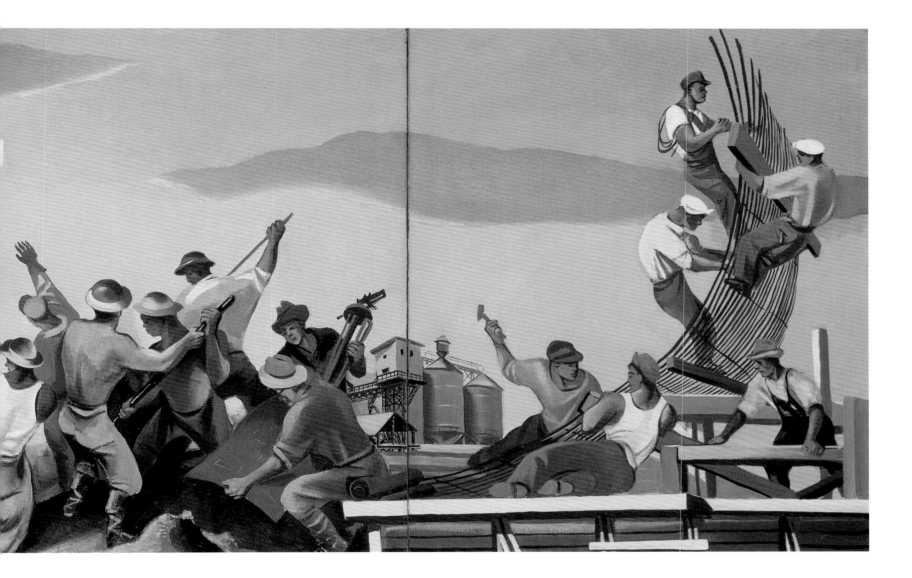

WILLIAM GROPPER

Construction of the Dam
(study for mural, Department of
the Interior, Washington, D.C.)
1938

roads, and sewers, and refurbishing schools and hospitals. A great part of its success was the understanding that the money distributed was not relief but wages. The New Deal had put millions to work; it had built the Grand Coulee and Bonneville dams, the Shasta on the Sacramento, Fort Peck on the Missouri; it had brought electricity and industry to the Tennessee Valley. The Farm Security Administration had protected farmers and maintained labor camps that sheltered thousands of families. The New Deal rebuilt regional economies and fostered small businesses. It inserted a notion into the American consciousness that the federal government had a responsibility to ensure the health of the economy and the welfare of its citizens. The New Deal patronized the arts and created housing. It brought into the fold the rural poor, the marginal immigrant communities in cities, and the elderly and unemployed, and gave them a sense that they too had a stake in the future of the nation.

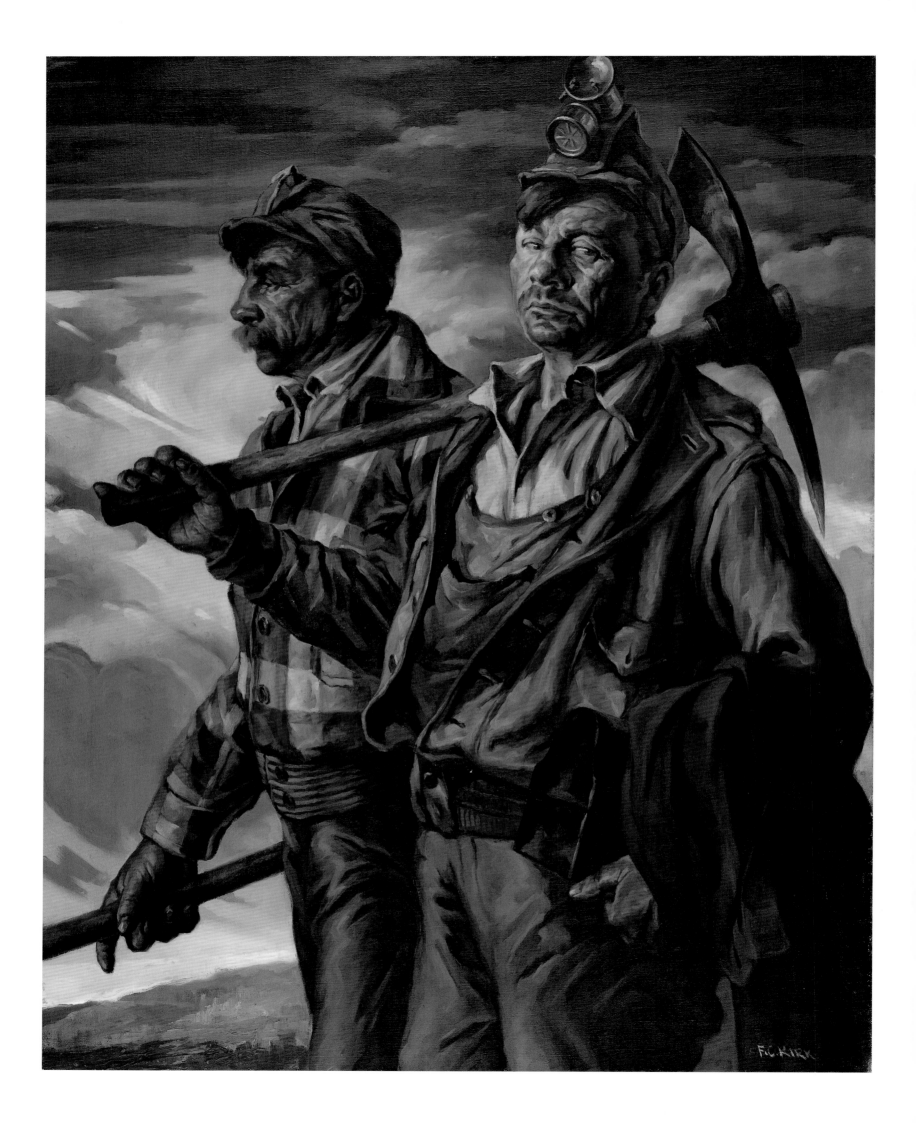

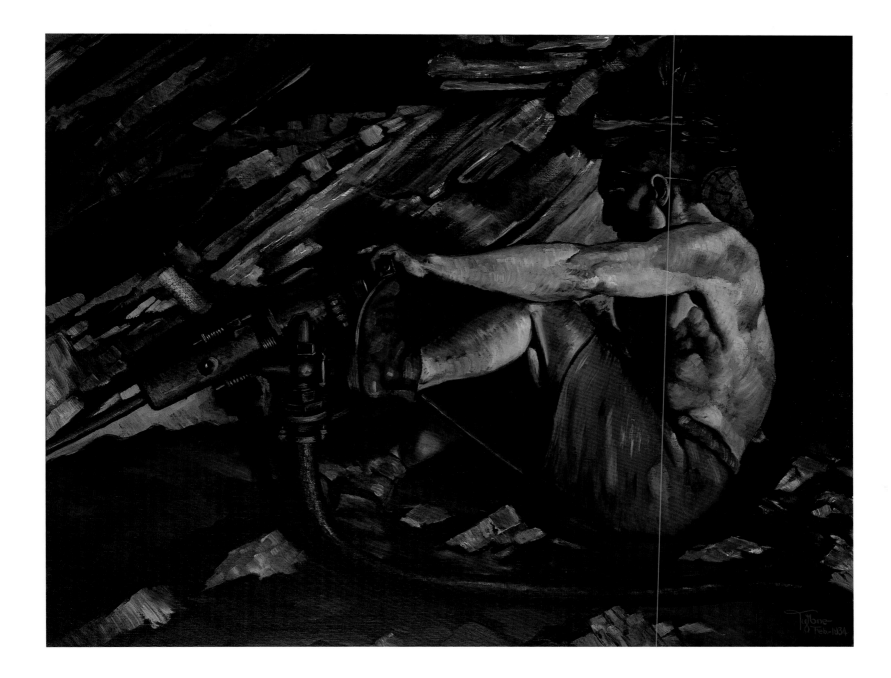

TYRONE COMFORT

Gold Is Where You Find It

1934

FRANK C. KIRK

Homeward

1933

I don't want your millions, Mister,
I don't want your diamond ring.
All I want is the right to live, Mister,
Give me back my job again.

JIM GARLAND

"All I Want (I Don't Want Your Millions, Mister)"

1930s

*...real prosperity
can only come when
everybody prospers.*

ELEANOR ROOSEVELT

1936

▲

FRANK HARMON MYERS

Sunny Jim

about 1937

▶

O. LOUIS GUGLIELMI

Relief Blues

about 1938

MORRIS KANTOR

Baseball at Night

1934

Pictures are for entertainment,
 messages should be delivered by Western Union.

SAM GOLDWYN
date unknown

▲

JULIA ECKEL

Radio Broadcast

about 1933–34

Folk Traditions

reat artists share a passionate will to create. Folk artists are sometimes set apart by their imaginative use of everyday materials and practical skills to make expressive, often visionary works. Inspired by a deep love of place, an untrained artist may feel compelled to record his surroundings using whatever materials he finds nearby. Landscapes and cityscapes convey the beauty and energy of a scene, though the artist might use house paint on paneling rather than oil on canvas. Sculpture might be hewn from sheet metal or molded with aluminum foil rather than carved in marble or cast in bronze. In the hands of folk artists, commonplace items become vehicles for self-expression. Their works voice opinions, political and otherwise, that span the entire spectrum. The spiritual impulse is frequently expressed; from Old Testament stories to apocalyptic visions, folk art warns viewers of the fires of hell or comforts with assurances of God as eternal shelter. The voice of the common man is rarely heard in the halls of power, but through their work, folk artists have won an audience for ideas outside the cultural mainstream by packaging them with wit and creativity. During the 1950s and 1960s, this sometimes antiestablishment "outsider" art became more visible.

Historically, folk art had included shop signs, weather vanes, and naïve portraits painted by itinerant limners who traveled from village to town from colonial times well into the nineteenth century. It also has roots in the ethnic traditions that gave us German Fraktur paintings, calligraphy, pottery, and needlework. Private and institutional collections grew rapidly, and scholars generally defined the genre as naïve or primitive.

Some untrained artists directed their creativity toward utilitarian ends. Quilts, duck decoys, shop signs, weather vanes, and canes all had practical roles that justified their existence, but the care and time lavished on creating the beautiful and the strange in these genres is evidence that the artistic impulse often outweighed

222

The products of the folk art world are truly the art
of the people, by the people, and for the people.

HERBERT WAIDE HEMPHILL JR.
Twentieth-century Folk Art and Artists
1974

UNIDENTIFIED ARTIST
Stag at Echo Rock
late 19th century

practical motives. Collectors could not resist them. They found a treasure trove in urban flea markets and junk stores and snapped up decorated handmade objects, many of them created by immigrants or made in European traditions.

Early collectors became familiar with African masks and carvings through exhibitions in New York galleries and museums during the 1920s and 1930s. They often accumulated separate collections of African art, or of Indian pottery and baskets from the American Southwest, as well as Inuit sculpture. During the first half of the century, artists produced an enormous body of naïve and visionary art. By the 1960s a field that had once scorned anything made after 1880 began to take note of this more modern work and in the process raised the most basic questions: Who is an artist? What is art?

In practice, artists refused to remain in comfortable, neatly defined boxes. Though potters such as Ben Owen at Jugtown in North Carolina continued to mine the local red clay and produce traditional pots and face jugs, and while some Indian potters and weavers maintained ancient skills and traditions, this new generation incorporated foreign styles and contemporary American motifs. Jugtown Pottery produced new forms with clear Asian influences, while Navajo artists wove rugs depicting modern life, and carvers highlighted daily activities.

Folk artists found new energy as they fused contemporary culture and ancient tradition, and refused to be limited by academic definitions of art. Collectors were captivated by the range of work they found; they collected what they loved, and in so doing challenged museums to follow them into uncharted territory. They recognized that this art movement was not ruled by New York gallery owners, but by the artists themselves. Folk art expresses the passions of place, populism, and spirituality that unite Americans from every corner of the continent.

▲

ATTRIBUTED TO HENRY LEACH

Black Hawk Horse Weathervane
Pattern
1871–72

Mattie Lou O'Kelley

Farm Scene

1975

▶

Unidentified artist

Bandstand

about 1890

◀

Shields Landon "S. L." Jones

Country Band

1975–76

▲

JOHN V. SNOW SR.

Trout

1990

▲

ABRAHAM GOULETTE

Perch Decoy

about 1920s

▲

ANDREW TROMBLEY

Bass Decoy

about 1940s

▶

IRVING DOMINICK

Marla

1982

228

UNIDENTIFIED ARTIST

Missionary Map

late 19th century

EDGAR TOLSON

Paradise

1968

The vision of the folk artist is a private one,
a personal universe, a world of his own making.

JULIA WEISSMAN
Twentieth-century Folk Art and Artists
1974

231

Perhaps he was building a temple for his own soul.... his Throne *was an object of devotion, his life's work, his spiritual obsession, and his sanctuary and temple for tomorrow.*

BETYE SAAR
American Art
1994

▶

JAMES HAMPTON

The Throne of the Third Heaven of the Nations' Millennium General Assembly
about 1950–64

JAMES LEONARD

> *Wind Machine with Gabriel, Eleanor*
> *Roosevelt, and Louis Armstrong*
> 1984

▶

MALCAH ZELDIS

> *Miss Liberty Celebration*
> 1987

In our search, we found the real America—not
the blue-highway America of romantic fiction,
but the dirt-track and South Bronx America....
And wherever we went, we found art.

CHUCK ROSENAK

> *Museum of American Folk Art Encyclopedia of Twentieth-century*
> *American Folk Art and Artists*
> 1990

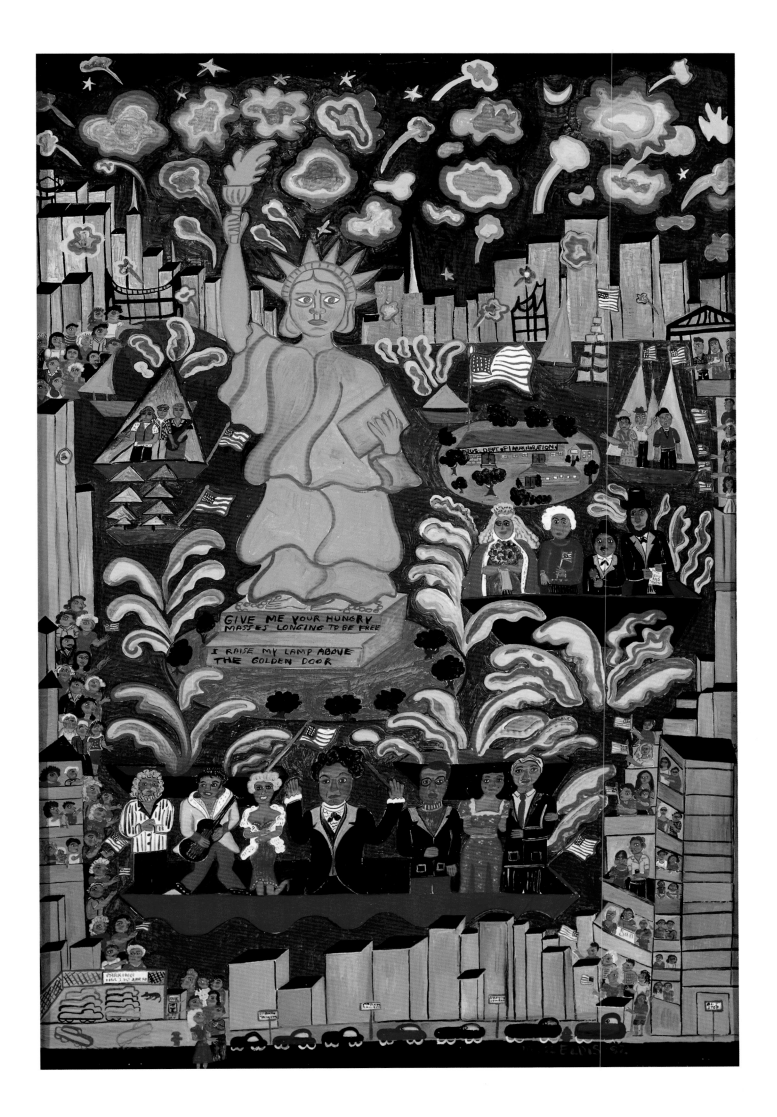

Americans at Midcentury

During the 1920s and 1930s, the United States was in the grip of an unshakable isolationist conviction, rooted in its experience in the Great War (later called World War I). Immigration quotas were passed by Congress in 1921 and 1924, and Americans rejected the notion of membership in Woodrow Wilson's League of Nations. Congress refused to forgive France and England their war debts, and passed a series of Neutrality Laws that banned arms sales or further loans to countries at war. Having suffered the sting of a punitive peace in 1917, Germany withdrew from the League of Nations in 1933, and in 1935 Hitler renounced the disarmament provisions of the Versailles treaty. In 1936 a German army occupied the DMZ between France and the German Ruhr valley, a bold move that elicited not a squeak from England, Italy, or the United States. Also in 1936, General Francisco Franco raised a Spanish army in Morocco and, crossing to Cadiz, launched an attack that plunged Spain into three years of civil war. In November 1936 he aligned himself with Italy in the Rome-Berlin Axis agreement, and over the following years the Nazi war machine began its inexorable conquest of Europe. It absorbed Austria and part of Czechoslovakia in 1938. Mussolini invaded Albania on April 9, and on September 1 the Wehrmacht rolled across Poland. On April 9, 1940, Germany occupied Denmark, Norway, followed by the fighting war that enveloped Holland, Belgium, Luxembourg. In May the Germans skipped across the meaningless Maginot Line. By mid-June, the French had capitulated.

The Japanese attack at Hawaii in December 1941 lasted just over an hour, but in that time eighteen U.S. naval vessels were sunk or heavily damaged, 180 planes were destroyed with another 120 crippled, and 2,403 Americans were dead, with another 1,178 wounded. The U.S. Navy took its revenge at the Battle of Midway in June of 1942, when Dauntless dive-bombers arrived at the precise moment Japanese

First Air Fleet was exposed and undefended. By the end of the day, Japan had lost four of the six aircraft carriers with which she had attacked Pearl Harbor, and the war in the Pacific, not by any means yet an American victory, had not been lost.

The Allied triumph in World War II was gained not only through millions of Russian, European, and American casualties, but perhaps in part on American production lines. By early September 1944, the United States had forty active divisions in France, each consuming between six and seven hundred tons of supplies per day. American factories continued to pour out guns, tanks, trucks, and airplanes while the American generals in Europe confronted the almost insurmountable problem of transport to keep troops supplied. German officers commented that the Americans, after suffering heavy losses on one day, were constantly resupplied with arms, vehicles, gasoline, and food overnight. The Germans found themselves unable

Look at an infantryman's eyes and you can tell
how much war he has seen.

Up Front

1945

PAUL CADMUS

Night in Bologna

1958

to face the British and Americans, with help from the French resistance on one side and Stalin's relentless Russian troops on the other. The conference at Yalta in February that brought Russia into the war against Japan was among Roosevelt's last strategic triumphs. He died at Warm Springs, Georgia, on April 12. On April 28, Benito Mussolini was shot and hanged by his feet. Two days later, Hitler shot himself in a bunker in Berlin. On May 8, 1945, all German troops laid down their arms. The war in Europe was over, but the Pacific war would continue until two atomic bombs were dropped at Hiroshima and Nagasaki on August 6 and 9. Japan surrendered on August 10.

The immediate aftermath of the European war was a new era of hostility that came to be called the cold war. But the United States would not return to its isolationist policies. The country that less than a generation before had scorned membership in the League of Nations championed the founding of the United Nations and voted to become a charter member of the North Atlantic Treaty Organization. It committed $17 billion to the Marshall Plan in 1948, continued to shuttle medical supplies and food to Europe for more than a decade, and opened its doors to more than half a million refugees.

The use of the bomb had changed the potential conduct of war and therefore international affairs for more than a generation. The war had been fought with industrial and technical might, but it had also unleashed a destructive power that must change the conduct of all nations even in peacetime. It had also carried Americans out of the Great Depression. By 1945 the United States owned half of the world's manufacturing capability and was producing twice as much oil as all other countries combined. Wartime inventions in aviation and electronics

LOUIS FAURER

Untitled

1950

would form the basis of new postwar industries, and for a brief moment the United States had a monopoly on atomic power. Many of the soldiers who had fought all across Europe and the Pacific came home, went to college on the GI Bill, married, and bought tract houses in suburban housing developments. These families enjoyed incomes and a standard of living beyond anything their parents had hoped to achieve. They had fought the last "good war," and were now living the good life, with indoor plumbing, a refrigerator, washing machine, a telephone, and even a television. They turned their attention to Hollywood entertainment and enjoyed the plenty produced by their unparalleled manufacturing capabilities. They poured money into new housing, schools, and roads on which they could drive the sleek cars that reconverted factories were producing in record numbers. But the uneasiness of the atomic age was with them. The United States had been drawn

REBECCA LEPKOFF

Untitled

1948

into a new conflict in Korea, and the tension of the cold war affected even children through the duck-and-cover drills they conducted at school.

John F. Kennedy's inauguration in 1960 marked a moment of optimism. America, now a superpower, wielded cultural influence to match its military might. Where poverty and illiteracy reigned, America would deploy a new kind of army— the Peace Corps—to foster economic growth and promote education. Elements of American culture, from Coca-Cola and cars to films, pop music, and fashion found their way to every continent and country; they would even seep through the iron curtain to seduce citizens of the Soviet bloc.

The most important domestic issue of the decade was civil rights. The movement began in the South, with Martin Luther King applying Gandhi's practice of passive resistance to achieve for blacks the rights they had been promised

243

ANDREW WYETH

Dodges Ridge
1947

in the Declaration of Independence and Constitution. The most vital was the right to vote, but other struggles for equality quickly followed: the right to a seat on a bus, the right to drink from a public water fountain, the right to order at a lunch counter, the right to a decent public education. The successes of the Freedom Riders and the bus boycott in Montgomery, Alabama, led to the lunch counter sit-ins and to the Supreme Court decision that separate schools were inherently unequal. It also led to a violent backlash that could be seen in police brutality and church bombings. Black Americans had not realized civil or economic equality in the century since the Civil War. Although racial injustice had never been eliminated, Americans would begin to confront its consequences through the 1960s and 1970s.

GEORGE TOOKER

The Waiting Room

1959

I have seen the moment of my greatness flicker,
And I have seen the eternal footman hold my coat,
* and snicker,*
And in short, I was afraid.

T. S. ELIOT

"The Love Song of J. Alfred Prufrock"

1915

Nature's first green is gold,
Her hardest hue to hold.
Her early leaf's a flower;
But only so an hour.

Then leaf subsides to leaf.
So Eden sank to grief,
So dawn goes down to day.
Nothing gold can stay.

ROBERT FROST
"Nothing Gold Can Stay"
1923

▲

HUGHIE LEE-SMITH

The Stranger

about 1957–58

◄

EDWARD HOPPER

Cape Cod Morning

1950

247

Is there no way out of the mind?

SYLVIA PLATH
"Apprehensions"
1962

▶

LEON LEVINSTEIN
Untitled
date unknown

◀

GEORGE SEGAL
The Curtain
1974

Roy DeCarava

Graduation, New York
1949, printed 1982

GARRY WINOGRAND

Albuquerque, New Mexico, from the
portfolio *Fifteen Photographs*
1958, printed 1974

*...common sense tells us that our existence
is but a brief crack of light between
two eternities of darkness.*

VLADIMIR NABOKOV
Speak, Memory: An Autobiography Revisited
1951

251

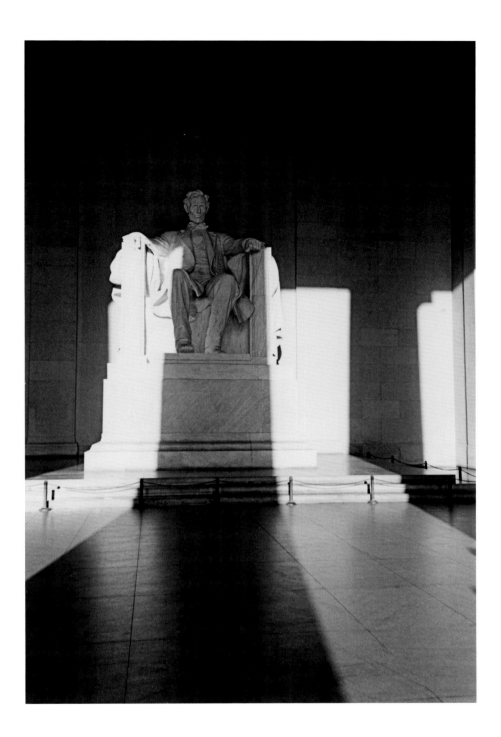

For where does one run to
when he is already
in the promised land?

CLAUDE BROWN
Manchild in the Promised Land
1965

LEE FRIEDLANDER

Lincoln Memorial, Washington, D.C.,
from the series *The American*
Monument
1976

LEON GOLUB

Head I 1961
1961

LEE FRIEDLANDER

Veteran's Memorial, Stamford,
Connecticut, from the series
The American Monument
1973

Maybe I couldn't be dafter,
But I keep wondering if this time we couldn't
settle the differences before a war
instead of after.

OGDEN NASH
"Is There an Oculist in the House?"
1962

LEE FRIEDLANDER

*Major General Henry W. Slocum,
Napoleon Gun, and Stevens' Fifth Maine
Battery Marker, Gettysburg National
Military Park, Pennsylvania,* from the
series *The American Monument*

1974

MAN RAY

Autoportrait

1933

CHRISTO

Package 1961

1961

I can't say who
I am
Unless you agree
I'm real

LEROI JONES

"Numbers, Letters"

1969

ANDY WARHOL

Jackie III, from the portfolio
11 Pop Artists, Volume III
1966

SAM GILLIAM

April 4
1969

Somewhere I read that the greatness of America is the right to protest for right.

MARTIN LUTHER KING JR.

1968

The Abstract Impulse

Through the period of rebuilding and renewal that followed World War II, there was a sense that great progress was possible. American will, with the help of its manufacturing might, had been a factor in stopping the Axis machine. Many Americans believed that events had vindicated the recurring idea that a free people can prevail in the face of unimagined challenges. But as the 1960s progressed, new forces transformed old convictions. The civil rights movement was proving that citizens could challenge authority and change "the system"; gains in voting rights and school integration inspired similar conviction in the antiwar, youth, and women's movements. Well educated and politically active, women entered the workforce in numbers unprecedented since World War II—a trend that now seems irreversible. But just as the women's movement came into its own, the economy faltered. The right to work had been won, but other items on the feminist agenda, such as the equal rights amendment, wage parity, and universal child care, were never achieved; social change had moved at lightning speed, only to become mired in protracted cultural battles. The youth movement, so loud and visible partly because the baby boomers were a demographic bulge of such staggering size, declared its independence from the past through music and fashion; the boomers fought in Vietnam; they explored formerly forbidden territories of drugs and sex; they went to college; some danced naked in the rain at Woodstock while others fought fiercely for social and political reform. They were determined to challenge authority, tear down tradition, transgress barriers, shock and offend their elders. The term "generation gap" was coined in an attempt to describe the abyss that separated them from their parents.

A smorgasbord of infinite choices was no more a guarantee of happiness than was the safe, suburban world of the middle-class 1950s. By 1968, the year

Physical concepts are free creations of the human mind, and are not, however it may seem, uniquely determined by the external world.

ALBERT EINSTEIN
The Evolution of Physics
1938

FRANZ KLINE

Merce C

1961

Robert Kennedy and Martin Luther King Jr. were shot, a sense of safety and security seemed to be slipping away. The economic promise of the fifties had not been fulfilled; Lyndon Johnson's War on Poverty had not been won, and the optimism that had characterized the early 1960s was spiraling toward disillusion. From Kent State to Detroit, from Washington, D.C., to Los Angeles, the violence that had escalated throughout the decade in the rice paddies of Vietnam, half a world away, was manifested in riots on American streets.

By the time of Watergate, questions that would never have been asked about Dwight Eisenhower or John F. Kennedy—does the president have the best interests of the country at heart, has he cheated to gain political advantage, has he lied to the American people—demanded full and public answers. Broadcast on television, the Senate Watergate hearings revealed the details of the "cancer on the presidency" and led to President Richard Nixon's resignation. Americans were shocked and saddened by the illegal and unethical activities at the highest levels of government.

Americans were blessed with a wide array of choices and a cornucopia of consumer goods. The wonders of mass production meant that there was an infinite variety of toasters, washing machines, and cars in every color from white to avocado green, to suit every taste. Over these decades, the art world had offered a similar breadth of possibilities. When the abstract expressionists, or the New York School, emerged in the 1940s and 1950s, critics struggled to explain why these works exerted such a powerful effect on those who saw them, and ultimately on the culture. The New York art scene was enriched by a wave of immigrants fleeing the war in Europe. The avant-garde ideas they brought with them were completely transformed in

America. These artists, both immigrants and native born, had pursued art as a journey of self-discovery, as the primal expression of emotion, as raw feeling transferred directly to the medium without the interfering filters of figure or representation. Feeling animated the art-making process; the feeling guided a gesture, and the gesture conveyed that feeling to the canvas.

Some of the abstract expressionists had come to this new kind of art from surrealism; some believed in automatism; others were influenced by Jungian ideas. Robert Motherwell described painting as "voyaging into the night, one knows not where, on an unknown vessel; an absolute struggle with the elements of the real." They were not so much abandoning representation as making an entirely new connection with the act of painting, a change described by critic Harold Rosenberg: "The apples weren't brushed off the table in order to make room for perfect relations of space and color. They had to go so they wouldn't get in the way of the act of painting." As the group showed their works to increasing success, many worked on an ever-larger scale, hoping to let the experience of painting direct their actions as painters. Mark Rothko, who produced series of oversized canvases, described the influence of scale: "To paint a small picture is to place yourself inside your experience, to look upon an experience . . . with a reducing glass. However you paint the larger picture, you are in it. It isn't something you command." Some painters experimented with color, often in a formal way. Some took the canvas off the easel and put it on the floor; some took the canvas out of the frame and draped it against the wall.

Some artists offered political readings of their work, while others demanded that art remain untainted by ideology. Their argument was overtaken when cold-war strategists encouraged the Museum of Modern Art to tour traveling exhibitions of

abstract expressionist works in the late 1950s, claiming them as proof of American freedom of expression. Another group of artists dissented from the noble vision and sought their material in popular culture, finding an impetus in mass-produced images and advertising. Andy Warhol once said that pop art was about loving everything; he took delight even—or perhaps especially—in kitsch. In an orgy of fun, the pop impulse pricked every bubble of pretension it could find.

LÁSZLÓ MOHOLY-NAGY

Leuk 5

1946

WILL BARNET

Positano

1960

One of the things which distinguishes ours from all earlier generations is this, that we have seen our atoms.

KARL K. DARROW

The Renaissance of Physics

1936

▲

HANS HOFMANN

Fermented Soil

1965

◀

CLYFFORD STILL

1946-H (Indian Red and Black)

1946

That's one of my Goddamn precious American rights, not to think about politics.

▶

ROBERT RAUSCHENBERG

Reservoir

1961

◀

SAM GILLIAM

Swing

1969

271

TOM WESSELMANN

Still Life #12

1962

WAYNE THIEBAUD

Jackpot Machine

1962

▲

HOWARD MEHRING

Triple Double

1964

▶

HELEN FRANKENTHALER

Small's Paradise

1964

The earth's about five thousand million years old,
at least. Who can afford to live in the past?

HAROLD PINTER

The Homecoming

1965

275

Gene Davis

Wall Stripes No. 3

1962

276

▲

KENNETH NOLAND

Shoot

1964

RICHARD DIEBENKORN

Ocean Park, No. 6

1968

The body ... is subject to the forces of gravity.
But the soul is ruled by levity, pure.

SAUL BELLOW

"Him with His Foot in His Mouth"

1974

IRVING PENN

Nude No. 58—New York
1949–50, printed 1976

The composer ... leaves us at the finish with the feeling that something is right in the world, that something checks throughout, something that follows its own laws consistently, something we can trust, that will never let us down.

LEONARD BERNSTEIN
The Joy of Music
1959

▶

ISAMU NOGUCHI
Grey Sun
1967

ALFRED JENSEN

Honor Pythagoras,
Per I–Per VI
1964

For at least two million years, men have been reproducing
and multiplying in a little automated space ship called earth.

R. BUCKMINSTER FULLER

Saturday Review

1964

284

*These paintings are concerned
not with the last moment—
the act of painting—but with the
lasting moment of the image.*

BARBARA BUTLER
Arts Magazine
1956

◄

ELLSWORTH KELLY
Blue on White
1961

For it was only when
they were on the move
that Americans
could feel anchored
in their memories.

NORMAN MAILER
The Armies of the Night
1968

DAVID HOCKNEY

Snails Space with Vari-Lites,
"Painting as Performance"
1995–96

Toward the Millennium

Recently artists have struggled to make sense of a culture moving at an ever-faster pace. Thanks to the information age, American discourse seemingly happens at warp speed. The Internet and more than 200 channels of entertainment, all available twenty-four hours a day, have created a noisy universe marked by great diversity. Millions of viewpoints clamor for attention via media as high-tech as blogs and as old as radio; American society seems to be scrambling in multiple directions at once. Communication technologies have also brought a greater awareness of the world at large, spawning a new age of globalism. These three forces—technology, globalism, and diversity—have converged in the late twentieth century to create a busy intersection where meaning is not readily apparent.

The information age exploded when mainframe computers with their twitching reels of magnetic tape gave way to personal computers. The first PCs made their way into homes and businesses in large numbers in 1980 and 1981 and were powered by DOS. This comparatively simple bit of code was the foundation of Microsoft and Bill Gates's success. The rise of the personal computer was followed by a series of inventions: the fax machine, the video cassette recorder, cable television, the compact disk, and the cell phone. Technology invaded our lives with the promise of faster and easier communication; but each improvement brought its own set of demands and complications. Easy manipulation of complex data made statistics instantly available and transformed both politics and commerce. As immediate communication and world travel became less expensive, businesses transformed their notion of markets from local and national to truly global.

With technology's transformative power, the world had entered a new age of internationalism. World events loomed large in the American consciousness. The

NAM JUNE PAIK

Megatron/Matrix

1995

◄◄

ALEX KATZ

Black Scarf (detail)

1995

proliferation of nuclear weapons—not only within the United States and the Soviet Union, but also among an ever-larger and more volatile group of nations—was dangerous as well as ruinously expensive. President Jimmy Carter made it a primary goal to limit strategic arms among the superpowers; in 1978, America hoped for peace in the Middle East when he brokered a fragile peace between Egypt's president Anwar Sadat and Israeli leader Menachem Begin. But that success in the region was tempered by the hostage crisis in Iran; in November 1979, Iranian militants occupied the U.S. embassy in Tehran and held hostages for more than a year—just through the inauguration of Ronald Reagan. One of Carter's lasting legacies was his effort to establish diplomatic relations with the People's Republic of China, which changed the face of world trade.

Even before Reagan's election, the Soviet bloc's once solid façade was beginning to show signs of wear. John Paul II was elected to the papacy in October 1978;

MASAMI TERAOKA

Oiran and Mirror,
from the *AIDS Series*
1988

his subsequent journey to his native Poland in 1979 lit the brand of Polish resistance to Soviet control. In August 1980, workers led by Lech Walesa in the shipyards of Gdansk went on strike. By August 31, they had formed the first independent non-Communist trade union in the Soviet empire, which soon swelled to almost ten million members. Though the Polish government banned Solidarity and arrested thousands of its members, the tide had turned. By 1990, Walesa had been released from detention, had won the Nobel Peace Prize, and been elected president of Poland. The Soviet hold on Eastern Europe was dissolving.

During his first term, Reagan denounced the Soviet Union as an "evil empire." Yet in 1985, soon after Reagan's second inauguration, a change occurred. The vigorous Mikhail Gorbachev was elected secretary general of the Soviet Union's Communist Party. He believed the only way to fix the faltering Soviet economy was through reform

*The world breaks everyone
and afterward many are
strong at the broken places.*

ERNEST HEMINGWAY
A Farewell to Arms
1929

ABELARDO MORELL

*Camera Obscura Image of Manhattan
View Looking West in Empty Room*
1996

ERIC FISCHL

*What Stands between the
Artist and...*
1994

and demilitarization. Gorbachev promoted economic innovation, or *perestroika*, and political openness, known as *glasnost*. Nationalism then took hold throughout the Soviet bloc. Following Poland's example, Hungarian leaders began to dismantle sections of the iron curtain. Czechoslovakia's Velvet Revolution, led by Václav Havel was a peaceful coup of only two weeks duration. Romania's revolution brought Nicolae Ceausescu's government to its knees. By November of 1989, new laws permitting travel across the border between East and West Germany went into effect; within a matter of days, the infamous wall that had separated Berlin since the early 1960s was destroyed.

The easy exchange of ideas, increasing trade, and relatively inexpensive travel were changing political relationships among Europe, Asia, Africa, and America. One unintended consequence of global travel was the spread of diseases once confined to remote areas. The lethal AIDS virus had found its way to Europe and America, where it

And this is the house I pass through on my way To power and light.

JAMES DICKEY

"Power and Light"

1967

▶

DUANE HANSON

Woman Eating

1971

◀

EDWARD KIENHOLZ AND

NANCY REDDIN KIENHOLZ

Sollie 17 (detail)

1979–80

was well established by the 1980s. In those early years there was no treatment and much confusion over how it was transmitted. Even as the international community searched for a cause and treatments, fear and ignorance bred discrimination and stigma.

Furthermore, the information age brought a heightened awareness of tragedies worldwide. The world witnessed famine in Africa, genocide in Rwanda, and "ethnic cleansing" in Bosnia. Issues such as arms control, terrorism, drug trafficking, human rights, and environmental degradation, among others, continued to fester. Meanwhile, during the 1990s, the United States enjoyed the longest economic expansion in peacetime history. During President Bill Clinton's administration, unemployment dropped from 7.5% to 4% and the Dow Jones Industrial Average of stocks soared from 3,200 points to over 10,000. The federal budget, which ballooned during Reagan's presidency, switched from a quarter-trillion-dollar

I'm martyr to a motion not my own;
What's freedom for? To know eternity.

THEODORE ROETHKE
"I Knew a Woman"
1958

KAREN HALVERSON

Mulholland near Canyon Lake Drive,
March 30, 1993
1993

deficit to a surplus. Nevertheless, the economic boom hardly dented the rate of child poverty, nor did it improve conditions for unskilled and poorly educated workers.

The hope that the world's—and America's—problems would be solved with the dissolution of the Soviet Union proved to be an illusion. Americans had believed that with more knowledge, unchallenged power, greater understanding, truthful dialogue, and better diplomacy, their nation could fulfill its promise as the shining city on the hill. But that goal still seemed to elude our grasp. Just as one set of problems was unknotted, another tangle presented itself. The first bombing at the World Trade Center in 1993 gave Americans a hint of new dangers, but their appreciation of the threat would be changed forever on September 11, 2001.

Perhaps without conscious intent, American artists have absorbed and responded to the spirit of each era, from colonial times to the present. From our

LEN JENSHEL

Monument Valley, National
Monument, Arizona
1985

vantage point, we can see that from the earliest moments of colonization and settlement, artists have given voice to American desires, represented American ideals, reminded us of our fears and demons, and shown us the way through myriad difficulties. Some reacted directly to the destruction and loss of 9/11; for others, its effects have been more subtle. We cannot doubt that America and its artists will feel the pull of currents set in motion by this tragedy for decades; seeing Eric Fischl's *What Stands between the Artist and . . .* or Abelardo Morell's *Camera Obscura Image of Manhattan*, we sense invasion, disruption, and disorientation. While neither of these works is a commentary on the events of 9/11, their stark imagery tempts us to form new associations. Such is the resilience of great art. It speaks of a particular person, time, and place; but its truths also resonate into the years ahead. Successive generations form their own stories and associations, their own reasons to love and cherish each work.

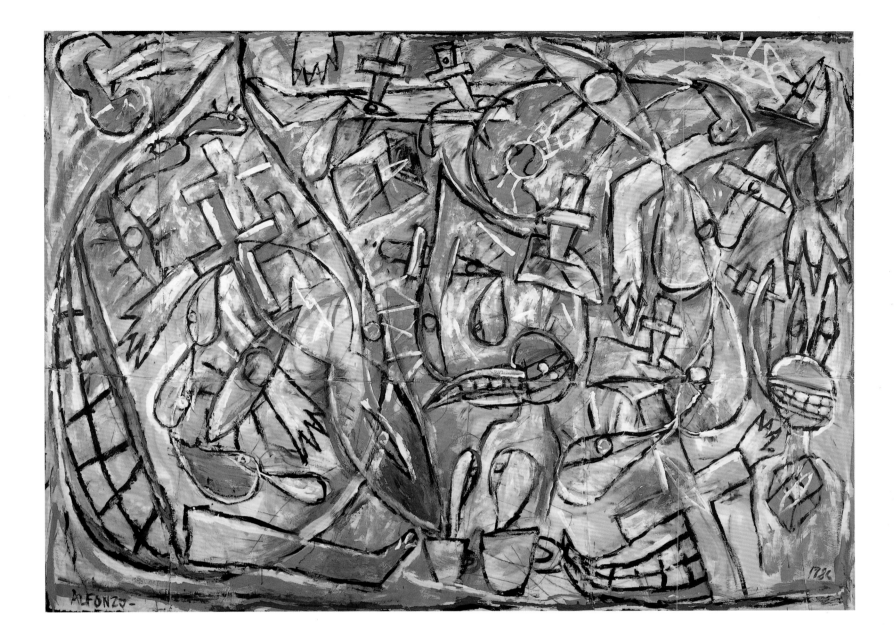

CARLOS ALFONZO

Where Tears Can't Stop

1986

JESÚS MOROLES

Georgia Stele

1999

As we face an unknown future, Americans will find strength in familiar places. Merely a generation after the civil rights movement, America's burst of economic and cultural vitality can be traced to the talent of all people, including those established here for generations as well as more recent immigrants. Cultural, political, and economic contributions from every ethnic group are essential to the national conversation.

In that diversity, where all races, ethnicities, and religions raise their voices and demand to be heard, both citizens and artists still need to connect to the past. American artists have portrayed our beginnings and our yesterdays. In those images we may find the understanding we need to continue the American journey, some of which has been recounted here. Without the distance that time will offer, the sound of so many voices may seem cacophonous to our ears. But over time, the discord will resolve into stories and imagery that will guide our path toward the future.

▲

VIK MUNIZ

 Valentina, the Fastest,
 from the series *Sugar Children*
 1996

▶

VIK MUNIZ

 Big James Sweats Buckets,
 from the series *Sugar Children*
 1996

▶▶

NAM JUNE PAIK

 Electronic Superhighway:
 Continental U.S., Alaska,
 Hawaii
 1995

300